W9-BDU-126

THE SUCCESSFUL
ARTIST'S
CAREER GUIDE

Finding Your Way in the Business of Art | MARGARET PEOT

NORTH LIGHT BOOKS
CINCINNATI, OHIO
www.artistsnetwork.com

CONTENTS

INTRODUCTION

If you have decided to make your living as an artist, you have taken a kind of leap of faith: that your ideas will move people, that they will be useful and desired, that you will be able to have a life making art. It is absolutely possible that you can succeed in doing so. We are entering a time when lots of people have the ease and leisure to actively seek beauty in their lives, and they are more discriminating about what they want to look at and interact with. Good and interesting images and design can be found from Madison Avenue to suburban box stores, from the Metropolitan Museum of Art to the apps on your iPhone.

As artists, we often define ourselves first as Artists, and then hope we'll be able to work out how to make a living. However, "making a living" doesn't just refer to what you choose to do to make money. It is about you as a whole person—making choices about how you want to live, how you spend your leisure hours, in what way you wish to contribute to your community. It will be easier to maintain a life making art if your art and life are not separate things. The life you wish for is the very life you now hold in your hands, if you are willing to shape it with the same care and attention that you bring to your art-making. This book is designed to help you make your art-making a realistic part of your life, assuming you have made the decision to be an artist and have some education or experience that is driving that decision. Art schools may not address how to make a living as an artist, and unless you have a relative or friend who makes his living this way, you may not get much guidance or encouragement making the choice to pursue an artistic career. But you are not alone—other artists have gone before you.

I will share with you the benefit of my experience. Other artists and business people will give you their advice, too. This advice is not infallible—ultimately you will have to pick and choose what feels right to you. This book will provide you with information, opportunities for self-reflection, and a little fun to help you find the best path for you as an artist. Most importantly, this book will show you how to structure a life in which the business of living doesn't totally halt your art-making. You have been pro-active and ambitious in planning your artwork, and this book will help you to be similarly proactive in planning your life.

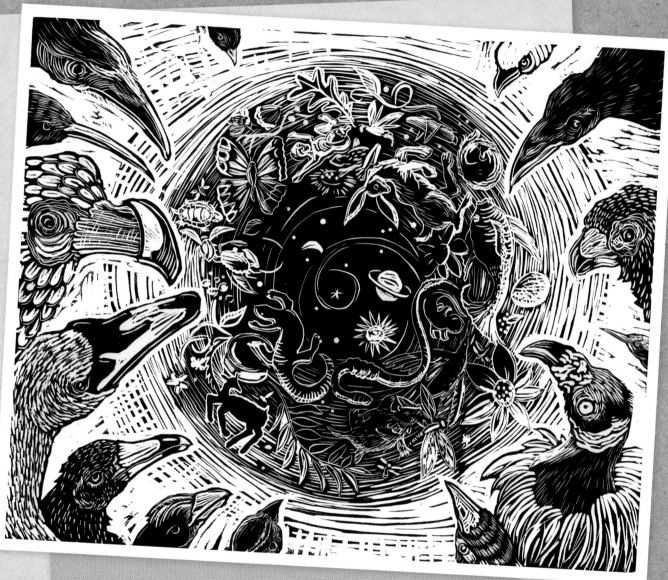

Creation, Margaret Peot
Woodcut on Rives BFK
16" × 20" (41cm × 51cm)

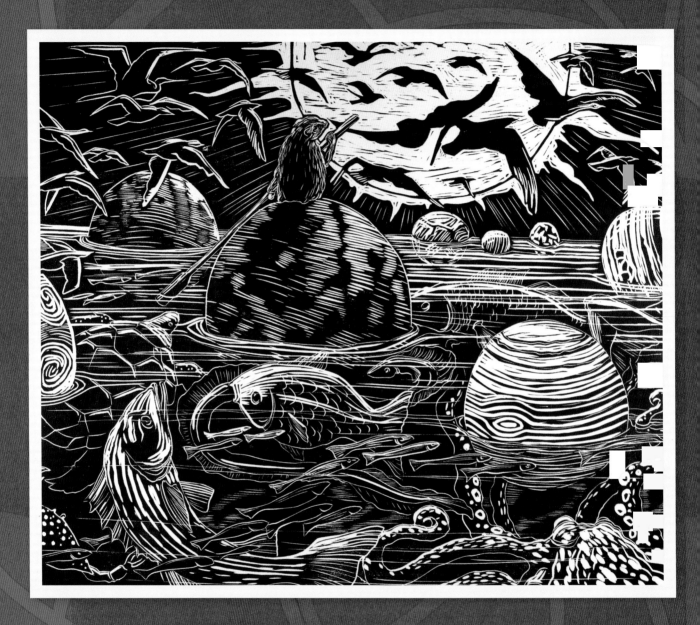

1 WHAT DO YOU WANT TO DO, AND WHERE DO YOU WANT TO LIVE?

There is a myth in our society that artists have to struggle, live in freezing garrets (*La Bohème*), and never have enough to eat. There's the misconception that artists are often addicted to alcohol (Jackson Pollock) and drugs (*Rent*), or perhaps have a streak of insanity running through them (Van Gogh) which contributes to the creation of their masterworks. Think of all the films you have seen or books you have read that perpetuate these ideas.

Despite our resolve to ignore these societal biases, we artists still think that we are not really allowed to choose what we want to do for a living, but instead must merely grab any opportunity offered to us. We find ourselves doubting that we're able to live full, productive lives contributing to society, paying taxes, participating as respected members within our communities—all while doing what we love to do.

Like everyone else, as an artist you have a choice as to where you live and what you plan to do there. You can shape a life for yourself somewhere that is exactly right: your living space, your studio, your job, your mate, your work. Only in rare instances do some of us get it all right the first time. As the years pass, you will get closer to what you like and want, and your needs and interests will change.

This chapter will help you figure out where you want to live and what kind of work you might find there.

Shepherd Watch, Margaret Peot
Woodcut on Zangetsu
20" × 24" (51cm × 61cm)

I'VE GOT AN ART DEGREE—NOW WHAT?

Many of you will have graduated from BFA programs, and more than half of you will go on to get an MFA. A much smaller percentage of you will go on to teach college art courses. I mention this here because often, teaching is the only career track suggested to aspiring artists. This is because the people who propose it are often teachers themselves—people who love teaching and have chosen it for their own careers. It's a path that they know well and can whole-heartedly recommend. However, the amount of college teaching positions available is quite small compared to the number of graduates seeking them.

Let's say there are approximately one thousand accredited college programs that offer BFA/ MFA programs. Each of those programs graduate, conservatively, thirty students per year, and each college has, extravagantly, one or two open teaching positions each year. That means that if all the graduating students sought college teaching positions, there would be thirty thousand students applying for about two thousand jobs. And that's just one year's worth of graduates, which doesn't include the thirty thousand from the previous year, or all of the experienced faculty looking to relocate or move up in their teaching careers.

Teaching college can be a great gig, offering the opportunity to share your knowledge with others, a schedule that permits time for work in your studio, summers off, and even the occasional, well-earned sabbatical. But the fact is, there are simply not as many opportunities to teach as there are applicants—not by a long shot.

If you love teaching and feel that this is your true calling, then you may be ideally suited to follow this career path. However, if the thought of teaching doesn't thrill you, but it is the only thing you can think of doing to earn a living, or if you don't happen to have a higher degree in art, then you should know that there are many other options out there to consider.

Spinning a Life

The following worksheets will help you begin the process of brainstorming a life for yourself based upon what you would really love to do, rather than what you imagine might be all you're allowed to do. Consider them and fill each one out in as playful and expansive a frame of mind as you can. After we get a few ideas about who you are and what you'd like to do, then we can start using practical tools to help get you to that life you imagine.

"If the thought of teaching doesn't thrill you... there are many other options out there."

WORKSHEET: IMAGINE YOUR DREAM LIFE

In your most extravagant dreams, what would you like to do with your life? Imagine the most gorgeous fantastic life you can think of with all the trappings: time to work, a wonderful studio, interesting clients or buyers, a supportive mate, a nice place to live, etc. Don't shortchange yourself in this exercise by not writing down certain dreams because you "know" they won't come true. Write it all down. Fill a page with your dreams.

© Patrick Hajzler

Now break your dreams down into a list of "wants." Beside each want, write the first couple steps towards having that part of the dream be a reality. These pipe dreams are the scaffolding upon which you will build your real life. Allowing yourself to dream will imbue your intentions and actions with great power.

© Patrick Hajzler

What you like to think about and do is not incidental. Sometimes the thing that you take the most for granted can be the thing that will be the basis for your art-making career. Perhaps you already have a good sense of who you are and what you like to do. But if not, these questions will help you focus:

What is your primary medium? _____

What media are you interested in but have not yet tried (bookbinding, encaustic, puppet making, glass blowing, ukiyo-e, shibori, egg tempera, pop-up structures, animation, type designing, letterpress printing, weaving…)?

When you go to an art museum or look at art books, what are you drawn to? _____

Are there time periods of art that you respond to especially? Which ones? _____

Are there countries/cultures whose works inspire you particularly? Which ones?_____

Do you ever go look at pottery, armor, clothing, jewelry or reliquaries? Which of these, and why? __

What artists do you like? _____

What do you do extremely well, or what would you like to do extremely well? _____

Have you ever been asked to do something because you were the "creative one" that you liked
and would like to do again? What was it?

What things are you interested in outside of your artwork? _____

What is a secret fun thing that you like to do but wouldn't necessarily tell anyone about? (Nothing too deviant, please!)

What do you collect or have you collected? _____

What was an experience that left you speechless with delight? _____

Where do you want to live? _____

What lifestyle do you think would suit you more: the city life or country life? Why? _____

© Jean Scheijen,
www.vierdrie.nl

If you won the lottery today, and could afford to do anything, go anywhere, buy all the art supplies you needed, even hire people to help you—what would you do with that freedom?

If you can't think of anything, if your mind is blank, then write that down, too. Are you really fried? Tired? Are you anxious about something? Can you not imagine a life where you could get to do whatever fun thing you wanted to do? That's significant, too, and worthy of some thought.

© drouu

Sometimes what we want to do will dictate where we need to live. For example, if you wanted to be more proficient in the Japanese art of shibori, perhaps you would go to Japan to study there. Other times, where you want to live might be driven by family, pleasure or a leisure activity that interests you.

Make a list of places you have lived in, visited or read about that you liked. Next to those places, write why you liked it there. Was it the climate? The people? Opportunities? Proximity to family and friends?

Locations and what you liked about them:

© M. Cooper

Where would you most like to live? Prioritize your list, 1-2-3:

1. _____

2. _____

3. _____

WORKSHEET: ART JOBS

Here is a short and incomplete list of possible things to do as a visual artist. Check the things that seem interesting to you, that pull you, regardless of your current knowledge about them. (For a more complete list of art jobs with definitions, see chapter 6.)

- ☐ Paint scenery for the theater
- ☐ Make props or masks for the theater
- ☐ Paint dioramas for theme parks or museums
- ☐ Paint murals
- ☐ Restore murals, paintings, vintage wallpaper
- ☐ Teach art to children or adults
- ☐ Do art workshops with children, the elderly, the chronically ill
- ☐ Design, dye or paint fabric for fashion
- ☐ Make clothes, hats
- ☐ Design or weave textiles or rugs for homes
- ☐ Print T-shirts
- ☐ Paint baby clothes or biker jackets
- ☐ Write about art or art techniques
- ☐ Work in a gallery
- ☐ Show in a gallery
- ☐ Do sculptures for public spaces on commission
- ☐ Design posters, cards, stationery
- ☐ Work as a color consultant for a catalog clothing company
- ☐ Work in a museum as a docent or an events planner
- ☐ Make or restore religious artworks
- ☐ Make stained glass or do glassblowing
- ☐ Make pottery
- ☐ Make jewelry
- ☐ Forge iron fences, restore ironwork

- [] Write an art techniques book, write and illustrate a book
- [] Do cartooning, make a graphic novel
- [] Animate a film
- [] Sell your work at art fairs
- [] Illustrate science books or medical texts for magazines
- [] Collect and sell other people's art
- [] Design websites
- [] Design movie posters, CD covers
- [] Silk-screen wallpaper
- [] Apprentice to a well-known artisan (learning blacksmithing, shibori dyeing, etc.)
- [] Assist another artist (manage schedule, chauffeur, buy art supplies, stretch canvasses)
- [] Other (list things as you think of them):

What have you checked? Number your list in order of preference, without worrying about the viability of what you have chosen as a potential career.

ACTION STEPS: CAST YOUR NET

Look back at what you considered and wrote about in the worksheets. What seems like the most interesting thing? The most fun? What would you like to wake up and start working on tomorrow? Where would you like to start doing this work?

Do some research online to help your brainstorming. Using a search engine, such as Google or Yahoo!, type the number-one job that you checked, followed by a comma, and the number-one place you would like to live. For example, if you would like to paint murals (regardless of whether or not you know how to paint a mural) in New Mexico, type: mural painting, New Mexico.

You will find photos of murals and who painted them, artists who have painted murals there and may or may not live there. You will find not-for-profit groups who have commissioned a mural to grace a school or library, pictures of murals done long ago that are or are not being restored. You will also find lots of things that are not pertinent at all, so give yourself plenty of time to sift through all of the information.

If you find a mural or a project that you like in particular, call the person who painted, designed or organized the project. If no phone number is available, email them and ask if you can call. Tell them you like the work

they did. Ask how they got the gig. Ask if they ever hire anyone to help them, or if they know of any other projects happening there that you could be a part of in some way.

With a simple phone call expressing genuine enthusiasm, you can easily ascertain if it would be appropriate to send a résumé or examples from your portfolio, and perhaps even more importantly, what *kind* of résumé to send. Then write to them, thanking them for their time. Include your résumé or examples of your work if it seems appropriate (see chapter 5). Do this with at least five different people or organizations.

Then, when you are ready, plan a trip to New Mexico. Call and tell the people you connected with on the phone that you will be in the neighborhood. Offer to take them out for a coffee or beer, and ask if you can pick their brain. Ask if you can see their studio or workspace. Ask to see some of the other things that they have painted. Soon you will have all kinds of information about availability of work, if there is enough work to sustain you in living there permanently, even what part of town it would be the best place to live.

"Whoa, whoa, WHOA," you say, "I don't know how to paint a mural. I don't know the first thing about it. I just chose it because it sounded cool." The point is to show you that you don't have to sit around your whole life

> "With a simple phone call you can easily ascertain what *kind* of résumé to send."

wishing you were painting murals in New Mexico while never actually taking any steps to get closer to that dream. Don't you love reading about people who live their dream life? Well, you can be that person too!

If you don't know anything about mural painting, get a book on mural painting or scenic painting from the library. Look at murals online. Teach yourself how to paint bricks and stone, foliage and flowers, and architectural detail (all of which you really know how to do already if you paid attention in your life-drawing and painting classes) using latex paint and colorant. Practice a bit, then paint ten different large-ish samples of these things on heavy-weight paper or canvas and photograph them.

Paint a mural in a child's room and take a picture of that. Ask around to see if anyone will let you paint a mural or floorcloth (a mural that goes on the floor, like early linoleum) for free for their home and take photographs of that. Not only will you have learned something, you'll also have some practical experience—and a portfolio!

Back to the computer! Research your number-two job and location (example: art workshops for the chronically ill, Montana). Contact relevant organizations. If someone tells you they have nothing for you and can't help you, maybe you haven't asked the right questions. Here are some things you could ask an employee or organizer of art workshops for the chronically ill in Montana:

- I am developing (be specific) a workshop for chronically ill kids that involves making sock puppets and telling stories with them. Is that an idea that would work with your program?
- Can you please send me some information about your program?
- I am interested in relocating to Montana. Are there any other opportunities or organizations in this field in your area that you could tell me about?

If you find someone interested in talking, ask them what life in that area is like.

"Don't you love reading about people who live their dream life? Well, you can be that person too!"

THE POWER OF GENUINE ENTHUSIASM

"... it helps to be persistent and genuinely enthusiastic."

I painted scenery for theater to make a little extra money during school, so when I got to New York, I hustled for scenic painting jobs. The only jobs I could get were non-union, where I mixed a lot of paint and schlepped five-gallon buckets of it around.

I decided I wanted to really paint and add to my skill base, too. On the days I didn't have work, I went to the Mid-Manhattan Library and looked at books on mural-painting and trompe l'oeil or, "deceive-the-eye" paintings. I copied down the name and contact information of a company that appeared in many of the books, Tromploy, Inc. I thought they were doing the most interesting work, so I called them and asked if they were hiring. When they said no, I told them how much I admired their work and asked if I could come to see their studio.

As it happened, the owners, Clyde Wachsberger and Gary Finkel, were union scenic artists who had started a business painting murals. I visited and oohed and aahed all around their loft—they did quite amazing work. Two weeks later, they called and asked me to work with them on a trio of trompe l'oeil niches at a residence on Park Avenue. I worked for them off and on for two years and learned so much. So, it helps to be persistent and genuinely enthusiastic.

A NOTE ON CALLING PEOPLE

When I first started doing freelance mural and scenic painting in New York, I had stretches of time when I didn't have any work. Mostly this was fun, when I had a little money in the bank and knew I had another job coming up, because I could work in my studio or go to museums and enjoy the city I was beginning to call home. But before I did any of those things, I forced myself to make at least five phone calls. These would be to potential employers or people I had met while working who might have leads on other jobs.

I hated making those calls. I spent a lot of time dreading them and psyching myself up to make them. I'll admit, sometimes I didn't do it—promising myself that I'd make ten calls tomorrow.

But here's the real deal on calling people: Relax and use your common sense. It might sound obvious, but before you call, figure out why you are calling. What do you want to know? That is the essence of putting your best foot forward. You don't have to pretend to be someone else, someone more professional or knowledgeable. You just need a real reason to call.

THE GOOD, THE BAD AND THE UGLY

So far, I've probably painted a relatively cheerful picture of what life is like for an aspiring artist. It's only because I really believe it is a good life; a life that you carve out for yourself, an invented life.

In the interest of full disclosure, however, I will tell you that there is some gloom to be found in this life, too. Because you are carving out your own path, you must decide that your ideas are worth pursuing. Occasionally, your ego will let you down, and you will question all of your decisions—right down to how you spend the individual minutes of your day.

Author David Foster Wallace said that true freedom "means being conscious and aware enough to choose what you pay attention to and to choose how you construct meaning from experience. Because if you cannot exercise this kind of choice in adult life, you will be totally hosed."

I think what Wallace meant is that you don't have to be pushed or bullied by our media-driven culture or by what other people say or think. You don't have to be what others think an artist should be, nor make art that you imagine others want you to make. You have an inner compass that guides your daily choices as well as your life choices.

Sometimes we forget to listen to these inner mechanisms, which causes us to doubt ourselves and leads to fear and misery. Sometimes this is caused by contorted ideas that we formed a long time ago about how life should be. Be brave; stand tall. If being brave and standing tall proves impossible, or if self-doubt is leading you to engage in self-destructive behaviors, don't be afraid to seek the advice of a certified therapist or psychiatrist. We don't all have to go the route of Van Gogh and cut off our ears to be artists!

Fortunately, as an artist, you have a strongly developed right brain that makes you ideally suited for this task of creating a life for yourself. Shaping your life will be your finest work!

"You don't have to be what others think an artist should be..."

ADVICE FROM VIRGINIA CLOW

Virginia Clow paints costumes and fabric for Broadway, dance, fashion and other venues. She is known for her intricate, time-saving textural stencils, spot-on color sense, and high standards. She has a BFA and an MFA in painting. I asked her what advice she might give to a young artist graduating from college.

I don't know how you could put this, but I wish someone had suggested to me that there was some sort of "track" besides going to graduate school and trying to get a teaching job. I think if I had even thought about how I could be an artist in a more realistic context, I might still be painting on a regular basis. Don't get me wrong, I love my life on most levels. I just wish I had used a little more cunning in terms of integrating art into living.

I think people need to travel as much as possible to look at art of all kinds. You're at a disadvantage in these college towns far away from good museums. Again, somehow they have to get places to look at the real things, both old and contemporary.

I also wish I had known how important it is to never stop making art. Daily if possible, because it takes so many years to find your voice. Early success isn't the point. It's so easy to get discouraged if no one is interested in what you're doing, but, in fact, there are lots and lots of late bloomers and they usually have more interesting careers.

And, this is a tough one, I'm not sure I would encourage people to come to New York. Other cities have vibrant art scenes and museums and are a lot more affordable and don't have as many distractions. Philadelphia leaps to mind. And the way things are now, people can still get others to look at their work, even if they live out of the Big Apple. I think a city is good but it doesn't have to be this one. I love it here, but that affection and attachment sometimes feels confining.

Tree and roots stencil (detail), Virginia Clow
Mylar, 12" × 18" (30cm × 46cm)
This detailed stencil was cut with a stencil burner (a tool that looks a bit like a soldering iron with a bent copper tip that melts Mylar), perfectly capturing the pattern of exposed tree roots in a muddy riverbank in the remaining light-colored Mylar.

Textural stencil, Virginia Clow
Mylar, 10" × 14" (25cm × 36cm)
This useful stencil, also cut with a stencil burner, was originally made for painting an undersea creature costume for a parade. It was intended to look like brain coral. However, it has been used for many costumes requiring texture since then, from dance to circus productions.

Water stencil, Virginia Clow
Mylar, 14" × 20" (36cm × 51cm)
This delicate textural stencil, cut with a stencil burner, has multiple uses but was cut initially to represent water.

INTERVIEW WITH
PARMELEE WELLES TOLKAN, PAINTER

Parmelee Welles Tolkan has been painting costumes and scenery for the theater for almost thirty years, working with some of the great designers and master scenic artists of the American stage. She also designs and paints murals for hotels, restaurants and private homes in Lake Placid, New York, and does fine-art paintings.

Did you always want to be an artist?

No, but I was always really good at art, especially copying. By the time I graduated from college I was pretty set on a theater arts career.

You are a scenic artist and a costume painter. How did your mural painting evolve from this?

When I moved to Lake Placid, a woman who was starting an interior design business asked me to do a mural. It was as simple as that.

Do you design the murals you paint, or do you work from a designer's elevations?

So far I have always designed my own murals. I have a conversation with the decorator or the client about what their wants and desires are, and then I start doing research.

I love doing research and looking at all sorts of different artists' work. I adapt older paintings or take photos and do montages to work from—it just depends on the desired product. I admit that I depend on doing the research and "borrowing" from whatever is suitable. I always do a scale rendering of the finished product that I get approved before I start. Then I approach the project as if it were scenery. I don't let the ego get too involved, just present a finished product that pleases the client.

What training do you have and what paths did you follow to get to doing what you do?

I went straight from college to New York City in 1970. I got a job moving scenery off-Broadway and worked as an assistant to set designers Kert Lundell and David Mitchell. I mostly built scale models of scenery.

Four Seasons, Parmelee Welles Tolkan
The Northwoods Inn, Lake Placid, New York
Mural, 8' × 150' (2.43m × 45.72m)
Parmelee says, "The challenge here was to draw the eye around and not be too 'Adirondacky.'" She made a collage of photos that she over-painted to create a rendering to present to the client. "I was asked to do something with landscapes and animals. I came up with the idea of a continuous painting that cycled through the seasons. It started in one corner with winter and moved through spring and summer into fall. This was a very long painting that I wanted to complete as quickly as possible. I hired a colleague, Lynn Zuliani, to paint the animals and birds as I forged ahead with the landscape. This mural is my style of painting," she says.

I discovered scenic art at the off-Broadway theater and asked where I could study it. I enrolled at Lester Polakov's Studio and Forum of Stage Design (which used to be in the West Village) where he gave an intensive study in the tools of scenic art. In those days there were many summer-stock theaters, and I worked three summers at three different theaters. That was a good start, but the real place to learn the craft was on the Union (United Scenic Artists' Local USA 829) jobs.

I took the union exam in scenic art three times and finally passed in 1976. I then felt that I had to stop painting costumes (which I had started doing in 1972) and concentrate on painting scenery so that I could really learn from the master scenic artists who were in the Union at the time. I worked nonstop for nine years. This work is the basis of my mural painting.

During the years when I was unable to pass the United Scenic Artists exam, I painted fabric for costumes at Ray Diffen's costume shop. I was really lucky to work closely with costume designer Willa Kim who helped me to *see* color and draw much better. Her costume sketches were always so inspiring and it was fun to paint the fabric for the various shows and ballets she designed. I also got to work with many of the other great designers of the time.

Later, when I started spending the bulk of my time in Lake Placid, I reverted to costume painting as it is more portable and I am able to do it away from New York City.

Do you have an art-making practice that is separate from what you do for a living?

I do some landscapes to order, but I do not find the life of a solitary artist as fulfilling as the collaborative process of theater.

What keeps you motivated? Where do you go, what do you do to get inspired?

The next sketch that comes in the door of Parsons-Meares costume shop keeps me motivated and inspired. I love the sampling process, where I am creating the method of painting the fabric to produce a finished product that reflects the designer's vision. Also, interacting with the drapers and figuring out various approaches to a costume is very interesting to me. I get bored if my method takes too long so I am always trying to create an approach that isn't too crazy, but I'll do those thirty-two-piece piece stencil jobs if that's how to solve a problem.

Similarly with murals, the next job is the one that keeps me interested. The collaboration with the decorator and doing the scale

renderings to work out the problems is the part of the project that interests me the most.

For inspiration, I love museums and books of artists' work. Frequently the costume designs I am working on reflect nature and it is so interesting to see the fabulous animals, insects or fish that are all around us.

How do you balance the business of art with art-making?

I'm afraid I'm not a very good business person. I just want to do the work. Thank goodness for the Union and the contracts that they enforce! On the other hand, I have been able to have a career in art and worked at different aspects of art and made a living.

What is the most important piece of advice you would give to an aspiring artist?

Dream your wildest dreams and go for them. Don't be afraid or intimidated. Do every job with your whole heart, even if some of them don't enthrall you. Everyone gets one good, big break—be ready for yours. You won't know when it will present itself, but work away at gathering all the "tools" you will need to do that dream job when it comes your way. It probably won't come twice. The answer is: If it looks right to you and pleases you, it is right.

Wine, Women and Song, Parmelee Welles Tolkan
Nicola's on Main, Lake Placid, New York
Mural, 8' × 8' (2.43m × 2.43m)
This mural was also used on all the menus and advertising for Nicola's on Main. It is based on the painting *Pulcinella in Love* by Gian Domenico Tiepolo. Parmelee chose it because she thought it made a good welcome to a restaurant.

She painted directly on the wall using Glidden house paints for everything except the red cloak, saying, "I added Liquitex Cadmium Red to the wall paint to intensify the color. I have had very good luck using house paints as a medium for my murals."

2 WHAT WILL BE YOUR EXPERTISE?

Sometimes special knowledge or skills you have will open doors for you that would not be open to a generic painter or sculptor. Are you interested in encaustic? Letterpress printing? Blacksmithing? Gyotaku? Shibori? Fresco? Tempera painting? Glassblowing? Do you make your own pastels? Do you whittle? You don't need a gimmick to be successful, but if you work in a medium that is unusual and specific, it is more likely that you will be asked to teach, demonstrate or write articles about it. There will be organizations for that sort of artist with websites, blogs, instructional videos and books. See all the opportunities for you already?

When our parents or grandparents were young, people could work for a company for thirty years and retire with a gold watch and a pension. Opportunities like that may still remain, but they are increasingly rare, and rarer still for artists. Many people work three or four different jobs, including multiple career paths, in their lifetime.

There are artistic careers that follow a traditional nine-to-five, five-days-a-week pattern where projects and goals are set for you. More often than not, however, when you are making a career as an artist, you will have to invent what you do and set your own goals. In this chapter, we'll explore the working world of artists and what you may be able to do with your expertise.

Undersea, Margaret Peot
Fabric painting sample
I have painted and dyed costumes for the past twenty years for Broadway shows, film, television, dance, the circus and various events. The paint used for costume painting is a dye suspended in a gelatinous thickener that washes out in the dye-setting and washing process. Painting with dye is a bit like painting with watercolors—all transparent. This sample was painted on nylon. The light was maintained using wax as a resist.

> "Being an artist and a skilled artisan sets you up perfectly for making a living..."

ARTIST AND ARTISAN: WHAT'S THE DIFFERENCE?

An artist is defined as a person who creates a work of art. An artisan is someone who skillfully makes something, a crafts person. With few exceptions, artists are usually highly skilled artisans. They have to be in order to make their art successfully.

Being an artist and a skilled artisan sets you up perfectly for making a living as an artist. If you have an artistic career where you use your artisanship, where you think about line, color, mark and texture (as an illustrator or scenic artist, for example), or how things move through space (fashion or industrial design), how things are organized on a page (graphic or alphabet design), or how to make shapes and marks work at a distance (theater painting or design), then this feeds your whole life as an artist. Not only will you be working in a community of other artists (great for support and contacts), but you will learn skills that will inform your art-making practice. You'll learn important lessons about collaborating with other creative people as well.

YOUR TIME IS NOW

The world needs you now! Images, design and stories are needed to enrich peoples' lives. In the midst of a sea of information, people are hungry for meaning and joy, context and creativity.

In Dan Pink's book, A Whole New Mind, he suggests that we are entering the Conceptual Age. There was the Agricultural Age where we farmed for our livings, then the Industrial Age, where we learned to mass produce things in factories. We are now passing out of the Information Age—the age of knowledge workers, people adept at using and moving information with the Web, crunching numbers and analyzing data.

In the Conceptual Age, left-brained thinking (organizing data, analyzing details) will no longer be enough to thrive. Right-brained thinking (creativity, intuition, hunches), which used to be looked at with suspicion and even contempt, is needed to survive.

Artists are good at seeing the whole picture, intuiting the next step, sensing patterns and making meaning out of them. This is your time!

ARTISTS MAKE GOOD EMPLOYEES

Many artists can be excellent employees. We are able to see the entirety of a problem and turn it in our minds, because we do this with our own work. We are able to think on our feet and are good at organizing time and resources, because we do this in our own studios. We thrive in situations where an employer tells us what the goals are and then turns us loose to figure out creative solutions.

Artisans and artists make capable free-lancers as well, possessing characteristics that make them ideal self-starters and problem-solving employees.

Those are the ideal situations. But more commonly, you will find yourself hired to do what is realistically six hours of work with the expectation that you will be there for an eight-hour day. That means that you will have to fill two hours with looking busy while wasting time, idling, hiding and doing busy work. You will be paid by the hour, so the incentive to finish the job early is curtailed because if you hustle and get the work done, then you lose out on those extra hours of pay!

The other thing that can happen when you work for someone else is that the reward for doing your job well and quickly may be a promotion into a managerial position where you are no longer solving problems related to making something, but instead are managing others while they do so.

When you have a full-time job, you have structure, security, a steady paycheck and benefits. When you are a freelancer, you have to provide your own structure. You will have to get comfortable with not knowing exactly how much money you will make that year. You will have to seek out and pay for your own health insurance, and create your own pension fund.

Which approach appeals to you, and why? Your confidence in your ability to imagine and create structure may offer some insight. It's also possible that you might not figure out what your preference is for years. For now, to get a better idea of who you are as a worker, complete the following worksheet.

"Many artists can be excellent employees."

This worksheet will help you decide if you are more suited to freelancing, full-time or part-time work. Many of these are yes-or-no questions, but take a minute to elaborate on your answers.

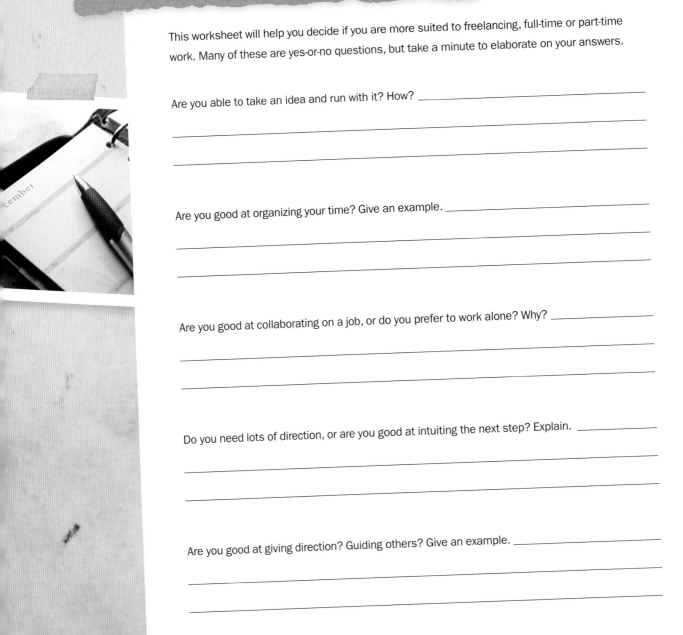

Are you able to take an idea and run with it? How? _____

Are you good at organizing your time? Give an example. _____

Are you good at collaborating on a job, or do you prefer to work alone? Why? _____

Do you need lots of direction, or are you good at intuiting the next step? Explain. _____

Are you good at giving direction? Guiding others? Give an example. _____

Are you able to adapt to different environments? Are you flexible? Give an example. _____

Are you fast, or do you like to take your time? Why? _____

Do you have confidence in your own ideas? Give an example. _____

Can you think on your feet? Or do you get rattled when things don't go as planned? Explain.

Are you good at communicating with others? Give an example. _____

Are you good at solving problems? Other people's or just your own? How? _____

INTERVIEW: MARGARET JANIK, GRAPHIC DESIGNER

Margaret Janik came to New York City with her University of Florida diploma and an all-black wardrobe. After years at the in-house art departments of Macy's and Lord & Taylor, she crossed from print to web design. Since 2008, she's been freelancing while raising her daughter in New York City, joyfully returning to her markers while compulsively volunteering to design every school flyer and community event that crosses her path. You can see her recent work at margaretjanik.com.

How would you describe what you do?
I'm a graphic designer. I collect inspiration from the visual language I see all around me and use it to make new signs, symbols and presentations for things that other people need help communicating.

What training do you have? What paths did you follow to get to do what you do?
After studying graphic design at the University of Florida, I came to New York City and got a job in advertising. Once you work as a graphic designer, and acquire the skills to produce design, it's an impossible profession to leave. We encounter design in every facet of our lives, and a designer cannot help but find projects everywhere, whether they have assignments or not.

Did you always want to be an artist? Or did it evolve from something else?
I was a child inclined toward drawing and making art, but was mostly inspired by the pop culture of my day: Saturday morning cartoons, cereal boxes, toys. I made signs for every room in our house. I made my own fake cigarettes and game boards. I wanted to grow up to be an "Artist." I had the idea of painting on the Left Bank, wearing a beret. But as I grew up I realized that the images in my head were better suited towards work in design than expressing myself in a fine-art way.

What keeps you motivated? Where do you go, what do you do to get inspired?
Design inspiration is unavoidable. We are all bombarded with graphics every day. Terms like

Yogasmoga, Patchits, Kidfit, and Cosmident
logos designed by Margaret Janik.

"fonts" and "layouts" are part of the common vernacular. Even bad design is inspiring because it becomes an exercise in thinking about how to improve it.

How do you balance the business of art with art-making?

This is hard, because I constantly have to remind myself that I'm not "making art!" As a graphic designer, I am working for a client. I get paid by satisfying the client. I also have to remind the client that it's not about what I want to say, but what my professional instinct tells me they should say. But the bottom line is that I am working to get paid.

Do you work at home?

For many years, I worked for a company in an office, then I started working from home. In both locations, there were many wasted, unproductive hours. But at home, those hours create more guilt, and are not paid for! Now, I rent outside studio space to work out of. My most fruitful design time could still be in any location, at any hour, as long as I can plug in my laptop. But as a freelancer and a night owl, I find it's imperative to be in a daily location that gives my mind some structure.

How important has your volunteer work been to making business contacts?

Hugely important. Volunteer work enables me to choose a project and that puts me into close proximity with people who share my interests. And the people I meet often come from other professional backgrounds that I would not otherwise cross paths with.

How has parenthood changed the way you shape your work life?

I would like to say that parenthood makes me better because it forces me to work smarter and be more efficient with my time. But I really miss the ability to spend time on some typographical or color nuance that no one but myself will appreciate, because it's in those obsessive moments that I love what I do the most. But kids are so creative too, and they provide all sorts of lessons in creative thinking. The other day I was grueling away on some logo ideas. For every one idea I came up with, my daughter quickly sketched out ten on Post-its that she stuck all over my computer. It did help to inspire me to loosen up!

What is the most important piece of advice you would give to a designer starting out?

Best advice for a designer ... I am going to quote Paul Rand, who quoted Ludwig Mies van der Rohe, who said something like, "Don't try to be original. Just try to be good."

INTERNSHIPS

Internships are wonderful opportunities to learn and make contacts in a field you are interested in. Internships often lead to jobs. Unfortunately, internships do not pay anything, so you will need another source of income, like savings or help from parents or a spouse.

Often there will be people doing exactly what you are doing as an intern but getting a little pay for it, as well as benefits, sick leave and vacation time. This is because internships are a great way for a company to train someone to shoulder some of their workload without having to pay them. This doesn't mean you should steer clear of internships—just keep in mind that they don't pay, so you have to weigh their worth carefully.

On the other hand, if you know nothing at all about your field of interest, and have an alternate source of income, an internship can be like a free course and a great way to get some practical experience for your résumé.

THE SAWMILL

That said about internships, let me tell you a story about my grandfather...

During the Great Depression, it was very hard to find work (a familiar state of affairs in our times as well). My grandfather wanted to work at a sawmill, but was told by the foreman that they had no places available. Nonetheless, he showed up the next day and swept the massive amounts of sawdust as it was created, allowing the saw operators to continue sawing instead of have to stop and sweep. He expected no pay, and he got none.

The next day he came and swept again and straightened up. He did this for two weeks with no pay. At the end of that time, he was hired to work there. He had proved—by showing up, working hard and being friendly and helpful—that he was a valuable guy to have around.

In the costume shop where I work, my boss takes on interns. When she has more work than the basic staff can do, she sometimes hires from the list of people who were interns—but only those who were diligent, helpful and friendly.

WORKING A NON-ART-RELATED JOB

The work you do for money will always affect your life, regardless of whether it is art-related or not. Unless you are incredibly adept at sectioning off disparate parts of your life, one will flow into the other. Some artists prefer their work for money to have nothing at all to do with making art. Perhaps it is because they feel that by using their "art muscles" all day—their visual sense, their aesthetic sense, even the physical energy that is required to do some art-related jobs—that there will be nothing left when they go to their studio to work.

Other artists do work for money that uses their art-making abilities but is far from what they do in their studio. They like this because they feel that they can experiment with visual language in a format that is not loaded with the emotional and spiritual elements of studio work.

Some artists like more social jobs such as teaching, working in a museum or even bartending to offset the solitary nature of making art alone in a studio. Over time, you will figure out what suits you best.

THE PURPLE TELEVISION SET

After calling and calling this scene shop in New Jersey, I was finally hired to work for two weeks on a set of a television show. The set was made out of wood, poorly constructed with badly matching joints that had to be filled, taped and sanded before the whole thing could be painted purple—glossy purple. The gloss showed every flaw in the construction. There was nothing creative about the job, except, perhaps, matching the paint to the sketch.

I had been hired along with three other painters and, after taking one look at the horrible mess, I decided the only fun in it would be getting it done. After the first day, I was approached by the other three painters and told to slow down, that the job had to last the whole two weeks, and that I was messing it up for them.

What a miserable two weeks it was, trying to look busy! I spent the whole time watching the clock. For years I thought that it was the fault of those other painters—that they were lazy, deceptive, no better than thieves. In retrospect, however, I realize it was the fault of the employers. They had provided no incentive for getting the job done quickly, and had missed an opportunity. I encountered other situations like this in the full-time work world, and so, I decided early on that working a nine-to-five job wasn't for me.

HONESTY IS THE BEST POLICY

Being honest is always a good thing. When you exaggerate your skills and importance, you will always be found out. If you are good at something, say so and stick by this. If someone wants to hire you on the spot to paint signs for their grocery store using sign-painting brushes, but you have never done this and are not even sure what sign-painting -brushes are, it is best to say so. They might hire you anyway, and will appreciate your honesty in any event.

That being said, when I originally applied for a dyer job at the costume shop where I currently work as a painter, I brought in an elaborate portfolio of indigo-dyed shibori samples; I even had tie-dyed plaids, stripes and star bursts. Then the owner of the shop asked if I could dye something all one color with no texture at all. I had not done this, but thought, "How hard could it be?" I told her yes, but I practiced dying things one color the entire week before I started!

STRENGTHS AND WEAKNESSES

When you go to an interview, often you'll be asked to name some of your strengths and weaknesses. This is a standard interview technique. These questions help the interviewer determine whether or not you would be able to work with others in their organization.

Books on finding jobs will tell you to rehearse a couple of weaknesses that can be viewed as strengths, in case you get asked what your weaknesses are. For example, a weakness-as-strength could be, "I am very determined and goal-oriented, but sometimes this can make me less flexible." Or, "I am really good at organizing time and moving things along quickly, but sometimes I get caught up in the flow of the minutia of production and lose sight of the whole project." See? You can state a positive about yourself along with something that you are working on. It shows self-knowledge.

Thinking about the relationship between your strengths and weaknesses is also a useful tool for self-evaluation. It can help you focus more clearly on what work you might be best suited for, and what might not be the best fit.

> "If you are good at something, say so and stick by this."

WORKSHEET: STRENGTHS AND WEAKNESSES

Name your five greatest strengths. These can be artistic, like, "I draw the figure really well," or "I am an excellent colorist." They can also be social strengths, like, "I work well with others," or "I organize my time well."

© Steve Ford-Elliott

Name five of your weaknesses. These can artistic like, "I draw babies poorly," or social, such as, "I am too impatient with beginners," or "I do not mentor others well," or "I am too emotional; I take criticism to heart."

Look back over your two lists. What connections might you make between your strengths and weaknesses?

FIND YOUR CENTER

You may sometimes be counselled by well-meaning non-artists to take whatever opportunity presents itself. After all, you have chosen a difficult path, and anything art related is another stepping stone closer to your goals. Right?

In fact, this isn't good advice. Of course everybody along the way will have to do jobs that are not their number-one favorite thing to do. But everything you do must generate from your center—from what you know to be right, interesting and good for you. You should have a template in your mind and heart of who you are and what you want to spend your time doing. Every opportunity that arises should be held against this template to see if there is a fit.

Sometimes the fit isn't perfect and you go with it anyway. But if it is completely different from your inner template in a way that dismays you, then simply say no. Beware of anyone that tells you that if you miss this opportunity, it will never be seen again, or encourages you to do something for free or very low pay because it will get your foot in the door.

That's not to say you should say no to everyone who says this—just keep in mind that you have been socially prepped your whole life to "take what you can get." Some-times saying no can be a positive step towards what is a better fit for you.

As an artist, you can move confidently through the working world. Your aesthetic sense, your ability to balance the structure and freedom of art-making, and your inherent problem-solving abilities (all artists have them) will make you a capable freelancer or valuable member of any team. The trick to all life planning is to make a choice about what expertise you want to offer the world.

After you do that, some obfuscations will fall away, and certain avenues will become more attractive than others. You will know how to support your decision and find the information and resources to implement your plan. With every step, the path will become clearer. You don't have to know the whole journey and its outcome at the beginning of the trip—you just have to know which direction you are going.

> "...make a choice about what expertise you want to offer the world."

BE CAREFUL WHAT YOU WISH FOR

Sometimes we can get so focused on getting a job that we forget about holding the prospective employment up to our inner template.

A job arose at a Midwest college for a theater scene-shop technician. They were excited about having someone who could paint scenery and set up and run a dye shop for their costume shop. I'd been freelancing, painting scenery and murals in New York, and was getting tired of the stress of wondering where my next paycheck would come from. This job prospect seemed perfect—it was steady money with benefits, doing something that I was good at. I put together a great application and had two enthusiastic telephone interviews. I had packaged myself as their perfect employee!

One night, I woke with a start and realized that I had forgotten about my inner template. Was this job really a match? I remembered that main reason I liked free-lancing was because it allowed me the time to do my own artwork, but this other job was full time. I recalled that there wasn't a vital arts community in that Midwest town, and most importantly, I had neglected to find out if my boyfriend was willing to move six hundred miles from New York City.

The next morning, before the process went any further, I called the man who would have been my boss and explained that I'd had a change of heart. It was not too cool—I should never have let things progress that far without thinking of my poor, neglected inner template!

After that, I started working as a costume dyer, painted textile designs on the side, got my first real art studio in Tribeca, and most importantly, married my wonderful boy-friend—none of which would have happened had I forgotten my inner template altogether, and taken that job.

© Daniel Silva

My Mistress' Eyes, Margaret Peot

Woodcut, 20" × 20" (51cm × 51cm)

Sometimes your art career will specify what art you make in your studio in a surprising way. I paint costumes as my main free-lance venture. There is a lot of color mixing and painting with brushes, sponges and airbrushes. So what does my studio art look like? Black-and-white woodcuts! I must have decided on some subconscious level that in my studio I wanted no colors and no brushes. Yet, when I painted several Ursula (an evil octopus) costumes for various productions of *The Little Mermaid*, an octopus swam into my woodcuts and seems to be sticking around!

INTERVIEW: APRIL VOLLMER, MOKU HANGA ARTIST

April Vollmer is an artist living on the Lower East Side of New York City. She focuses on moku hanga, Japanese woodblock printmaking, in her creative work and also teaches classes in this traditional technique. April has exhibited extensively, and her work is in many public and private collections.

Did you always want to be an artist? Or did it evolve from something else?

My mother was an artist, so it always seemed a logical thing to do. I anticipated being an artist when I was still in high school, before I understood what it required. I never planned my career in a practical way—I simply put making art first, and never thought much about having kids, a car or a house in the country.

What training do you have and what paths did you follow to get to doing what you do?

I have a Master of Fine Arts degree from Hunter College, City University of New York. I moved to New York City in 1975 to attend college, with the idea of becoming an artist.

In the early '80s, I renovated a tenement building on the Lower East Side of Manhattan with a group of artists. That project gave me a

low-cost place to live with a small studio, and also introduced me to the architectural office where I still have a part-time job. New York's vital artist community is an important reason

Kosha #6, **April Vollmer**
Woodblock and mixed media on panel
12" × 12" × 2" (30cm × 30cm × 5cm)
Koshas are the layers of being in Indian philosophy. This panel was created by layering several printed sheets of thin washi (a Japanese kozo fiber paper) over one another. The architectural plan is a composite of several offset-printed Indian temples. The birds were printed using moku hanga Japanese woodblock. This panel is part of a series of a dozen that concern the overlapping of interior and exterior spaces.

I have stayed in the city. I have kept in touch with artists I met in graduate school and have made many more connections through curatorial work.

In the 1980s I organized shows at alternative spaces with an artist group called Artists for All Species, concerned with environmental issues. Later I curated shows on my own at spaces including Henry Street Settlement and Ceres.

Do you have an art-making practice that is separate from what you do for a living?

I juggle multiple identities—showing my work, teaching workshops and working part time in an architectural office. Managing the client billing and overseeing the computer network for them still accounts for the majority of my income. I enjoy the architects I work with, and respect the work they do in historic preservation.

I often use architectural plans as elements in my artwork. A few years ago, I was invited into a show, *Day Job: Work Influencing Work* at the Arts Center of the Capital Region in Troy, New York, where I exhibited a series of large digital prints based on Bramante's Renaissance architectural plans. More recently, after a trip to India, I incorporated Indian temple plans into a series of woodblock panels. One of the panels from these works, the Kosha Series, was selected by the International Print Center New York for their *New Prints 2010/Autumn* exhibition.

How do you balance the business of art with art-making?

Balancing office work, teaching, art-making and art business is an ongoing effort. It is important to have enough money to travel and to buy art supplies, clothes and a computer. I shop at thrift stores, and I stay with friends when I travel, but I don't want to pass up opportunities because I don't have enough money. I have no children and no car, and my small studio is located in the back part of my fifth-floor walk-up apartment. I renovated the building with a small group in the 1980s, and now my partner and I own our floor, so maintenance expenses are low. Teaching is rewarding but sporadic, so I still rely on my architectural job for my health insurance and most of my income.

Since I work in an office without a long summer vacation, I have found that spending a few weeks dedicated to making art at residencies has been an important way to balance art and business. I have been to the MacDowell Colony, to Banff, and many times to the Virginia Center for Creative Arts. Each stay has been essential to getting started on

a new body of work, and each has given me contacts and ideas that sustain my practice into the future.

Have you found that concentrating your attention on moku hanga has opened doors for you? What drew you to this technique?

Concentrating on moku hanga, Japanese waterbase woodblock, has opened many doors for me. I have always relied on print making for the structure it gave me to develop an image. Moku hanga in particular suited my temperament because it is a form of print making where sensitivity to materials (wood, steel, paper) makes a huge difference. Washi, handmade Japanese paper, has great character and requires special awareness of its properties to make the best prints. Color enters the fiber of the paper during printing, rather than sitting on the surface as with oil-base printing. I have always been interested in cross-cultural understanding, and moku hanga offers a way to connect with Japanese culture through the specifics of materials and techniques.

My work as a moku hanga artist has given me an identity apart from other print makers, and has given me many opportunities to travel. I teach regularly at the Lower East Side Printshop, and have given workshops at many other locations across the country. I went to Japan for six weeks in 2004, when I was accepted to help at the Nagasawa Art Park program. Since then I have been to Canada, Estonia, England, Germany, Poland and Serbia for exhibitions, conferences and teaching. Most recently, I was invited onto the Board of the First International Mokuhanga Conference in Kyoto and Awaji in June 2011.

Do you find that your teaching informs your studio work?

Gradually my teaching has become more in demand as more people have become interested in moku hanga, and as more people have become aware of my work as a teacher. In addition to its importance as the technique of classic Japanese ukiyo-e prints, moku hanga is nontoxic and doesn't require the use of a press, so issues of culture and the environment are incorporated into my classes.

Making art is about communicating to an audience; teaching has a similar aim. I always emphasize history and show my own work as an example of contemporary art built on that foundation. I often become aware of new aspects of my own prints when I discuss them in a class. I get great support from my students, who are mainly artists themselves. Many have remained friends, and all are part of my network of art connections. Teaching

has reinforced my understanding of the significance of art as a way to communicate with other people.

Where do you go, what do you do to get inspired?

I love living in New York, and for the first decade I lived here the excitement of being in the center of culture was my inspiration. I went to all the museums, and especially enjoyed the small ones, the Hispanic Society, Japan Society, China Institute, the Explorers Club, The Frick before its expansion and the old, small MOMA when it felt like a private club. I loved going to Soho when it was a neighborhood of artists, and the East Village storefront galleries before AIDS.

In the '90s I started visiting Italy and saw the treasures I had studied in art history classes. I learned everything I could about art history, first the Renaissance, then Baroque. Then I looked deeply at ancient Roman art, the mystery cults and the origin of religious ideas.

In 2004, I was invited to Japan to work with the Nagasawa Art Park program in recognition of my study of Japanese woodblock. The trip expanded my understanding of the technique and its place in Japanese culture.

In 2008, I was invited to show my Japanese woodblock prints in Belgrade, Serbia, with a residency in nearby Nis. I discovered that was the birthplace of Constantine, connecting the conflicts of Eastern Europe with the history of Rome. I was excited by the idea of being an American talking about Japan to an audience of Serbians. World peace is elusive, but making personal cross-cultural connections through art is a small but meaningful contribution.

What is the most important piece of advice you would give to an artist starting out?

I have found that most opportunities come from other artists, so I maintain memberships in many artist organizations and always keep in touch with friends and colleagues within the artist community. I email everyone on my mailing list a few times a year, or when I have a significant exhibition. It is very important to have a business card of your own handy to trade with other artists, and a website that is easy to locate for people to find your basic information and some pictures of your work. If your address is in the format: artist@aprilvollmer .com, then every time you send an email you remind people of your website address.

Be generous to other artists. What goes around actually *does* come around. I have been invited into many exhibitions by artists to whom I have given exhibition opportunities.

Dress nice. Answer your email. Get some exercise. Drinking and smoking seem to be out of fashion. Spelling counts. Oh, and most important: work like crazy—time is short!

Inhale, April Vollmer
Digital plus silkscreen print on handmade Japanese washi
26" × 38" (66cm × 97cm)

3 WHAT IS YOUR ART WORTH?

Your art is a priceless gift that you give to your world. It is the conduit by which a wordless intimate thing passes between two humans—the artist and the viewer—something that may touch our hearts, or assure us that we are not alone. Art might share a mighty truth, or show us a tender, slight idea—as perfect as a dragonfly. Art-making is powerful magic, a mysterious act that holds a place in every society.

In this chapter, we will focus on what art and art-related services are worth. Freelancing will be covered at length. When you work full time, the salary is already set, but when you freelance, you must continually determine your worth. We will also discuss bidding on jobs (with three practice projects to consider and bid on yourself), touch lightly but firmly on contracts, and explore retail sales of artwork.

Victorian Specimen Case (detail), Margaret Peot
India ink, watercolor and colored pencil on Rives BFK paper,
mounted in a wood specimen case with styrene cover
36"× 36" (91cm × 91cm)

SETTING VALUE ON ART IS HARD— OR IS IT?

In Lewis Hyde's book, *The Gift: Imagination and the Erotic Life of Property*, he says, "The spirit of an artist's gifts can wake our own." Mr. Hyde also goes on to say, "But if it is true that in the essential commerce of art a gift is carried by the work from the artist to his audience, if I am right to say that where there is no gift there is no art, then it may be possible to destroy a work of art by converting it into a pure commodity."

As children we learn that a gift should be given freely—that you can't give a gift in expectation of return in kind. And yet, even though our art is a gift, a successful working artist must set a price on it, or the making of it, in order to live by it. The strange puzzle of art making is that we can't make it with its potential retail value in the front of our minds, and yet to be good business people we must be able to set a value on it after it is made.

It is hard to set a value on art. Art is ephemeral, unable to withstand the rigors of cost analysis—or is it? Somehow artwork and art-related services get valued every day by artists and others. How do they do it? Deciding the price of an individual artwork (such as a print, painting or a sculpture) and deciding and bidding on the cost of an art-related service (such as painting a mural, illustrating a children's book, designing a T-shirt for an organization) are the basic ways that artists need to learn to value their artwork.

Fortunately, artists excel at these kinds of mental gymnastics: The act of making art is one of inquiry, trust, meditation, and also of fine craft and careful artisanship. We must embrace and also forget what our teachers told us. We must remember where we are on the great artist continuum. We must keep informed about what other artists are doing, but also learn to ignore that altogether, so that what we do in our studios is particular to us.

> "...though our art is a gift, a successful artist must set a price on it..."

FREELANCING

Freelance used to refer to a mercenary soldier of the Middle Ages, someone who hired out his talents to the highest bidder without particular allegiance to any side or country—a *free lance*.

In regards to artists, a freelancer is someone who hires out his or her artistic talents to a variety of employers without any long-term commitment to any of them. If you are providing an art-related service, you are probably going to be working as a freelancer. Artists are often freelancers, as there are few full-time jobs that allow for the kind of creative freedom they want. Working freelance also allows time for artists to continue to focus on their own studio work.

Freelancing has lots of benefits: You can set your own hours, work from your home, and have multiple clients and therefore a larger income base. Did I mention that you set your own hours?

There are also downsides to freelancing: You have little or no job security, no benefits, no pension or 401(k). You must make your own contacts and pay your overhead and operating costs. Having income from various sources can make filing your tax return more complicated, and you will have to pay estimated taxes every quarter. Eventually you will have to set up your own retirement fund to draw from later in life. (See chapter 4 for advice on how to manage these potential downsides.)

When you work a full-time job, somebody else pays for the workspace and the cost of materials, as well as providing an interface with the world that brings the jobs to you. The price of the jobs is set by others, and all you have to do is show up and work. As a freelancer, you have to do all of this yourself.

> "...remember where we are on the great artist continuum."

DON'T DESPAIR!

On a personal note, I will say that if I had read about all of the downsides of freelancing as a twenty-two-year-old, I would have planned a totally different career path. But don't despair! I have worked as a freelancer for more than twenty years, and while there have been some anxious times, they have gotten fewer and farther between over the years. Having the freedom to do what you want when you want to do it (within some self-set limits) is wonderful. It makes you the Ultimate Adult, and that will give you a degree of confidence hard to find anywhere else.

INTERVIEW:
JEANNE GENTRY KECK, PAINTER

Jeanne Gentry Keck has exhibited at the Corcoran Gallery of Art in Washington, DC, The Trenton City Museum in New Jersey and the Museum of Florida Art in DeLand, Florida. Her richly textured paintings are in many public and private collections around the world, including NationsBank corporate offices in Charlotte, North Carolina and Anne Arundel Hospital in Annapolis, Maryland. She is represented by the Brenda Taylor Gallery in New York City, where she's had one-person shows. She is also represented by the Montage Gallery of Federal Hill in Baltimore, Maryland and the Hodges Taylor Gallery in Charlotte, North Carolina. Jeanne has been awarded multiple Maryland State Arts Council grants. For more information, visit jeannekeckartist.com.

What do you do?

I make abstract paintings with mixed media. I begin a painting without a preconceived idea of what it is about, simply trusting that the concept will be revealed to me through working, exploring and writing. My goal is for authenticity, and I have learned to trust this process for that purpose. My love of textures and words is not simply found in my titles, but has worked its way into the paintings as well.

What training do you have? What paths did you follow to get to where you are now in your career?

I studied at William and Mary College but really did not become interested in painting until later in life. I have always written, and as a child, imagined myself becoming a writer for *National Geographic*.

When I was young, I was very interested in fashion, and my desire for self-expression in that area was natural and strong. While my husband was still in college, I had my own cottage industry of designing and making clothes. But it was after seeing some paintings that so

Alone Together, Jeanne Gentry Keck
Oil, mixed media on canvas
Diptych, 60" × 96" (152cm × 244cm)

moved and transported me that I began to take painting classes. Soon the passion for painting dominated all other creative endeavors.

How do you balance the business of art with art-making?

These are such difficult times for galleries and artists. I have just learned that a gallery that represented my work is closing. In the past two years, two other galleries that showed my work have also closed. Trying to stay alive while trying to practically remake the known way of showing art in this new time is overwhelming.

Early on, in order to make sense of making so many paintings, I knew I must do the hard work of finding good fine-art galleries to show the work. I had read articles and books on how artists were supposed to do this, but after seeing the large numbers of envelopes from artists in the same galleries I also was interested in, I knew I must do something different.

Mostly, I did all the things the books tell you not to do. I simply went into galleries, asked to speak to the director or owner, and told them about the work and myself. Sometimes I could direct them to my studio or another show I was having nearby. I had some success this way and found a couple of galleries to represent my work.

Finding gallery representation is hard and unpleasant work. I could never plan on when I could or would do it. One day I might say, "Tomorrow I am going to go to such-and-such gallery," only to wake up and discover that I had no courage that day. Curling into a fetal position might be what I felt more like doing. In retrospect, I can see the value of naiveté.

How did your paintings evolve from watercolors to mixed media?

There is nothing like a one-person show to inform you about your work. It was after a show at Grimaldis Gallery in Baltimore that I had a realization that I wanted the work to be about more. Even though the work was based on my philosophy, I felt it was too generic and safe.

I went to the Contemporary Artists Center in North Adams, Massachusetts for a month to work and get away from familiar surroundings and perceptions about my work. It felt urgent to make this discovery. I did no research on the place itself, and just struck out after being accepted. While there, I worked diligently and freely for a month. I also worked differently and began to use materials to satisfy my desire for surface variety. I did not know what I thought about the work—I simply did it. Upon reflection, I knew the work felt more authentic and more interesting.

Since that time, my work has evolved to what it is today. Guess what? I lost the Baltimore gallery as a result of that growth.

The director simply did not like the new work, nor did he believe it was as saleable. But, I had confidence in it, and found galleries that could see what I was doing, believe in it and trust me.

I also went to the Vermont Studio Center on a full fellowship, and later to Assisi, Italy on an independent studio program for freedom to search out other changes occurring with my work.

Did you find your art changed by virtue of your gallery representation?

I have really been tested in this regard. I have always been true to the work, even on occasions when a gallery tried to lead me into a way of painting or wanted me to continue in the way I had been working. I followed my instincts and knew I would never sacrifice the work in order to get into a gallery or remain in one. That does not mean that these experiences (losses) were not disappointing, because they were.

What keeps you motivated?

Life—the awesomeness of life. Ever since I can remember, I have sought answers about the human experience, from its magnificence and order, to its chaos and despair. I was attracted to painting, because it is a way to continue my exploration of this search for understanding and to satisfy the urgency to express the search.

I do not accept the idea of "being blocked," but rather believe that creativity has its natural flow as does everything else. There is a continuity of "taking in" and "expressing" that is a part of the creative process. There is a myth about making art, that one is inspired and rushes to the studio to express it. Whereas, in fact, one develops a discipline of being with the work when you feel like it and when you do not.

That being said, in the taking-in department, I enjoy a rich life of experiences with family, friends, museums, concerts, books, theater, writing, film and travel—*life*. Traveling is a passion. I have a lot of curiosity about other cultures and take every possible opportunity to experience that. Traveling changes one's view of self in the world, and since my concepts are internal, it plays a role.

What advice would you give to an artist starting out?

The advice I would give to any artist is to create the discipline to do the hard work to find your own voice. The only work that is truly interesting and has longevity is the work that is authentic. There is just no way to arrive at that without hard work.

FREELANCING PROS

Freelancing has many benefits:

1. Set your own hours

2. Ability to work from home

3. Multiple clients can mean a larger income base

4. More time to focus on your own work

5. More creative freedom than nine-to-five jobs

FREELANCING CONS

Freelancing also has its share of downsides:

1. No job security

2. No health benefits

3. No pension/401(k)

4. Cover your own overhead and operating costs

5. Income from multiple sources complicates filing tax returns

BIDDING ON A JOB

How do you decide how much to charge for a project?

Some employers will offer a freelancer a set fee, while others will ask you to bid on a job. In both cases, you need to be able to work out a bid—an estimate of time, labor, costs and value.

When bidding on a job, you should review the problems inherent in an assignment and try to figure out how much it will cost you to do it, allowing enough for materials, overhead, assistance if necessary, and income for yourself. Some of the bid will be based on your practical knowledge of the job at hand, some will be rank guesswork, and some will be padding for hidden costs. (And don't forget that you should plan on having about 35 percent of your net being paid out as taxes!)

Following are three worksheets with examples of potential jobs for a freelance artist to bid on. Practice with these three examples: an installation for a children's museum, a rush mural job and a personal portrait.

WORKSHEET: PLAN A BID—MUSEUM INSTALLATION

You have been asked to do an installation in the foyer of the Newark Children's Museum. You have some autonomy over what you will do, based upon your specific skills—you can do a painting or a sculpture or some combination of these things. This is not an interior design job; you have been asked to create artwork that can fit in this space.

Here are the specs:

- The foyer has a large window and whatever will be in the space will get full sunshine for about five hours a day.
- The piece or pieces you install must be safe for children—nontoxic, not sharp, etc. (This is not a good place for the broken-glass sculpture you have been dreaming of, no matter how sparkly it is.)
- You will have to do preliminary sketches to be approved by the museum.
- You are bidding against other artists, so not only does your installation have to be cool looking, it has to be cost effective.
- This institution is known for hiring artists to teach at the museum and to create artwork for special events and donor gifts. This is a good contact for you to have.

Keep in mind, if you don't charge enough, your bid will not be considered as you will be thought of as inexperienced, and maybe a possible flight risk. If you charge too much, however, you run the risk of losing out on the job to another artist. What do you charge for the job?

Things to consider in your bid:

How much do you want to be paid by the hour? _____

How will your time be spent? _____

How much time will you spend thinking about this project in the shower, in bed when you can't sleep, on the subway? That counts, too!

How many meetings will you have to attend? _____

How much time to do a sketch and a sample? _____

What materials are you going to use? What will they cost? How much time will it take you to gather the materials?

For this particular job, whatever materials you use must be lightfast; they cannot fade or rot in sunlight. So, you will have to spend time researching this and buying products to try out. How much will that cost and how long will it take?

Will you be paying someone to help you either to make or install this artwork? How much will you pay them?

Do you need a scaffold? Will you have to rent one and get an accompanying scaffold license?

Is the museum a union space? In that case, will you need to pay them to move your equipment in?

Will you have any overhead expenses? Studio rent, light, heat, car, gas, meals out, insurance? Will you be paying a kiln fee (or some other similar fee)?

What amount can you add to this bid to accommodate errors in your judgement or to account for the possible mercurial nature of the museum board you have to please?

WORKSHEET: PLAN A BID—RUSH JOB

You have been asked to bid on the refurbishing of a room full of murals at a famous botanical garden. There are paintings of gardens in the four corners of the 40' × 100' (12m × 30m) ballroom, and trompe l'oeil latticework and sandstone blocks in the rest of the room. It is the space they rent out for parties—their main bread and butter. The walls have been damaged by water, and have been patched by another contractor. Their next event is in three weeks.

Here are the specs:

- The walls were designed and painted by a famous designer, so the colors and style must be matched exactly, preserving everything that you can of the original work.
- The water damage is at eyeball height and below, so you won't need a scaffold, but might need a ladder.
- You must be done in three weeks. There is no wiggling on this. You will not be allowed in the door after the three weeks are up, because the rooms will be filled from morning to night with debs and their dates.
- The walls are painted with latex paint, and must be light and wash fast.
- If you do this job well, there is another refurbishing job in another part of the garden that looks really fun and profitable.
- The colors are very pale, subdued.
- You can leave your supplies in a janitor's closet, so you will not have to haul them back and forth every day, but the garden is not close to any easy form of mass transit, so you will have to take taxis, rent a car or drive your own.

Generally speaking, clients expect to pay more for a rush job because they know that if you have other jobs, you'll be putting them aside to do theirs quickly, and won't be taking on anything new in the meantime. You must factor this into your price; however, you don't want to charge them so much that they feel like chumps for hiring you. What do you charge for the job?

Things to consider in your bid:

How much do you want to be paid by the hour? _____

How will your time be spent?_____

How much time will you spend thinking about the problems inherent to this project when you are not doing it?

How many meetings will you have to attend? _____

How much time will it take you to mix the colors? Don't forget they must be exact. How many colors are there? Will it take you two days? A week?

What is the original surface of the walls, and what surface will you mix the colors on? What light will the walls be seen in primarily?

Can you design and cut a stencil to help you paint the latticework parts of the walls? How big of a stencil will you need? How much will the materials cost and how long will it take you to cut the stencil?

What supplies do you need? Acrylics, a couple of gallons of latex base white, tape, Mylar, gloves, brushes, a lining tool, a bucket, sponge, paper towels, containers to mix colors in?

© eccentriceye

How will you get to the job site every day?_____

Will you have to hire someone to help you?_____

What formula can you apply to your fee that reflects the rush nature of the job but doesn't close you out of additional work at the garden?

WORKSHEET: PLAN A BID—PERSONAL PORTRAIT

You have been asked to paint a picture of a girl and her horse. The girl's father loves the work he saw of yours at a group show, and wants to you in particular to do this painting. He wants you to be somewhat creative, but he really wants the girl and the horse to look like themselves. (Minus warts and all!) The rest is totally up to you.

Here are some additional specs:

- The client wants you to do the work in a medium that you feel comfortable with—you don't have to learn to paint in oils if you don't know how.
- The client would like you to have the piece framed.
- The piece must be 40" (102cm) wide, as that is the width of the space above the mantel where it will go.
- The painting is a birthday present to the client's wife, and so must be finished in six weeks.
- The client implies that once others see this portrait, you will have so many commissions that you won't have to ever actively look for work again.

What do you charge to do the job?

Things to consider in your bid:

How many sittings will you need to have with the girl and the horse? _____

Will you have to go back and forth to the site to draw and paint? How will you get there? How much will it cost?

Will you need to buy or borrow a camera to take pictures of them? _____

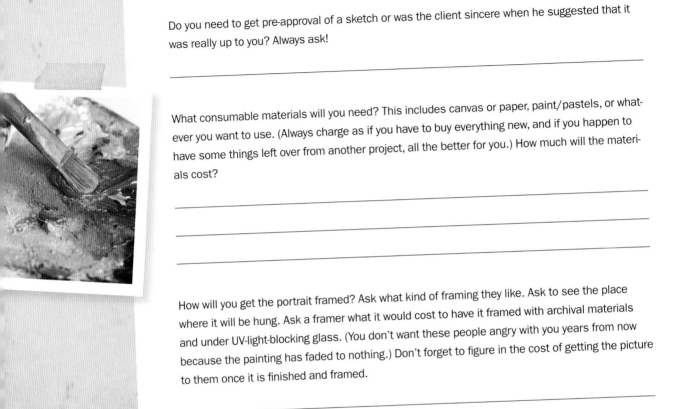

Do you need to get pre-approval of a sketch or was the client sincere when he suggested that it was really up to you? Always ask!

What consumable materials will you need? This includes canvas or paper, paint/pastels, or whatever you want to use. (Always charge as if you have to buy everything new, and if you happen to have some things left over from another project, all the better for you.) How much will the materials cost?

How will you get the portrait framed? Ask what kind of framing they like. Ask to see the place where it will be hung. Ask a framer what it would cost to have it framed with archival materials and under UV-light-blocking glass. (You don't want these people angry with you years from now because the painting has faded to nothing.) Don't forget to figure in the cost of getting the picture to them once it is finished and framed.

Add up your time and costs, then double this figure. That is your price.

As you might be figuring out, there are no right answers for these questions. It all depends on where you are in the country, what clients are accustomed to spending where you are, if you are actually turning down other work to do this job, and if you want to create a future working relationship with this client.

CONTRACTS AND HIDDEN COSTS

It is always good to have things in writing before you start. This can be a simple letter of agreement—a contract in letter form between individuals or organizations, signed by all parties stating what you and your client think will happen, how long it will take, and how much it will cost. Sign it, have the client sign it, and make sure that everyone gets a copy.

Sometimes a simple email exchange can be enough of a record for a less formal job. Or, your contract could be a more complicated document that needs to be drawn up by a lawyer. If a hiring institution or individual presents you with a contract, do not ever sign anything without reading it first, and also perhaps, without asking the advice of a lawyer. (See chapter 4.)

Even the most experienced artists mess up on their bids, however. No matter how long you have been in the business, you can still miss some hidden costs. Here are some examples based on my own experience:

- **Pleasing More than One Master:** Make sure that you know who has the final say. Once I had a job painting props for a theatrical performance, getting paid a set amount per piece. I painted them all to match the assistant designer's example. When the designer came, she rejected them all, as well as the assistant's example. I had to paint them all again, for no additional fee.

- **The Wrong Stuff:** If a client insists you use materials that you know will be wrong for the job, build into the bid a cost for doing the job twice—once the way the client wants it done and once with the right materials. Or consider graciously backing out of the job, as I once did when asked to paint unset dye onto fabric that was going to get wet.

- **Kill Fee:** Jobs can be cancelled for various reasons. Make sure you build a kill fee into your contract, perhaps 50 percent of the original bid, to pay you in part for work put in on a project before it was scrapped. (Kill fees don't apply if they simply don't like your work.)

- **Sample Fee:** If you will spend more than 60 percent of a job working out how to use new materials, or materials that will be durable under particular environmental constraints, consider putting a sample fee into your contract. This is when the cost of sampling is priced separately rather than tied to the finished product. This protects you if a job is cancelled, and also if a job gets taken to a lower bidder—you will not have worked out how to do it, for free, for someone else.

> "Even the most experienced artists mess up on their bids..."

> "...people who are successful at selling their work spend as much time marketing their art as they do making it."

RETAIL SALES

Selling a piece of artwork or a craft item, whether you sell it in a store or in a gallery, is retail sales. What this means is that for whatever price you sell your work, you will have to pay a percentage off the top of that to the gallery. Gallery commissions can run anywhere from 20 to 50 percent!

What Do I Charge for a Work of Art?

Let's say you have made a painting. It is 4' × 4' (122m × 122m). It took you thirty hours to complete at $40 per hour—an hourly rate you have decided on yourself. This includes time spent doing sketches, idle thinking about it, and actual execution of the painting. You spent $100 on supplies to execute the painting, and you had it framed for $300. The total of these expenses is $1,600.

The gallery where you intend to sell the work will take 20 percent off the top of the selling price. Do you add 20 percent to the top of $1,600 to make the total charge $1,920?

There are many factors you will need to take into consideration when pricing this work of art for sale:

- Can your local market sustain a painting that costs $1,600? Are you selling it in a fine arts gallery, or off the wall of your local café? Are you in a big city or in a small town? Is the small town an arty one, or a little farming community?
- Are you well known? That is to say, have you sold other works and your paintings are in high demand? Or are you an unknown?
- Is the work itself elaborate, using a special technique, or is it conceptual?

If your local market cannot sustain the price you have set for your art, and you are not able to reduce the price to what is realistic and sustainable within your local market, then go online and look for other opportunities to show and sell your work. (See the Useful Organizations section at the back of the book for information about other sources).

The people who are the most successful at selling their work are those who spend almost as much time marketing their art as they do making it.

Charging by the Area

Another way to figure out the potential price of an artwork is to charge by the square inch or square foot. When pricing out a mural job, painters will often charge by the square foot: a smaller amount for a simple texture (like a vaguely cloudy sky), a bit more for a more involved surface (marble or sandstone), and quite a lot for every square foot of, for

example, detailed flowers. People who make paintings for hospitality venues—restaurants, hotels, hospitals—are often asked what their "square-inch price" is. This is because they have a budget for filling a set amount of space with something beautiful and suitable. Like carpet or wallpaper, there is an area charge.

Hospitality venues have different display needs. If you make relief surfaces, where there are bits of things sticking out (like Red Grooms' work), or make quilts, you may have to add to your price the cost of having a Plexiglas box built to house the work.

You can figure a square-inch price by measuring the more labor-intensive bits of your artwork and charging more for those, and less for washy color.

You can also average out a square-inch price based on another rubric. Let's go back to your 4' × 4' (122cm × 122cm) painting. If you charge a dollar per square inch, your painting would cost $2,304.. If you charge $0.70 per square inch, your painting would cost $1,612.80. Is that enough for your painting? You will get better at figuring this out over time.

Trial and Error

What you will do for a living, and how much you can charge for it will be determined in part by where you live, how much it costs to live there, and how much cost the local market can sustain. Some of this will come to you by research and some by trial and error.

DON'T BE SNOBBY

When I was in college, my fellow art students and I were snobby about what we painted. We would certainly never stoop so low as to consider someone's décor—they would have to rise up intellectually to meet us and hang whatever we gave them! I am embarrassed to tell you this is what we thought.

Artists working in different media make fine artwork to grace the halls of hospitals, hotels, restaurants and corporations. Some of these potential clients can be very brave in what they have on their walls, and some just want something beautiful to comfort or relieve the tedium of a beige wall. Or maybe to comfort and relieve the tedium of a family waiting through a loved one's medical procedure.

Sometimes the income (and potential joy) of making something wonderful to cover the beige wall can pay for a month of making that Allegories of Hell series you have been thinking of doing.

INTERVIEW: JOANIE SAN CHIRICO, MIXED-MEDIA ARTIST

Joanie San Chirico's work is a unique combination of painting on canvas, photography and stitching, that makes for lush microcosmic and macrocosmic landscapes. She is a full-time artist with work in public, corporate and private collections in the United States and Europe. Joanie has exhibited in galleries and museums and has permanent site-specific installations in many public spaces.

How long have you been making your living as an artist?

Some years are better than others, but I've been working as an artist and selling my work for almost twenty years.

How do you work out your schedule—do you have the day broken down into time spent in the studio and time spent making calls, answering emails? Is it more on a weekly basis? Or is it less rigid than that?

Usually, I spend a couple of hours in the morning answering emails, working on proposals and doing PR. Afternoons are painting time. However, if I have a tight deadline, that changes.

How much time do you spend making art versus making contacts and promoting your art? Is it 50/50? Does the promotion take more or less time than the art-making?

It's very close to 50/50.

How do you maintain your conviction that your work is worth promoting, and keep the inner critic at bay?

I don't have that feeling at all anymore. I've been selling my work for so long now, I feel that if people want to spend their hard-earned money to buy something that I made, that's pretty validating. Obviously, when an artist is just starting out, that perception might not be as applicable. I do believe that there is a market for most art; you just have to find your niche.

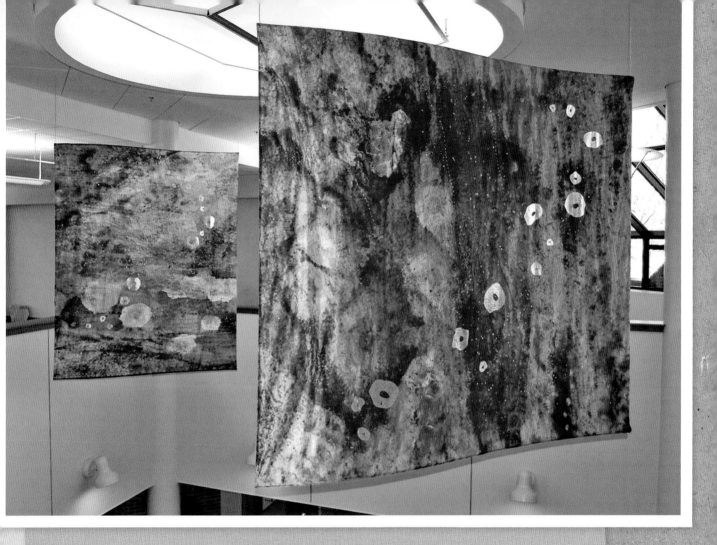

Sandbar 1 & 2, Joanie San Chirico
Ocean County Library Headquarters, Toms River, New Jersey
Suspended atrium sculpture, permanent installation
6' × 7' (1.9m × 2.1m) and 7' × 6' (2.1m × 1.9m)
For this public art project, Joanie created two double-sided soft paintings. The theme of the work is aquatic using abstract imagery to depict ocean shallows and sunbeams filtering through the water. The work is pigmented in hues of blues, greens and sand-colored tan-oranges. There are hints of silver to suggest sea foam and integrate the stainless-steel framing of the glass UV filter. Stitching holds the textile layers together and implies water motion and bubbles. The aluminum armature is slightly S curved to indicate wave motion.

Do you do artwork that is site specific as well as artwork that is personal?

I make both—art for myself which is to exhibit, and site-specific work for clients.

What do you consider when bidding on a job? Do you start with your hourly rate and then figure in time for creating, meetings, cost of supplies and travel? Or do you apply a different rubric?

I've developed a rubric that I use to determine pricing for my work. It's important that prices stay the same whether you are selling work yourself or through a gallery. No buyer wants to see work selling at different price points. That isn't considered professional. Gallery owners will not work with you if you undercut them. An example would be selling the same work that is hanging in a gallery on your personal website at a discount.

When working for a client, however, pricing is determined a bit differently. Usually an art consultant works in wholesale pricing—pretty much the same amount that you would get from a gallery after they took their commission. Often they want to know your per-square-inch price. Typically, they are working within a budget and size of art required and need to see if your art will fit in.

When working in the public art sector, in addition to the above, you would need to factor in hiring construction crews, fabricators, copyright fees and other contingencies, such as storage if the project gets delayed.

Regardless of the application, when working out a budget, you need to take into consideration not only time and materials, but insurance costs, studio overhead, travel, developing your concept, PR and other factors.

Do you think it is important/crucial to an art career to have an MFA?

I think it's crucial if you want to teach at the college/university level or work in a museum. A working artist relies on other business skills that unfortunately aren't taught in most art schools. Hopefully that will change. I run a small business, no different than if I were selling something other than art.

What advice do you have for aspiring artists?

Get a website. Use social media to promote it. Even a free blog is better than nothing. Join your local arts organization and volunteer. You'll be amazed at how many exhibition possibilities come through those sources. Persistence pays off. Get your work out there, even if it's just at a coffeehouse or at the local library. Making it as a working artist takes lots of effort because you are essentially selling yourself.

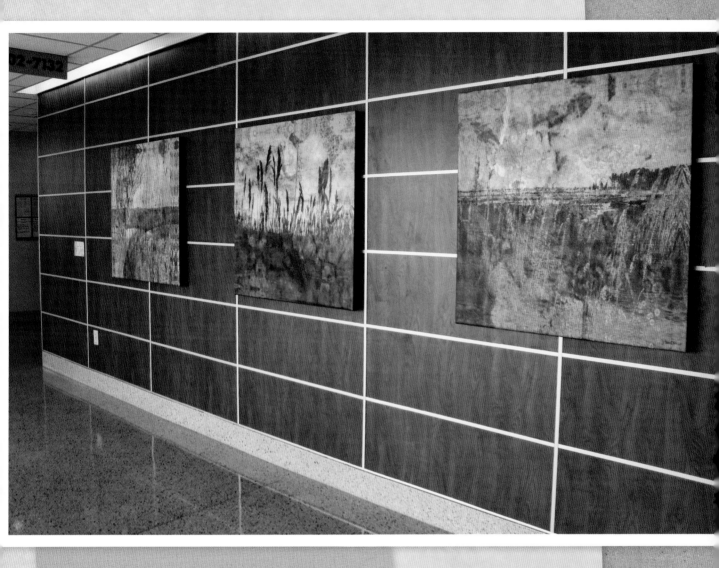

Marshlands Triptych #1, Joanie San Chirico
AtlantiCare Regional Medical Center, Atlantic City, New Jersey
Acrylic, photograph, stitching on linen
40" × 40" × 1.5" (102cm × 102cm × 4cm) each

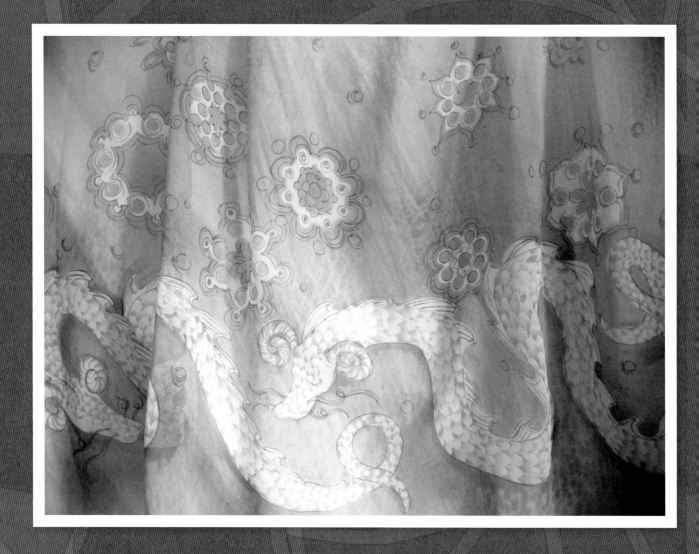

76

4. PRACTICAL CONSIDERATIONS

When you make a painting, you must plan the size and shape of it first by drawing and careful measurement. Then you buy canvas or linen and stretch it to your exact specifications. You prime the canvas with the whichever priming mixture you have come to prefer. After that, you draw, underpaint or transfer your drawing.

Then, and only then, comes the fun part—the splatter or impasto, the layering of gorgeous washes, the careful airbrushing or lacquering, or whatever it is you do that makes your work intrinsically your own. That fun part would not exist without the preparation. Even if you are not a painter, you will be able to find parallels to these careful preparations in your own medium. We all build the scaffolds from which our ideas take flight.

Artists can scaffold their own lives in a similar manner. In this chapter, we'll consider the artist as a full member of society and all the practicalities that go along with that—paying taxes, getting health insurance and investing. Because in order to do the fun part—making your art while living a full, rich life—you'll need a supportive, practical foundation under your feet.

Dragon, Margaret Peot
Fabric painting sample
This silk chiffon was painted as an idea for the border of a wedding dress.

ARTISTS IN THE WORKFORCE

Artists...

- are fly by night
- are airheads
- live off the grid
- live a hand-to-mouth existence
- are flaky
- are poor business people
- live on the outskirts of society
- are a burden on society
- are hippies/bohemians
- are deadbeats
- don't follow the rules
- are freeloaders
- are entitled trust-fund babies
- work the system.

Oh, not true? There are those assumptions again. So why is there this societal myth floating around that artists are flighty, not sensible, unable to hold a job? Or that they are troubled loners, struggling to make their vision a reality?

Here's a thought: In the Renaissance, artists were valued crafts people, taking pride in both their ideas and the execution of them—think of Leonardo da Vinci. As we entered the Baroque era, we started to see these troubled, struggling loners—Goethe, Beethoven, Caravaggio. Their stories are more interesting than someone working hard, making something wonderful, and then easily moving on to the next job. Perhaps we like to have this aura around ourselves, too. It is kind of romantic, isn't it?

There are countless stereotypical notions of what it is like to be an artist in society. And while some of them do go way back, others came about because some artists like the idea of being rebels living on the fringes of society. And non-artists like and reinforce this idea of their artist friends and relatives, too.

In 2008, however, the National Endowment for the Arts issued a report called "Artists in the Workforce: 1990–2005." According to this report, almost two million Americans officially identify their main occupation as Artist. The term Artist includes visual artists, but also actors, dancers, musicians, composers, designers, photographers, writers and entertainers (such as comedians and rodeo riders).

The NEA says that artists by this definition make up 1.4 percent of U.S. workers—making artists one of the largest classes of workers, only slightly smaller than active duty and reserve personnel in the military. And that doesn't count the 300,000 Americans who list their secondary occupation as Artist.

There are more citizens in the Artist group than there are people in the groups Agricultural Workers (farmers, fishers, ranchers), Doctors or Lawyers. The NEA estimates the

" ...almost two million Americans identify their main occupation as Artist."

 Sign up for a free trial subscription of Artist's Market Online at artistsmarketonline.com.

income of this artistic community at about $70 billion annually.

According to Dana Gioia, chair for the National Endowment for the Arts, "Compared to other U.S. workers, American artists tend to be better educated and more entrepreneurial. Artists are twice as likely to have earned a college degree as other members of the U.S. labor force, though they receive relatively less financial compensation for their educational level. Artists are also 3.5 times more likely to be self-employed. American artists have learned to be creative not merely in their chosen fields but also in how they manage their lives."

So, not only do artists comprise a powerful and largely unrecognized economic group, they also pay taxes, contribute to charity, do jury duty, have health insurance, make business plans, invest in their future. They contribute to society just like everyone else, plus a little more, because they contribute the gift of their art.

DEATH AND TAXES

The only sure things in this world are death and taxes, or so the old saying goes. And while nobody enjoys paying taxes, you do have to pay them. Even if you are a rebel loner making cutting-edge art on the fringes of society—if you earn money from your work, you must pay a percentage of it to the government. It is the law.

If you work at a restaurant or gallery and are paid on a W-2, your employer automatically takes money out of your base pay and sends it to the Federal and state treasuries. If you do a contracted job for an institution or sell your artwork through a gallery, they will report whatever they pay you (more than $600) to the government and issue you a 1099-MISC form to let you know the amount they reported to the government. If you get income from retail sale of your artwork through your studio or a street fair, then you may need to charge a sales tax in addition to reporting your income.

"... artists comprise a powerful and largely unrecognized economic group...."

INTERVIEW: SCOTT RODABAUGH, EA, CFP®

Scott Rodabaugh is a tax preparation specialist and financial advisor in Manhattan. After getting a degree in scenic design and lighting, he worked as a stage manager with some of the greats of the theater, and now owns and runs Premier Tax and Financial Services. His design background and experience make him the ideal person to do taxes and financial planning for artists of all sorts—and he does.

How does the IRS define *Artist*?

It is all about intent. If you intend to make money as an artist, and have set about doing this in a businesslike manner, then you are an *Artist*, engaged in the business of doing/making art.

Do you have a business plan? Do you have an account for this business? Have you had the proper training for your field? Do you have an expectation of a profit in the future? On the IRS website, they have a whole list of questions to help you decide if you are a business or hobby.

What difference does it make whether I am a business or a hobby?

If you are a hobby, you can only deduct expenses up to the extent you have income. If you profit from your hobby, the profit is subject to income tax but not self employment tax (Social Security and Medicare).

How do you differentiate between business and hobby?

Is making art your business, your hobby, your vocation or your avocation? Do you intend to make a profit in the future from your art-making business? As this book is not about taxes, I don't want to get too technical, but we also need to be correct so as not to run afoul of the IRS. So, when it comes to the question of whether you are a business or a hobby, the tax courts analyze nine non-exclusive factors under Reg. Code Section 1.183-2(b) as follows:

- The manner in which the taxpayer carried on the activity
- The expertise of the taxpayer and of his or her advisors

- The time and effort expended by the taxpayer in carrying out the activity
- The expectation that the assets used in the activity may appreciate in value
- The success of the taxpayer in carrying on other similar or dissimilar activities
- The taxpayer's history of income or loss with respect to the activity
- The amount of occasional profits, if any, which are earned
- The financial status of the taxpayer
- Whether elements of personal pleasure or recreation are involved

No single factor or set of factors is controlling. The determination is on a case-by-case basis.

Because my main source of income is art related, I can deduct art supplies, transportation to meetings and a host of other things. But sometimes I don't know whether an item is deductible. What is a good rule of thumb for determining what is a legitimate deduction?

In our office we use the laugh test: if you could ask an employer for the expense in question to be reimbursed without either party laughing, it might be legitimately deductible. The IRS says, "Taxpayers may deduct ordinary and necessary expenses for conducting a trade or business."

Let's say that I've done all the art-business things—spent time making art, sent out slides or discs with my paintings on them to hundreds of exhibition spaces and juried shows, made a business plan, took some classes to further my skills, bought books and art supplies, ordered business cards and set up a website—yet nothing has come of it. No one wants to show my work. I had to take a job waiting tables for money to live. Can I still say that I am an artist on my tax return and deduct expenses?

Again, it is a matter of intent and time spent. What do you intend to do with your art and how much time do you spend doing it? Do you intend to make a living as an artist? Then you are an artist and can continue to deduct expenses. If you show a loss (meaning your expenses exceed your income in your business) three out of every five years, then the IRS might question you. But if you carry on like an art business, then you are still an art business.

What the IRS doesn't like is when a taxpayer who pulls in six figures a year in one profession claims a loss on his "horse ranch," where he keeps horses that he rides for pleasure. Does he sell one occasionally? Sure. But

does he intend to make a profit in the future from his horse ranch? Probably not.

The IRS says, "An activity qualifies as a business if it is carried on with the reasonable expectation of earning a profit." And, of course, if you make a profit (meaning your expenses are less than your income), the IRS is fine with that, but you still may be a hobby if you do not fit the examples mentioned earlier.

What if someone pays me cash? Do I have to pay taxes on that?

Of course you have to pay! My clients never like my answer to this question, but as my mother says, "Don't ask questions you don't want to hear the answers to."

Let's say you are a performer, and do a show for a party on a boat in the Mediterranean. They pay you $3,000 in cash, which you stick in your pocket. You did not give them a receipt for the show, and they will never tell your government of the event. (You hope!) So you don't have to report this, right? Well, of course you do. It is income and, by law, you must pay taxes on it. And of course, if you report the income from that show, then some of your travel expenses will be deductible.

Will you get into trouble with the IRS if you don't report that income? No one can know if you will be audited—maybe, maybe not. That is not the issue here. This is an integrity issue. You have to remain true to some sort of "home base," a center where you do the right thing as best as you can measure it. All of the times in my life where things have gone wrong, and I have been disappointed or gotten into trouble, have been the times when I did not stick to that home base—doing what I know is right.

When do I have to charge sales tax?

Every state is different, so be sure to look at your state law. In general sales tax is a tax on the transfer of tangible personal property. In New York state, whether you sell your work out of your studio or at a stoop sale, for example, you have to collect sales tax. However, if you ship to a state that you do not operate your business in, then you do not have to charge sales tax. In New York, you must register with

SCOTT RODABAUGH, IN A LECTURE TO NYU TISCH SCHOOL OF THE ARTS DESIGN GRADUATE STUDENTS...

"How many of you think you are business people?" Nobody raised their hands. "You are wrong. You are all small businesses providing design-related services or products to the entertainment industry."

the Department of Taxation and Finance to be authorized to collect sales tax.

We hear a lot these days about good debt and bad debt. What is considered good debt or bad debt?

Starting in the mid–90s more people began using debt buy goods or services that would not appreciate in value. For example, bad debt would be getting a home equity loan to pay off credit card debt, which was incurred by buying goods or services that could not be paid for with your current income. The other term for this is "living beyond your means," or, more practically, your first step towards bankruptcy!

However, using debt to buy an asset that may appreciate in value, like a home, can be good debt. School loans can also be considered good debt, because you have paid for an education that hopefully will aid you in making money in your future.

You are an investment consultant in addition to being a tax professional. When should an artist start investing for the future?

Immediately. First, you should honor your financial responsibilities—your credit card bills, loans, living expenses. Then you should start putting money towards your retirement. People are living longer, so it is good to start putting money away for the future as soon as you can. Rule of Thumb: save a minimum of 10% of your income.

Disclaimer

To ensure compliance with requirements imposed by the IRS, we inform you that any U.S. tax advice contained in this book is not intended or written to be used, and cannot be used, for the purpose of (i) avoiding penalties under the Internal Revenue Code or (ii) promoting, marketing or recommending to another party any transaction or matter addressed herein.

In order to be recognized by the IRS as a legitimate art business, you need to have a business plan. Not only will the plan legitimize you in the eyes of the IRS, it will help you focus on what you want and how you can get there, instead of drifting from one chance happening to another.

Try to think about your art-making business as analytically as you can. In this worksheet, pretend you are at the bank, asking for a loan for your small business. You need to describe to the loan officer what you do. (No muttering, ducking your head or scuffing your feet!)

Are you selling a product or art-related service? What is it? _____

Do you intend to make a profit in your art business? How? _____

Do you have a business plan for your art business? Explain. _____

Do you keep records of expenses and income as related to your business? Do you have a system? Would this system make sense to another person?

Do you put enough time and effort into your art business to keep it afloat? How do you record the time spent?

Do you depend on this income for your livelihood? Do you ultimately intend to? _____

Do you have a plan to improve productivity and profitability? Explain. _____

Are you qualified to make this a successful business? _____

DECISIONS, INTENTION AND THE BUSINESS PLAN

"The most valuable thing you can make is a decision, whether it is a right or wrong one."
—Hans Peot (my dad)

When you make a decision, you automatically have the shape of a plan starting before your eyes, an idea of which paths to go down, a notion of what you might need to implement your decision. If you don't make a decision, you are stymied: You can't move forwards or backwards. You are in a state of perpetual dithering. Even if you make the wrong decision, you will know it soon enough and be that much closer to the correct decision. Making a decision is the beginning of making a business plan.

Making a business plan is the thing you do after you make a decision about what you want to do. Though it seems radically different, the business world is more similar to our own world than we might like to think. We know that to do our best artwork, we must know our intention. We have to carry our purpose in our mind, and direct all of our energy to defining that purpose within the work of art we have set about. When we do artwork without that intention, or center, or purpose of mind, we have a less successful experience.

When you have a business plan, it means that when opportunities arise, you have a plan to hold those opportunities up against to see if they match your intentions for your future. Your business plan must be flexible, so that if an opportunity arises that doesn't exactly match, you can make a good decision about it.

In order to interface with the business world, you have to figure out what your true intention is for your art business and communicate it as clearly and calmly as possible.

> "Making a decision is the beginning of making a business plan."

Business is gainful activity—an activity by which you hope to gain something. What business are you engaged in that you hope to gain by?

Why do you want to do this? _____

Who are your competitors? What is it you do that is different or better than what they do?_____

Who will pay you for this activity? Who are your potential customers? _____

© Rita Kristjansdottir

How do you intend to tell potential customers about your product or service? Or in other words, how are you going to advertise?

How will your business grow? _____

What experience and background do you have that makes you ideal for implementing this business plan?

What tools do you have that will help you? Do you need any new tools?_____

Can you do this business in your home or do you need a special space? What are the requirements for this space?

What are the financial requirements of your new business? How will you finance your business start-up?

Do you intend for your new business to be your sole source of income? _____

What will you do for money to live on while starting up your new business?_____

INTERVIEW: GB TRAN, CARTOONIST, ILLUSTRATOR

Gia-Bao (aka GB) Tran was born in South Carolina in 1976, a year after his parents fled Vietnam. He aspires to continue living the good life as a Brooklyn cartoonist/illustrator thanks, in large part, to the endless patience of his wife. His parents constantly remind him that if this "art thingy" doesn't work out, as the only family member born in the U.S., he can legally be president instead. Find him at gbtran.com.

How would you describe what you do?

I'm a cartoonist, drawer of my own writings and writer of my own drawings, who moonlights as an illustrator and apparel graphics artist.

What training do you have? What paths did you follow to get to do what you do?

My formal training was a BFA degree with an emphasis in visual communication. Like a number of grads out there, I didn't take full advantage of my college experience, so virtually everything I've learned to get to where I am now was picked up after graduating by surrounding myself with creatives overflowing with drive and dedication. I'd say the path I followed to do what I do has been a path of openness to the opportunities life presents you, and discipline to follow through with the things you're most passionate about.

Did you always want to be an artist? Or did it evolve from something else?

I've drawn comics for as long as I can remember, but the belief that I could do if for a living didn't occur until after college when I started learning from real flesh 'n' blood cartoonists.

How did you get interested in comics?

My older brother introduced them to me when I was a little kid. He'd come home from the grocery with *X-Men* and *Transformers* and, if I was lucky, he'd let me read them.

How did your graphic novel *Vietnamerica* come to be written?

I reached a point where I wanted to better understand why my parents are the way they are. That led me to visit Vietnam for the first time. During that journey, snippets of their past life—decades of turmoil and struggle—

Cover art for
Vietnamerica,
Graphic novel
by GB Tran

came to surface. I soon realized that if this family history was to survive for future generations, it needed to be put to paper. And what better way to do that than with the art form I love? I think every parent hopes that one day their child will want to appreciate them and where they came from. *Vietnamerica* is me arriving at that point before it was too late.

What comic/graphic novel work did you do prior to this? Did you study cartooning? Illustration?

On the road to my BFA degree, I took as many illustration courses as possible, but they didn't include cartooning. After graduating, a grant from the Xeric Foundation for Comic Self-Publishers helped me get off the ground, and I slowly worked my way up to bigger and bigger projects.

Did your design for apparel fund the comic work when you were self-publishing?

Absolutely! Having a day job that was flexible and allowed me to creatively experiment without being too attached to the outcome was a boon to my comics pursuit.

Do you have an art-making practice separate from what you do for a living?

Fortunately, my art-making practices are integrated with what I do for a living. One feeds into the other and continues to help me grow personally and professionally.

How do you balance the business of art with art-making?

As a cartoonist, it's probably a little more natural for me to bridge the gap between the two since comics are rooted in a commercial context, but I'm still figuring it out. That balance will always be shifting. My main goal is to be OK with (as opposed to mastering) walking that fine line.

What keeps you motivated? Where do you go, what do you do to get inspired?

With all the amazing work out there, both old and new, my challenge isn't not to be inspired, but to step back enough from that sponge state to buckle down and create my own work.

What advice would you give to an artist starting out?

As far as comics go, it's a long process that requires patience as much as it does focus. Your first book doesn't have to be a three hundred-page opus. Start with something small and manageable. It's a lot easier to begin a project than to finish it. Once you've proven to yourself that you can do the latter, your next project will be that much better for it.

LEGAL ADVICE

Any time you interface with another individual over business, it is best to have a written agreement. This is so that both parties know what to expect from each other. Even if the agreement is between friends—perhaps especially if it is between friends—it is good to have your expectations in writing, and have both parties sign it.

Many times, you can get basic boilerplate contracts online. The Graphic Artists Guild (www.graphicartistsguild.org) also has basic permissions contracts that you can change to suit your purposes that deal with giving permission to someone to use your copyrighted images.

But if you need advice about a specific legal matter, you can consult a lawyer. The organization Volunteer Lawyers for the Arts (www.vlany.org) delivers legal services and information for free, and is committed to educating artists as to their rights.

THE RELATIVITY OF ECONOMIC DOWNTURNS

I moved to New York City in 1986, the year before a big recession in the United States. Because I had no money anyway, anything that anyone paid me seemed huge—amazing! And things in stores were cheap because everyone was having these big sales just to get people into the stores. I didn't even know there was a recession. I was twenty-three years old and life was rich, though perhaps not in dollars and cents. It was fun to not work and take in all the inexpensive things my new city offered to see and do.

I have been much more aware of this latest recession. Now my husband and I own our apartment, and we have a child who grows out of his clothes faster than he can wear them. So, because I have these responsibilities, it is hard to get back into that mindset of being delighted that I have time off work.

However, during a big chunk of time last year when work was slow, I wrote up a couple of book proposals. I also made art that I was interested in doing but had not previously had the time to delve into, and I ended up getting commissions out of that.

So, if you can keep your energy positive in hard times and try to make things happen without panicking, then your economic downturn can be a fruitful, productive retreat instead of a nightmare.

HEALTH INSURANCE
(WAIT! DON'T SKIP THIS PART!)

How many times have you heard someone say that they had to get a "real job" in order to have health insurance? Perhaps you have made this decision yourself. It might seem odd to spend even an inch of space on this topic in a book that is about making a living as an artist, but health insurance has unfortunately become an issue that drives many of our life decisions.

With the new health care legislation passed in 2010, there will be many reforms in the world of U.S. health insurance. What you get, what you pay for it, and who will be required to have health insurance will all be changing. Insurance is still regulated on a state-by-state basis in the United States, so rules will be different depending where you live. However, the essence of the problem remains the same.

Many people don't purchase health insurance at all because they simply cannot afford it. Others think they are young and healthy, therefore, would be better off spending the money on something else. (Beer, perhaps?) But regardless of how young and/or healthy you may be, you cannot guarantee that you won't ever get hit by a bus. So, it is best to have some kind of health insurance.

Then there are some people who want to avoid purchasing health insurance assuming that, if they were to get hit by a bus, they could just pay for the cost of their medical care themselves. Unless you are a millionaire, however, this is impractical. A two-or-three-night hospital stay can cost thousands of dollars, and will instantly drive you into serious debt.

You will hear advice from well-meaning people who tell you to find a "real job" where health insurance is provided. This is a fine thing to do and, if you do get a job, it is true that health insurance is often one of the biggest benefits to being an employee. What you want to avoid, though, is a situation where you end up working at a perfectly miserable job, but the only reason you are doing it is so that you can have health insurance.

Another alternative is to become a member of a group so that you can have access to group health insurance rates. This is, perhaps, the most sensible option.

You can join a union that is related to your specific trade—United Federation of Teachers, United Scenic Artists (theatrical designers, painters), IATSE (other theatrical workers such as electricians and cameramen)—and get health insurance through your union. As a union member, you will

"...health insurance has become an issue that drives many of our life decisions."

have to pay dues, but you'll still save money in the long run by gaining access to group health insurance rates.

If you are a freelancer, you can join the Freelancers Union (www.freelancersunion.org) to get group rates on health insurance. To qualify as a freelancer with them, you will have to prove that you bill for services, and prove that you are paid. To prove that you bill for services, you need to provide a copy of a contract, detailed invoice or payment agreement.

To prove that you were paid for services, you need to provide a copy of a check or bank statement showing a deposit. In addition to these proofs of billing and payment, you also have to make a minimum amount per six month period to qualify as a member. (In 2011, the minimum six-month income was ten thousand dollars.)

You could also join a group that is associated with something you do, such as the Authors Guild (www.authorsguild.org) if you write art books and art-related articles, or the Graphic Artists Guild if you work in the graphic arts (www.graphicartistsguild.org). Membership in groups like this can help you qualify for insurance at lower group rates.

The company Fractured Atlas, a non-profit organization that serves a national community of artists and arts organizations (www.fracturedatlas.org), offers group health insurance rates as well.

Group insurance plans range in price. You can pay higher premiums (what you pay each month) and start getting benefits past a smaller deductible (the amount you will have to cover by yourself before the insurance starts paying out medical costs). Or, you can pay less per month and have benefits paid by the insurance company past a huge deductible (for example, $10,000 from you, then the insurance kicks in.)

For those who cannot afford to spend much on monthly insurance premiums, I think of the low premiums/high deductible plans as "getting-hit-by-a-bus insurance." It may not be ideal, but it is better than having no health insurance at all.

There are also individual health insurance plans available for people who do not belong to a group and, therefore, are not eligible for group insurance rates. If you do buy insurance as an individual, your monthly premiums can be very high.

Disclaimer
The author of this book does not set herself up as an expert on health insurance. You have to make the best decision about this on your own, based upon your own research.

> "...become a member of a group so you can have access to group health insurance rates."

INTERVIEW: JENNIFER SATTLER, CHILDREN'S BOOK ILLUSTRATOR

Jennifer Sattler received a BFA in painting from the University of New Hampshire and an MFA from Indiana University, Bloomington, Hope School of Fine Arts. She worked for several years as a landscape painter and professor of painting and drawing. Jennifer has exhibited extensively, winning a National Endowment for the Arts grant in 1996. She is a member of the Society of Children's Book Writers and Illustrators.

What keeps you motivated?

There are two things I need to do in order to feel contentment in my life. I need to make something and I need to laugh. My career as a children's book writer and illustrator takes care of them both. My children are always my main inspiration. As they get older, I hope they don't start to take themselves too seriously (all of you out there with teenagers are probably snorting a laugh right now) because for the past eleven years they've done a terrific job of bringing out my inner goofiness.

Besides my kids (and other great kids that I know), I would have to say it's old *Looney Tunes* cartoons (gotta love that Daffy Duck!), and the sheer genius of the Pixar movies that really inspire me.

I know you are a parent. Did you always want to be a children's book illustrator, or did parenthood send you that way?

While I had done quite a bit of creative writing in college, everything but painting fell to the wayside when I was concentrating on getting my BFA, then later, my MFA. I was on a single track. If I were a "serious artist" (read: one who could support oneself), I needed a master's degree and I needed to teach. My inner goofball was not to interfere!

I was teaching painting and drawing at Skidmore College and the College of Saint Rose while I was pregnant with my first daughter. My mother-in-law teaches literacy and has a great love of picture books. She sent me her favorites. I loved the Sandra Boynton book, *Oh My Oh My Oh Dinosaurs!* and Janet and Allan Ahlberg's, *Each Peach Pear Plum*.

Chick 'n' Pug, **Jennifer Sattler**
Acrylic and colored pencil
"Pug! Pug! An intruder has entered your territory!"

I would read them to Mayzie (my first daughter) over and over again, perfecting my silly voices before she had any idea what I was saying. Our library grew. Before I knew it, there were more children's books in the house than art books. From there it was the *Olivia* books by Ian Falconer and Mo Willems' *Knuffle Bunny*. I was hooked. It felt completely natural, this idea of beautiful pictures and laughter going together. Making big oil paintings to hang on the wall suddenly felt like playing soccer in Mary Janes.

Is the work you produce In your studio different from your children's book illustrations? Do the illustrations inform the paintings or vice versa?

Of course, it took a while before I realized that the illustrations in children's books were not a whole different animal from the paintings I love to make. At first, I tried to mimic an illustrative style. I don't even like to think of those first paintings—ick! It was as if I were trying to paint with my feet. It wasn't until I was working

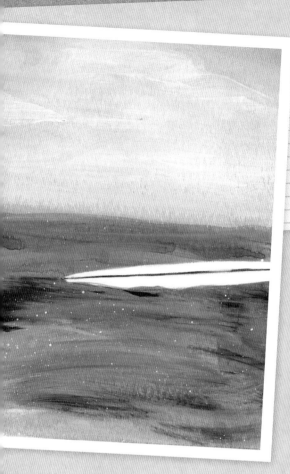

Pig Kahuna, **Jennifer Sattler**
Acrylic and colored pencil on vellum
After completing her illustrations, Jennifer scans them and then makes tiny fixes in Photoshop for production.

that kind of space. I pared down to what was necessary. I wanted the relationships between the characters and the nuances of gesture to be the main focus of each page. After all, that's where the funny was.

What advice would you give to artists just starting out?

Don't make the mistake I did of trying to fit your square self into a round hole. "Do what you dig," as they say… and get an agent.

Also, as a painter I always worked alone. I thought that I needed to be in control of every aspect of picture-making. I found out that working with great editors and art directors is both inspiring and invigorating. Being open to suggestions has 99 percent of the time spawned better pictures.

on my first national book, *Sylvie*, published by Random House, that I allowed my natural way of picture making to come through.

In *Chick 'n' Pug*, published by Bloomsbury the following year, I had a fantastic time experimenting with and evolving my process. The landscape paintings I had been doing on site for years were more about a sense of being in a place than the narrative descriptions of one scene. It felt natural to put my characters in

5 PROMOTING YOURSELF

If you don't tell anyone about your work, they won't know about it. It is as simple as that. While professionals such as publicists, marketers, designers and consultants can be a wonderful resource, their fees may render them inaccessible to an artist. You'll still need to promote yourself, your abilities and your artwork to potential customers. To do so, you'll rely on a combination of three things: common sense, good manners and creativity. I think of these three things as the Triad of Civility. You will see that term repeated often in this chapter; it is important to remember.

We will also talk about making a portfolio and creating all of the attendant paper stuff that you'll need to have—résumé, bio, business cards, stationery—as well as some tips on pulling your artwork into the digital age.

Captain, My Captain, Margaret Peot
Reduction Woodcut on Shikoku Surface Gampi, 14"× 12" (36cm × 30cm)

SELF-RESISTANCE

When you were a kid, did you ever think about whom a presidential candidate voted for when they themselves went into the polling booth? I bet you thought they voted for themselves, right? Well, when I was a kid, I assumed that the candidate voted for the other person running for President, as I would have, were I in the same position. The whole idea of going into a booth and voting for myself seemed seriously wrong, self-aggrandizing and ... impolite. So you can see where I had to start when considering promoting myself as an artist!

PORTFOLIO

Before you set about promoting yourself, you must have a body of work or art-related service to tell potential clients about, and a portfolio that presents it. Do you want to show them what you have made in the hopes of getting an exhibition or a grant? Or do you provide an art-related service that you hope to perform as a freelancer or as an employee?

It is important to decide what you want before you go out hunting for work, or establishing a freelance career. You don't have to be too specific, but you should have a template in your mind that generally maps what you want and don't want to do, what you will and won't do. Your portfolio, and indeed all of your promotional material, should clearly reflect who you are and what you want.

The purpose of your portfolio might be to promote your studio art—perhaps a series of woodcuts you made that depict the life cycle of a butterfly, or ten paintings you just finished, or a series of outdoor sculptures. You want to show your portfolio to gallery owners or potential customers because you would like to sell your work. Perhaps you hope to get a commission to make something similar to the pieces in your portfolio, or to obtain grant money to make more artwork.

If you want to illustrate children's books, your portfolio could include a series of illus-

trations for a children's book (for a story of your own devising). You could try to sell this to a publisher, or show it to publishers to get illustration work.

Or you might want to tell people about the hand-carved puppets you make, either because you want to sell them or you would like to collaborate with others to make puppets for a theatrical presentation.

Whatever your focus, be sure that your portfolio represents a body of work that is in line with your artistic ambitions.

BE CAREFUL WHAT YOU WISH FOR

Twice I have applied for work that I did not really want, but had gotten so involved in the happy activity of preparing for the interview that I lost sight of the day-to-day reality of the job that I might get. One of the jobs was working in a place that sold fabric paint and dye, and the other job was painting scenery in New Jersey.

I have always loved to imagine myself in different careers; I think it is fun. And I like to create all the stuff that one needs to promote oneself for a particular job—putting together the portfolio, shaping my work experience to make it seem like I know what I am doing, and making all the attendant stuff to hand out—business cards and whatnot. So, I happily prepared, applied, interviewed and then got both jobs I had applied for. Briefly, I was so thrilled. (They like me!)

But after getting the job at the paint-and-dye-selling place, I rode home on the train in a panic. The hours were long, the pay was poor, and it would leave me with little time and resources to make my own work. When I got home, I called them and said I couldn't take the job after all. It was very awkward and totally unprofessional. As for the scenery painting job, the two-hour commute, ugly set, poor pay and unusually heavy lifting just had to be followed through to its loathsome conclusion—and then never repeated.

Sometimes we all have to take jobs we don't like to provide our daily bread. But as a rule of thumb, it is best to figure out what you want first, and then hold all job ideas or offers against this template.

INTERVIEW: MARSHALL ARISMAN, ILLUSTRATOR, PAINTER

Marshall Arisman's illustrations, graphic commentaries on violence in our society, have appeared on the covers of *TIME*, *U.S. News and World Report*, *The Nation* and the *New York Times Book Review*. His fine art is in the permanent collections of the Brooklyn Museum and the Guangdong Museum of Art, in Guangzhou, China, among other institutions. He is the chair of the MFA program, Illustration as Visual Essay, at the School of Visual Arts in New York.

Did you always want to be an artist?

No. When I was a kid, I had two things I was OK at: music and art. I wanted to be a saxophone player. I was in a jazz band, and we played at dances, weddings and the country club. I was pretty good! It was my intent to go on to music school, but then I went to Buffalo and saw Charlie Parker play. I thought, "I'll never do this—I can't get close to him."

So I went to art school instead. There were a lot of older guys in school at that time, Korean vets—serious about their work. I had no art vocabulary, no experience and no real guides in my family, though my uncle painted. So I chose graphic design.

I graduated with a portfolio, and went to work for GM as a graphic designer. I made a lot of money, but I was unhappy. I wasn't ever good in groups; I didn't like collaborating. While I was in Detroit, I took drawing classes. I realized I was happy when I was alone, drawing. I was *not* happy at graphic design.

I quit GM and went to Europe. I lived there for a year, taking drawing classes and walking around with my sketchbook. Then I got drafted and was stationed in Georgia in the former USSR. I did my time, was out at twenty-three, went back to New York and thought, "Now what?"

How did you get into illustration from there?

I didn't want to be a graphic designer again. My roommate, Jerry Moriarty (now a graphic novelist), was illustrating at the time and suggested I try finding work as a freelance

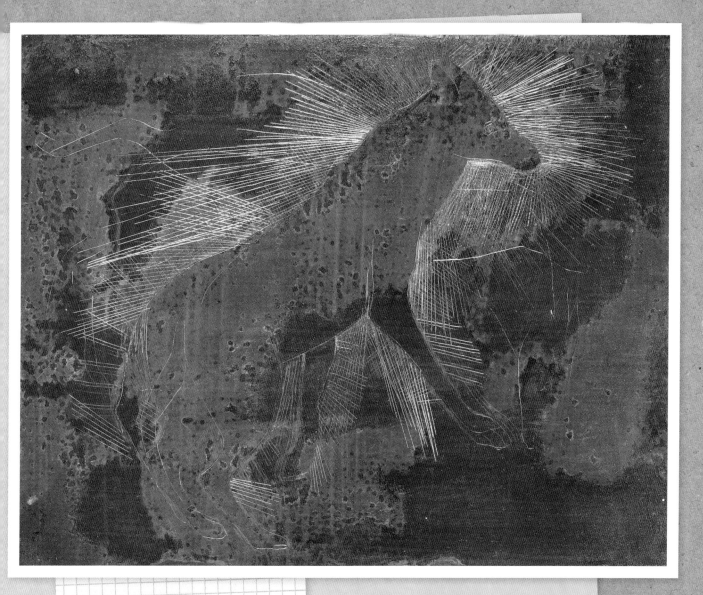

Wolf, Marshall Arisman,
Incised brass plate
5" × 8" (13cm × 20cm)

illustrator. So I put together a portfolio and started seeing art directors. It was a different time then, when you could actually call an art director and they readily saw people. It isn't that way now.

I worked two days a week in an art-supply store, and spent three days a week seeing art directors. I did everything right, but I still wasn't making a living! I made about $3,000 doing illustration work in that first year. Combined with my art-store income, I had money for rent and beer and movies, but it wasn't what you'd call making a living. I felt that I had failed at graphic design, and had failed at illustration.

How did you pull yourself out of that rut?

I realized that the thing that was missing is that I hadn't learned to draw. If you don't learn to draw, you can't do anything—you are always relying on tricks to get around the fact of not being able to draw. So I spent a year taking drawing classes. I started to realize that my portfolio was relying on style but missing content, and that I was spending all this time making what I thought other people wanted.

Ironically, it was at this time that I got a job teaching drawing at the School of Visual Arts. I was teaching and learning at the same time—not only about drawing, but about art-making. I began to realize on the days when I was alone with my sketchbook, that I had to start making some pictures for myself.

How did you set about doing this?

I made a list of things I knew about: cows, deer, guns and psychic phenomenon. (All this at the age of twenty-eight!) I decided that cows and deer weren't interesting enough, and I didn't know (and still don't, exactly) how to paint psychic phenomenon. So I started making ink drawings of guns (using India ink with spray-painted backgrounds.

That turned into drawings of the violence we do as a society with guns, to ourselves and others. I made forty-five drawings of guns and gun violence, and people started saying to me, "You have a book here." It was the Vietnam era, and people were starting to see photographic images of violence. Still, publishers would say, "We can't print this, it is too violent."

A *TIME* editor once said to me that the difference for viewers between a photograph and an illustration is that a photograph of a violent act or its aftermath seems to take just a second to capture, but an illustration of violence takes time to make, and something about that is super-horrifying to people.

Another editor told me that if I got someone famous to write an introduction for the gun drawings, it might be more publishable.

So I made a list of the people who I admired, and heading the list was Kurt Vonnegut. I sent him the drawings. He loved them and called and said, "What do you need—do you need some cash? How can I help?" And, "This book needs no introduction, but if that means it gets published, I'll write one."

And he did. (And that started an association of ten years—and every year I would send Kurt a case of gin and he would send me a case of scotch. That association gave me a tremendous source of energy.)

But, no one wanted to do the book anyway, Kurt Vonnegut intro or not. So I decided to print it myself. I chatted up some platemakers, made friends with the printers and managed to print and bind nine hundred copies.

Did you use the book to market your work, promote yourself?

I did not think of the book as a portfolio, but as this cool thing I had done. I sent books to people I liked, including some of the art directors I had worked for—just because I thought they were nice and I wanted to share this thing I had made.

The next day, people started to call—*Playboy*, *TIME*, all the people I had wanted to work for when I was taking around my portfolio of "illustrations" trying to get work. In fact, the art director at *Playboy* called apologetically, saying, "I know you are a fine artist, and illustration probably isn't what you are about, but would you please do this for us?" He made no association with the illustrator I had been, coming into his office and trying to get work. And the commercial work I was being offered was all stuff I would have done for myself anyway.

If the piece I was asked to do had meaning for me, I would keep at it and give it everything I had. If it didn't have meaning, the work didn't have the same resonance—it was just a job.

Later, when I started taking my paintings to galleries, they told me that I was too well known as an illustrator, and it was ruining my fine-art career. People have this snobbery about illustrations not being art. So I started taking my paintings to editors who paired the paintings with text.

Does your studio work, that is, your paintings that you do for yourself, inform your commercial work?

I have never learned anything about my art through illustration. But the personal work is moving underneath everything—it is the river whose energy fuels all other work, even though the personal work is not at all relevant to the commercial work that I do.

I have two walls in my studio. On one is my personal work, and on the other is my assigned work. I have no problem keeping the two separated.

How did you get this gig as chair of the MFA program, Illustration as Visual Essay at the School of Visual Arts?

I taught drawing at the School of Visual Arts (SVA) from 1965 to 1968. During that time, I was curator for a show of my students' work. The well-known graphic artist Milton Glaser saw it and told my boss, Silas Rhodes, "The guy that put together this show should run the department."

So Silas hired me even though I said I would only do it if I could do it for two days a week, maximum. (I'm still not sure how I had the moxie to say that!) I was inheriting a faculty of my heroes, which was humbling, and they agreed to try me out for a year. That was forty-five years ago, and I'm still doing this.

Does your teaching inform your studio work, or vice versa?

I find that I need the balance of the three things—the illustration jobs, my personal paintings and teaching at SVA. I tried to take a year off and just paint, but it made me too squirrelly. I find that I need the social aspect of the teaching and interacting with the world to make the paintings work.

How do you balance the business of art-making with the actual art-making?

I have attended Illustration conferences, and they are very business oriented—as if the solution to success is in this arena. But in fact, your career will be further ahead if you are doing meaningful work. And the meaning-ful work will take care of you.

What is your advice to an artist starting out?

Well, Joseph Campbell said it best when he said, "Follow your bliss." Paint what you know and care about. I tell my students to buy a cheap tape recorder and talk into it, reminisce, rant—don't edit, just talk. And through this, you will start to get at what is important to you. Its resonance with you will make it impor-tant to others.

I had a student who loved frogs as a kid. He knew everything about them—was quite passionate about them. One day, he caught a frog, and put it in a jar and left it on the porch. He forgot about it, and then sun shone on it all afternoon, and it died. He was stricken—heartbroken.

I asked that young man, "How often do you think about that frog?" He said, "I have thought about that frog thousands of times!" And that guy knows frogs—his drawings and

paintings of them show this. *That* is his portfolio. Does that make any sense?

I would say: Do a series of drawings that is meaningful to you, and that is a portfolio.

Also, you must learn that you can't only just make pictures. It's the presence of the other parts of you that is so important. What you remember and care about is not incidental.

Like the frog in the jar?

Yes! The worst thing that can happen is you will exorcise some old stuff, but the best thing is that you will come to a real truth.

Paul Theroux once said, "Never try to make a universal point, or write a letter to the world. Try instead to find a personal truth and hope that it becomes universal."

TRIAD OF CIVILITY

1. **Common sense**

 Present your work as clearly as possible. Keep your presentation short and focused on the interests of the person you're presenting to, while conveying your own interests clearly. (For example, if you are trying to get work as a muralist, you should not include your woodcuts in your portfolio. They might be very nice, but unless they have some application to mural painting, it is best not to muddy the waters by including them.)

2. **Good manners**

 Think about the person to whom you are presenting your work. Consider their time, attention and concerns. Do not make the typeface on your business card too small to read for the over-forty set. Do not fill your query letter with confetti so that they curse your name every time they find a piece of confetti in their office. And, follow the social niceties of the day—make eye contact, shake hands and brush your hair before going to your meeting.

3. **Creativity**

 It is important to provide all the commonly asked for things—the business card, portfolio, web address. But working within these strictures in a creative way—that enhances your art instead of detracting from it—will be fun and help you stand out.

If you attend to these three things, you don't have to worry about anything—they are all you need.

Marshall Arisman has a great story about how he came to make his portfolio. After making a portfolio of what he thought everyone wanted, which was unsuccessful, he assembled a collection of drawings about something he knew about—guns and violence. It ended up being the most powerful portfolio he could have made.

Before he made this portfolio, Marshall made a list of what he knew about:

- cows
- deer
- guns
- psychic phenomenon

What do you know about? What matters to you? Make a list of five things you know about. Don't worry that the things you know about might not be important. Remember—sometimes the thing you know the most about might be so second nature to you, and seemingly so far from art-making, that you might not think to write it down.

What do you know about?

1. _____

2. _____

3. _____

4. _____

5. _____

Now, pick just one of those things, and write down five things you know about that one topic/creature/activity:

1. _____

2. _____

3. _____

4. _____

5. _____

How can you make these five things visual? Is it a book? Is it a series of five pieces? Is it a bunch of small works? List five things you could make out of this thing you know so well:

1. _____

2. _____

3. _____

4. _____

5. _____

Any of the five works could from the basis of your portfolio, and the ideas will determine the form your portfolio takes.

© Marijn van Braak

YOUR PHYSICAL PORTFOLIO

Portfolios can take different shapes. A portfolio could be a collection of eight to ten photographs in a wonderful 8" × 10" (20cm × 25cm) book, or matted and arranged in a solander case or aluminum box. It might be a printed folio that contains images of your work and contact information that you can leave with people, or a short stack of postcards with different images of your artwork on them (see Web and Social Media Links in the Index).

What you are showing, and to whom you are showing it, should define the physical form of your portfolio. If you are sending your work to galleries far and wide, a CD or printed folio might be right.

If you are a painter, your portfolio could be a CD with ten paintings, two drawings and a print or two. The CD should also contain a digitized version of your résumé, bio and artist statement, along with hard or paper copies.

If you would like work as an illustrator, maybe you could make a book like Marshall did, about something you really care about. Information on making a simple pamphlet is available online. Or, you can have glossy pamphlets featuring an illustrated story or examples of your work made at Modern Postcard (www.modernpostcard.com), but you will have to order a minimum of four hundred copies.

It is also possible to make a photo portfolio through Shutterfly (www.shutterfly.com) or Creative Memories (www.creativememories.com) where you input images and text and they send you a hardcover book.

Consider where are you showing your portfolio as well. If you are meeting at a coffee shop, a small portfolio that you can easily flip through on a table would be most appropriate. (Make sure that the pictures are in plastic sleeves so that you don't get jelly on your reproductions!)

In any event, show work that you care about, and hope that your work will touch the person you are showing it to.

Giveaways

You can make a small portfolio of your work (including all your contact information) in the form of postcards with the online printing company, Moo (www.moo.com). You can design and order one pack of postcards with many images, and give away a packet of eight or ten different images to people you meet with as a reminder gift. This way, you can carry tiny portfolios with you, perhaps each in a vellum envelope, so that when you meet someone at an interview, or on the go, you can give them a neat reminder of your work.

"...show work that you care about."

PAPER PROMOTION

Someone explained to me once that having all the right things—a business card, résumé, stationery—proves that you can play the game by the rules. Simply by having them, you pass some kind of social test.

John Cage, the avant-garde composer and Buddhist practitioner, was asked by a fellow practitioner while he was signing autographs, "How can you do this? How can you reconcile being so involved with signing autographs and promoting yourself with your Buddhist practice?" Cage said something like, "Because this is what we have to work with in this life."

You can't get anymore erudite, intellectual, strange or refined of mind than John Cage—yet he did this stuff, too. So don't feel like you are taking away from your art-making life by doing some self-promotion.

The Triad of Civility also comes into play here. It is common sense to provide people with your contact information in multiple places so that if they want to contact you, they don't have to hunt all through the stuff you gave them to find your telephone number.

It is good manners to provide the things that people need to make a decision about your work, in a format that they have seen before and are familiar with. And your innate creativity will make these things fun to look at and memorable.

BUSINESS CARDS

You must have a business card. Your business card should have your name, address, telephone numbers, website URL, email address, and a word or two defining yourself—who you are and what you are about.

It might have a defining image on it. It should have a space on it where someone can jot a note about you. I found this out the hard way, after giving someone a thoroughly designed card and then having to hunt around for a piece of paper for them to jot something on which they probably ended up losing anyway!

It should not be too small to read without glasses. (If you are over forty, you might know what I mean.) I caution against the really cute half-sized cards since recently overhearing two forty-something editors at an event bitterly complaining about this trend because the cards were too small for them to read!

"Don't feel like you are taking away from your art-making life by doing some self-promotion."

"Don't make people wade through a lengthy résumé to figure out if you're a good fit."

STATIONERY

Stationery should have almost all the same contact information as your business card. You don't need to have a lot printed up, in fact you shouldn't, as you may change your address or website info. (Then you're just stuck with a bunch of fancy scrap paper!)

Instead get some nice paper and design some stationery on your computer. This way, you can print out what you need to send handwritten notes, or just type directly into a Word document.

With a basic word-processing program, you can insert an image of your work, and include all the information pertinent to you. If you search online for examples of stationery, you will get some neat ideas. If you have Photoshop, you can create something really fabulous.

ARTIST STATEMENT

Another piece of paper you will need to have is an artist's statement. An artist statement is, essentially, a short piece written by the artist that defines their artwork. Artist statements are like snowflakes—there are no two alike. (The same could be said of artists!) So it is difficult to tell you how you should go about writing yours.

Artist statements are a relatively new phenomenon, which came about in the last fifty years or so. Caravaggio, for example, didn't write one. Picasso didn't either, and probably not Barnett Newman.

Today, however, all grant applications, galleries, competitions and art-school applications require an artist statement. You must have one. After you write yours, you can morph it to suit the grant committee or exhibition space. Think of your artist statement as a flexible thing that will develop with you and your art.

Your artist statement could appear on your website or in your portfolio. When you print a copy to send somewhere or give to someone, make sure all of your contact information is on that piece of paper, too. (The worksheet, Tips for Writing an Artist Statement, later in this chapter will help you get started.)

LIKE SPRING CLEANING

Honestly, I have never read an artist statement that I liked. And I have never written one for myself that didn't make me roll my eyes after coming across it later. Writing an artist statement is a loathsome yet necessary activity. It is a bit like cleaning your toilet. If you do it well, it will reflect well on you, but no one will really pay much attention to it. But if you don't do it, people will wonder if you are a responsible grown-up.

RÉSUMÉ

As with stationery, don't print a huge stack of résumés. I have rarely sent the same résumé twice. Why? If I am applying for a job as a costume painter, I want to emphasize the shows for which I have painted costumes. If I am looking for gallery representation, or am entering a competition, I want the résumé to focus on my exhibition record. If I want a teaching gig, I can reorganize the résumé so that my teaching experience is at the top.

This is, of course, easier to do when you have lots of stuff that you have done in your life. But even if you are quite young, and just out of school, I bet you can think of ten art-related things you have done that you could organize on a résumé.

Your non-art-related experience can also fit in where each job-looking situation requires. For example, on a résumé you're sending to galleries for representation, you might not mention your year at Starbucks. But for a job that requires interaction with the public, it would be perfect to include.

There are no hard and fast rules for artist résumés, other than that they be clear and brief. It is common practice for fine artists to have a multipage résumé listing all their exhibitions, but some award or grant applications beg that résumés be kept to two pages.

This all goes back to the Triad of Civility. Don't make people wade through a lengthy résumé to try to figure out if you are a good fit. Keep it concise, and put the information they want right up at the top (after your contact information). Include the rest, but don't make it the main focus.

Writing a résumé is often stressful. You may start to wonder if you ever have or ever will do anything of substance. But if you put aside the stress and focus on the fun of targeting the information in a way that will be considerate, professional and effective, you will become a wonderful résumé writer.

On the following pages are three résumé examples. The information in all three of them is basically the same, just emphasized in different ways. One is a general résumé that I gave to someone who wanted information about me to promote an event. Another, I made when I was looking for a literary agent, and the third was from when I was interested in a job painting for a mural/conservation company. Check out the differences!

"There are no hard and fast rules for artist résumés."

MARGARET PEOT

000 Manhattan Avenue, New York, NY 10000, (000) 000-0000

margaretpeot@email.com

www.margaretpeot.com

www.theinkblotbook.com

Printmaker, Painter and Book Artist:

2011 *Margaret Peot: Woodcuts, Altered Inkblots and Curiosities*; one-person exhibit of woodcuts, boxes and altered inkblots, The Galleries at Saint Peters, Lexington Avenue at 54th Street, New York, NY

2011 *The Sketchbook Project*; group sketchbook national exhibition tour, Art-House Co-op, Brooklyn, NY

2010 *Women-made*; three-person exhibit, The Grady Alexis Gallery at El Taller Latino Americano, New York, NY

2008 *CROWnology*; one-person exhibit of woodcuts, boxes and altered inkblots, Ocean City Artists Guild, Island Heights, NJ

2006 *CROWnology*; one-person exhibit of woodcuts, boxes and altered inkblots, Lake Placid Center for the Arts, Lake Placid, NY

2001 *Wishin' Don't Make It So*; text for one woman story telling, with music for fiddle and guitars by Daniel Levy; La Mama Theatre's New Voices, New Works Series, New York, NY. 2000 and at HERE Arts Center, NYC 2002

2000 Center for Book Arts, artist member exhibit.

Publications:

2004 *Make Your Mark*; a nonfiction book of non-drawing techniques to jump start creativity; Publisher: Chronicle Books, San Francisco, CA

2011 *Inkblot: Drip, Splat and Squish Your Way to Creativity*; Creativity for kids; Publisher: Boyds Mills Press, PA

Articles in *The Artist's Sketchbook Magazine* and *Rubber Stamping Retailer*

Additional projects:

2009 Woodcut; for T-shirts, and shown and raffled to benefit the PS/IS 187 Environmental Group

2008 Woodcut; for T-shirts, and shown and raffled to benefit the WHNA Harvest Festival

2007 Woodcut; Four Dignities, for T-shirts and raffled to benefit Karme Choling, VT

2006-2008 Woodcut; given as gifts to participants in the Sarah Lawrence Poetry Festival

2002 Blackbirds; a card set featuring three woodcuts of crows, letter press printed by Robert Warner by Bowne and Company Stationers for the South Street Seaport Museum

Costume Painter (1989–present): Member: United Scenic Artists Local 829, Allied Crafts

Projects include: BROADWAY: *Spider-Man: Turn Off the Dark*, NYC; *Shrek the Musical*, NYC and tour; *Mary Poppins*, NYC and tours; *The Little Mermaid*, NYC; *Spamalot*, NYC and tour; *Wicked*, San Francisco, Chicago and NYC; *The Lion King*, NYC and tours; *Titanic*, NYC and tours; *Cats*, NYC and tours; *Kiss of the Spider Woman*, NYC; *Phantom of the Opera*, NYC, and others; DANCE: San Francisco Ballet; Pilobolus; American Ballet Theater; The Feld Ballet; FILM: *Bram Stoker's Dracula*; OTHER: David Byrne Concert Tour; Siegfried and Roy at the Mirage Hotel, Las Vegas, NV; Big Apple Circus; Ringling Bros. and Barnum and Bailey Circus, among many others.

Teaching (1993–2005):

Advanced Costume Painting Techniques, Tisch School of the Arts, New York University

The Creative Center, New York, Lake Placid Center for the Arts, Westbeth Community Center, Saint Peters Church, and private art lessons for children

Mural Painting (1987–1990)

Tromploy, Inc. (with Gary Finkel and Clyde Wachsberger): murals for public spaces including the LA Museum of Science and Technology, a Gaudi theme restaurant in Tokyo, a Di Chirico themed club in Japan, Telephones restaurant, as well as murals for many private residences in New York and Westchester

Education:

Miami University, Oxford, OH; B.F.A. cum laude 1986. Further study at NYU, The Center for Book Arts, and with printmaker Kathy Carracio, and at The Printmaking Workshop

MARGARET PEOT

000 Manhattan Avenue A10, New York, NY 10000, (000) 000-0000

margaretpeot@email.com

www.margaretpeot.com

www.theinkblotbook.com

Published Books:

Inkblot: Drip, Splat and Squish Your Way to Creativity; Boyds Mills Press 2011

Make Your Mark: Explore Your Creativity and Discover Your Inner Artist; Chronicle Books 2004

Book Projects:

Blackbirds cards; letter press printed by Robert Warner at Bowne and Company Stationers for the South Street Seaport Museum, 2002

CROWnology; paintings, story. 1999

Not All of the Blackbirds of Kentucky; Ohio and New York woodcuts, stories. 1998

Battle Folio; 24 etchings, coptic binding with steel covers, no text. 1998

Exhibitions, readings:

2011 *Margaret Peot: Woodcuts, Altered Inkblots and Curiosities*; one-person exhibit of woodcuts, boxes and altered inkblots, The Galleries at Saint Peters, Lexington Avenue at 54th Street, New York, NY

2011 *The Sketchbook Project*; group sketchbook national exhibition tour, Art-House Co-op, Brooklyn, NY

2010 *Women-made*; three person exhibit, The Grady Alexis Gallery at El Taller Latino Americano, New York, NY

2008 *CROWnology*; one-person exhibit of woodcuts, boxes and altered inkblots, Ocean City Artists Guild, Island Heights, NJ

2006 *CROWnology*; one-person exhibit of woodcuts, boxes and altered inkblots, Lake Placid Center for the Arts, Lake Placid, NY

Wishin' Don't Make It So; text for one woman story telling, with music for fiddle and guitars by Daniel Levy. La Mama Theatre's New Voices, New Works Series, NYC. 2000 and at HERE Arts Center, NYC 2002

CROWnology; two readings and show of accompanying paintings, Cornelia Street Cafe, NYC. 2000

Artist Member Show 2000, Center for Book Arts, NYC

Costume Painter (1989–present): Member: United Scenic Artists Local 829
Projects include: *Wicked, The Lion King, Phantom of the Opera, The Nutcracker* for the San Francisco Ballet, *Sleeping Beauty* for American Ballet Theater, *Bram Stoker's Dracula*, and Ringling Bros. and Barnum and Bailey Circus, among many other projects.

Education:

Miami University, Oxford, OH; B.F.A. cum laude 1986
Further study: NYU Publishing Certificate Program, The Center for Book Arts

MARGARET PEOT

000 Manhattan Avenue A10, New York, NY 10000 (000) 000-0000

margaretpeot@email.com

www.margaretpeot.com

www.theinkblotbook.com

Wallpaper/Mural Restoration (2007, 2009)

New York Botanical Garden, Restoring the lattice and sandstone wallpaper with paint, and touching up the murals in the Bunny Williams-designed Garden Ballroom and Foyer

Mural Painting (1987–1990)

Tromploy, Inc. (with Gary Finkel and Clyde Wachsberger): murals for public spaces including the LA Museum of Science and Technology, a Gaudi theme restaurant in Tokyo, a Di Chirico themed club in Japan, Telephones restaurant, as well as murals and floorcloths for many residences

Michael Curry: mural, decorative painting for the Fisher-Price Toy Showroom

Skills include: Good color matching/mixing, good drawing skills, can duplicate textures well, and blend new painted areas to old easily. Can work on site or on canvas on the floor that is installed later.

Costume Painter and Dyer (1989–present): Member: United Scenic Artists Local 829

Projects include: BROADWAY: *Shrek the Musical*, NYC; *Mary Poppins*, NYC; *The Little Mermaid*, NYC; *Spamalot*, NYC; *Wicked*, San Francisco; Chicago, tour and NYC; *Lennon*, San Francisco; *The Lion King*, NYC and tours; *Titanic*, NYC and tours; *Cats*, NYC and tours; *Kiss of the Spiderwoman*, NYC; *Phantom of the Opera*, NYC, and others, DANCE: San Francisco Ballet; Pilobolus; American Ballet Theater; The Feld Ballet; FILM: *Bram Stoker's Dracula*; OTHER: David Byrne Concert Tour; Siegfried and Roy at the Mirage Hotel, Las Vegas, NV; Big Apple Circus; and Ringling Bros. and Barnum and Bailey Circus, among many others.

Skills include: Painting and dyeing any kind of fabric, matching existing fabric in color and texture. Stencil cutting and printing, airbrushing, painting trompe l'oiel textures from fur

to stone, as well as florals, prints in styles ranging from subtle paisleys to op art, in repeat or engineered to fit a costume piece or space.

Has worked to remake and restore costumes for revivals of dance pieces and has originated costume painting for many designers.

Publications:

2004 *Make Your Mark*; a nonfiction book of non-drawing techniques to jump start creativity; Publisher: Chronicle Books, San Francisco, CA

Spring 2011: *Inkblot: Drip, Splat and Squish Your Way to Creativity*; Creativity for kids; Publisher: Boyds Mills Press, PA

Printmaker, Painter and Book Artist:

February–March 2010 Three Person Exhibition, Grady Alexis Gallery, paintings and woodcuts

January 2011 One-person exhibition of woodcuts, boxes and altered inkblots, St. Peter's Church Galleries, Citicorp Building, Lexington Avenue at 54th Street, New York, NY.

2007 *CROWnology*; one-person exhibition of woodcuts, boxes and altered inkblots, Ocean City Artists Guild, Island Heights, NJ

2006 *CROWnology*; one-person exhibition of woodcuts, boxes and altered inkblots, Lake Placid Center for the Arts, Lake Placid, NY

Additional projects:

2002 Blackbirds; a card set featuring three woodcuts of crows, letter press printed by Robert Warner at Bowne and Company Stationers for the South Street Seaport Museum

Teaching (1993-2007):

Advanced Costume Painting Techniques: Tisch School of the Arts, New York University

Inkblot and Creativity classes: The Creative Center, New York, Lake Placid Center for the Arts, Westbeth Community Center, Private art lessons for children

Education:

Miami University, Oxford, OH; B.F.A. cum laude 1986. Further study at NYU, The Center for Book Arts and The Printmaking Workshop

WORKSHEET: TIPS FOR WRITING AN ARTIST STATEMENT

When I write an artist statement, I compose it like I am writing a note to my next-door neighbor, George Halley, who is a fellow artist and my best fan. I tell him what I am doing, and with what media. I tell him what I am influenced or moved by, and how that thing specifically affects the particular body of work I am telling him about. I don't have to con him or convince him of anything because he loves me and my work. I just have to tell him clearly what I am making and what it means to me.

Finish the following statements, imagining you are writing to your supportive and smart friend...

I make _____

It is made from_____

I started making this because_____

With this work, I would like to say_____

I am influenced by_____

I chose this particular art-making technique because_____

The direction I see this work going is_____

Now take these answers, and combine them into an artist statement. Don't use these questions as sentence beginnings, and don't start every sentence with "I." Make something that flows. Try to keep it around a hundred words or less. Be personal, and try to really articulate some of the things that you think about when you are working.

Once you have a statement that pleases you, ask some other artist friends who know your work to read your statement and give you feedback. If you need more help, you can search "Artist Statement" online and find lots of examples. But I would encourage you to do this worksheet before looking at what other people have written.

© Barbara Vučić

WEBSITE OR ONLINE PORTFOLIO?

Our world has become smaller in a wonderful way. We can sit down and look up any topic in the world online, from the general to the most arcane, and we can find others from all over the globe who are interested in the same thing. We can download imagery for reference, join groups who are interested in our specific area of expertise or interest (not just "fiber arts" but "weavers who dye raw silk with mushroom dyes"), meet people, make friends and business connections.

It is a heady time! In fact, by the time I have finished writing the words on this page, the online world will have changed—again. But there are some things that will remain fairly constant.

It has become common practice for artists to have a website or online portfolio. There are several free portfolio sites. (See the list of online media resources at the back of the book.) You may even have a simple website-building template in your computer.

Like business cards, websites have become a test of legitimacy. Your website can be a simple portfolio site with examples of work that a viewer can flip through. It could be a more complicated site with a blog, links to video-viewing sites and the ability to link to other websites.

Should you have a website or online portfolio? If you want to have a place where interested viewers can go to delve deep into your work, read your résumé, artist's statement and bio, a portfolio site is perfect for you. If you want to blog, post articles, have some ability to interact with your viewers, then a website with blog potential is probably the best way to go.

You can hire someone to build a website or online portfolio for you, or make a perfectly serviceable one for free. Either way, you need to have an online presence.

> "It has become common practice for artists to have a website or online portfolio."

SOCIAL MEDIA AND MARKETING

Social media sites like Facebook, Twitter and LinkedIn have become a part of our social landscape. Most people have a Facebook personal page, and many artists are starting to build fan pages on Facebook where they can feature their portfolios, announce events and make contacts of all sorts.

Facebook can be professional, but is generally casual, personal and fun. Facebook is not a place to actively sell your work, or obviously promote a product. In fact, it is one of the things you agree not to do when you sign up on the site, and people have had their accounts closed down because of it.

LinkedIn is a more formal type of social media, that is less about the antics of your new French bulldog, and more about making contacts or looking for work in the business world. LinkedIn is a great way to slowly build up your contacts with curators and gallery owners.

Twitter allows you access to thousands of streams of information, and the people that generate that information. You join, you tweet 140 characters or less in length, and then look for other streams into which you want to dip your toes. You will find some wonderfully interesting things, and a whole bunch of stuff you are not interested in, but you can isolate the streams you care about and follow people or organizations who interest you.

To get started with Twitter, think of about ten things you want to say—don't be shy. Type (or "tweet") them in. If you follow someone, it is considered de rigueur for them to follow you—good tweeting etiquette. If you have interesting content and provide links to your work, it is a wonderful way to meet like-minded people from all over the world.

Finally, there are places online to sell your art, such as Etsy, or even your own website. But art professionals have mixed feelings about this. When you sell your work in a gallery, the work is priced to reflect the percentage they take. If you are selling something yourself, and are not counting a gallery markup, it can make gallery owners very angry to find that you are undercutting them. (Of course, if you are a painter, and sell your paintings in a gallery, but sell your note cards and heat-transfer handbags on your website, that would probably be OK.)

You must have a basic website or online portfolio, just like you must have a business card. And, if you want to market your artwork or art-related service, you really need to be on a social media site.

> "Social media sites ... have become part of our social landscape."

Spend a bit of time checking out the different social media sites and see which is the best fit for you. But I would recommend that you structure and limit your daily time online so that it doesn't take over your life. It can all be very seductive!

As with paper promotion and your portfolio, how you interface with social media, and how you organize your website, goes back to the Triad of Civility:

- It is common sense to have your work represented online and through social media in some form. That is what people expect these days. They want to find you when they search for you online.
- It is good manners to make it easy for people to find and contact you, and for your website to be easy to navigate so that potential clients can get quickly to what they want to look at.
- Creativity will help you tremendously here. Making an online platform for yourself will be fun, and utilize your sense of aesthetics, narrative, organization and problem solving.

> "...structure and limit your daily time online so that it doesn't take over your life."

PUT YOUR BEST FOOT FORWARD

All those things your mother taught you about combing your hair and putting on a clean shirt before meeting a new person are true. What we wear, how we move and the volume and clarity with which we speak all say more about us than we would like!

But again, it all comes down to the Triad of Civility:

- It is common sense to put your best foot forward in a business situation that you hope to gain by.
- It is good manners to dress up a little to honor the person you are meeting.
- You can be creative with how you let your personality shine through, while still meeting the basic criteria of social niceties.

REPOSE

When I first came to New York and was terrified (and thrilled) to meet and talk to people, one of the things that helped me immeasurably was a passage about repose in F. Scott Fitzgerald's book *Tender Is the Night*. In this context, repose meant the ability to walk into a public space without fidgeting, twitching one's tie, fiddling with one's lapel or touching one's face.

In the passage I like so much, six friends are in a stylish French restaurant, Voisins, watching the other patrons in the restaurant to see if they had "repose." Dick Diver (the incredibly charismatic, mysterious half of a glamorous couple of expats) announces that no American man except himself had any repose. A whole host of Americans come in, fingering eyeglasses and facial hair, stroking their cheeks, or pulling at their ears. Then a general comes in, and one of the companions, counting on the man's military training to have provided him with the elusive repose, makes a bet with Dick of five dollars.

"His hands hanging naturally at his sides, the general waited to be seated. Once his arms swung suddenly backward like a jumper's and Dick said, 'Ah!' supposing he had lost control, but the general recovered and they breathed again—the agony was nearly over, the garçon was pulling out his chair . . .

"With a touch of fury the conqueror shot up his hand and scratched his grey immaculate head.

"'You see,' said Dick smugly, 'I'm the only one.'"

Any time I have to walk into a room by myself, make conversation and meet new people, I force myself to think about Dick Diver's repose, and make a game of it. Something about playing a game with myself of not fidgeting makes the rest easier—almost as if some anxious part of my brain is taken up by and entertained with the activity, so that the rest of me can move around the room unhampered by fear.

INTERVIEW: BARBARA JONES
FOUNDER, ENGAGE COMMUNICATION

Barbara Jones is a consultant, coach and training leader specializing in written and spoken business communication. She is the founder of Engage Communication. Based in New York City, Barbara has over ten years experience with clients in consulting, financial services, nonprofit and marketing. She has served as Adjunct Professor of Business Communication at the Stern School of Business, and is a principal consultant for MBA Career Services at Columbia Business School.

Artists are often painfully shy. What advice could you offer the shy ones?

I work with business people who are shy, too. It can make it difficult to get their ideas across, especially to large groups. But a shy style is not a death sentence. In fact, some people find shyness refreshing!

There are two issues—the shy person's own discomfort, and the sometimes mistaken impression that shy people make on others, that they don't care, or are spacey.

For the person's own discomfort, here are two ideas: First, breathe—slowly and regularly. Second, prepare yourself for whatever the situation is. Know the environment. Prepare what you're going to say ahead of time—even small talk! And if you can, bring a trusted friend.

For the issue of mistaken impressions, practice some more direct behaviors—eye contact, smiling, an upright and open posture.

Do not do all of these at once. Just pick one and try it out. Then repeat.

Artists are often soft-spoken. What does the way I use my voice say about me?

How you use your voice says a lot about your confidence. If your style is more soft-spoken, you can still communicate effectively. Support your voice as best you can so that you can be heard, and don't trail off at the end of your thought. Don't mumble. Articulate clearly. Make sure there's lots of vocal variety so others can get a sense of your enthusiasm.

What unintentional body language might I be implementing that would make people feel I was not interested in them?

Everything communicates. Not just your words, but how you say them and your body language when you say them—it all says something

about you. Sometimes we don't know what impression we're giving with our body language—we're just used to our way of being.

But sometimes we send messages unintentionally. For instance, if we're nervous, we might get quiet, look away from people and make barriers by crossing our arms. It might look to others like we're aloof, or don't care.

If you're worried that you may be sending the wrong message, check the basics of your body language—posture, gestures, eye contact, facial expression and hand position. Project openness, curiosity, energy. Make adjustments and ask a friend if it's working.

How important is a handshake or eye contact?

People don't feel like they've seen you until they've seen your eyes. So let them. It's an essential piece of human interaction that can be mastered with practice.

And some form of the handshake has been around since civilization began. Get yourself a good one—firm, warm and dry. Add a smile and nice clear name, and you got yourself a confident first impression!

My art speaks for itself. But how important is my physical presence when I want people to look at my art?

Your art may speak for itself, but you can't stop there. When people are interested in a piece of art, they're often interested in the artist, too. They want to know more, understand it better. You are your art's representative.

Showing that you are confident and open to others can help. Upright posture, relaxed facial expression and open, available eye contact can communicate these well.

Do I need a business suit and neat hair? How do the rules for self-presentation apply to artists?

In short, if you want to play with the grown-ups, you have to show that you are a grown-up. So yes, business-appropriate dress and neat appearance is required. But this isn't so different from what we do every day. For example, you dress differently for working in the studio, going out with friends or for a big date. It's the same for the business of your art.

Sometimes we are reluctant to change how we communicate because we're afraid it will change our essence. But that's not true! Our essence is much sturdier than that! All you need to do is make some adjustments for certain situations to help yourself become successful. These are contextual adjustments, not changes to your essential self. And when it comes to dress, don't be afraid to tailor your look so *you* show through.

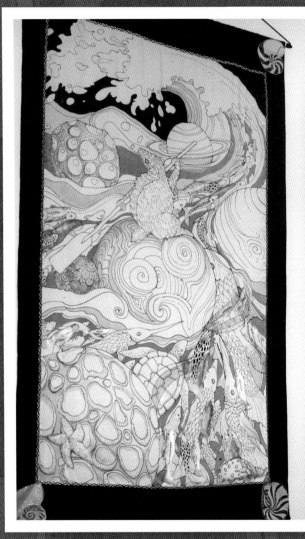

6 INTERESTING ART JOBS

You must have work to live. Some artists are able to produce artwork that sells, and by that, they make a living. Others, by choice or chance, separate making art and making a living to various degrees. Some of these artists like to have a job that is not art-related at all, but many like having work that is related to their skills. Within this arrangement, they can then try out different mark-making or aesthetic languages in a forum that is not their own personal artwork, fulfilling the requirements of a paying gig while learning, growing and honing their visual chops.

Everyone has come to be holding this book in their hands for different reasons. Some of you are artists looking to find art-related work. Some of you are just leaving school and have only a glimmer or two about what you want out of life. Some of you are looking to reconnect with your artistic selves after years of neglect, while others want to help a loved one who is an artist.

Chapter 1 asked you to consider career possibilities from the perspective of your own preferences and desires. This chapter invites you to consider your own potential from the opposite direction: What art-making jobs are available in the world, and which of those appeals to you?

Marybdis Trilogy: Captain, My Captain; My Mistress' Eyes; HMS Beagle, Margaret Peot
Painted silk with digitally printed collaged elements, cotton brocade border, silver acrylic, soutache
Each panel 7' × 10' (2.13m × 3m)
This trilogy of paintings was created for a solo exhibition at The Galleries at Saint Peter's Church in New York in 2011.

INTERVIEW: ANNIE SESSLER, GYOTAKU PRINTMAKER

Annie Sessler and her husband, Jim Goldberg, are owners of East End Fish Prints, makers of beautiful gyotaku prints. (Gyotaku is the Japanese word for fish rubbing.) Find them at eastendfishprints.com.

How would you describe what you do?

We make original rubbings of fish, or monotypes using actual fish as our printing plates. We sell them as framed and loose prints.

What training do you have? What paths did you follow to get to do what you do?

I married a fisherman who introduced me to this form of printmaking. I majored in design in college, and had taken a variety of studio art courses including printmaking. I worked in a family import and brokerage business for over ten years and learned all about running a business while there.

Did you always want to be an artist?

I admired my brother's artistic abilities when I was very young. In the last years of high school I was inspired by my studio art and art history professor Mr. Barrett.

What drew you to fish printing?

My husband, Jim, simply said, "You could sell these," after he saw the prints I made the night following his demonstration. The first fish print I ever saw was his, a swift and masterful execution of a squid, refined and sublime both in form and tone. He caught and cooked almost all of our inventory. As a fisherman and artist, he critiqued the prints.

Do you have an art-making practice that is separate from what you do for a living?

No.

What keeps you motivated? Where do you go, what do you do to get inspired?

I get inspired by making new work, toying with ideas, traveling to other countries to do new work and encounter new species, and meeting

Eels, Annie Sessler
Gyotaku, blue-black ink on satin
10" × 15" (25cm × 38cm)

all kinds of people—show vendors, visitors and other fishermen. Voyaging within during the art-making process is also inspiring.

How do you balance the business of art with art-making?

Since this is my "job," life dictates what is necessary and when. Works need to be produced to sell at shows and art fairs, online and in the studio. Attending and getting ready for shows, which generates an income stream, takes up a fair amount of time. Money needs to be managed to cover sales, production and growth expenses. Both money and time are needed to develop new ideas and products.

Do you find art fairs rewarding?

Art fairs have been the primary vehicle for exposure, advertising, sales and setting prices. Show vendors are the best resources for sharing knowledge of local, national and international shows as well as their personal experiences and histories as show people. I continue to do shows and will participate in shows farther from home as our young kids grow older.

How has your business model changed since you started out?

We are considering entering commercial markets with our works, producing and selling high-volume, lower-cost pieces for hotels, restaurants, etc.

At the same time, we continue to evolve as printmakers and work to create higher-quality pieces for high-end customers. We are also now selling works in stores, through agents and designers.

What advice would you give to an artist starting out?

Step out boldly. Embrace and celebrate your ideas. Feign confidence until you build it. Take action. Do. Make. Show. Sell. Let your heart and gut rule.

Striper (detail), Annie Sessler
Water-soluble inks on rayon/silk satin

Before you do formal research into the art job market, use these prompts to help you brainstorm outside your normal, reasonable decision-making process. Check the jobs that most appeal to you, regardless of whether you have any experience or education in that field. Later, we'll cover some brief descriptions of each job. Some of those job descriptions may ring a bell for you in a positive way that the job titles did not, or some may clarify that an attractive title actually masks a job you'd sooner run from than embrace.

Following the inner voice that says, "Yes, check that one—botanical illustrator," may open up possibilities that are not obvious at first glance.

Do you like to help people? Do you like to try to make your world a little better?

- ☐ Art therapist
- ☐ Arts-in-healthcare worker
- ☐ Interior designer
- ☐ Forensic artist
- ☐ Police artist
- ☐ Drawing books, instructional books
- ☐ Conservator
- ☐ Mosaic artist
- ☐ Art teacher
- ☐ Medical illustrator

Do you like a little technology with your art?

- ☐ Photographer
- ☐ Forensic artist
- ☐ Police artist
- ☐ Dinnerware design
- ☐ Industrial design
- ☐ Technical drawing
- ☐ Car design
- ☐ Toy designer
- ☐ Animation
- ☐ App designer

- ☐ Graphic designer
- ☐ Medical illustrator

Do you like a bit of science with your art?

- ☐ Dyer
- ☐ Forensic artist
- ☐ Police artist
- ☐ Conservator
- ☐ Illustrator, zoo
- ☐ App designer
- ☐ Botanical illustrator
- ☐ Medical illustrator

Do you like to work in 3-D?

- ☐ Model maker
- ☐ Jewelry designer
- ☐ Makeup artist
- ☐ Wig designer
- ☐ Mask maker
- ☐ Blacksmith
- ☐ Puppet maker
- ☐ Luthier
- ☐ Milliner
- ☐ Glass blower
- ☐ Stained glass artist
- ☐ Stone carver
- ☐ Furniture maker
- ☐ Clothing design
- ☐ Textile design
- ☐ Interior designer
- ☐ Package design
- ☐ Bookbinding
- ☐ Toy designer

- ☐ Graphic designer
- ☐ Costume painter
- ☐ Costume designer
- ☐ Display and exhibit designer
- ☐ Props maker

Do you like your artwork to be functional?

- ☐ Greeting card designer
- ☐ Mosaic artist
- ☐ Potter
- ☐ Dressmaker
- ☐ Rug designer
- ☐ Weaver
- ☐ Architect
- ☐ Woodcarver
- ☐ Visual aids artist
- ☐ Tool designer
- ☐ Sign painter
- ☐ Letterpress printmaker
- ☐ Jewelry designer
- ☐ Landscape artist
- ☐ Ceramic tile designer
- ☐ Makeup artist
- ☐ Wig designer
- ☐ Mask maker
- ☐ Interior designer
- ☐ Furniture painter
- ☐ Blacksmith
- ☐ Art quilter
- ☐ Fiber artist
- ☐ T-shirt designer/printer
- ☐ Forensic artist

- ☐ Police artist
- ☐ Luthier
- ☐ Milliner
- ☐ Glass blower
- ☐ Stained glass artist
- ☐ Stone carver
- ☐ Furniture maker
- ☐ Dinnerware design
- ☐ Industrial design
- ☐ Technical drawing
- ☐ Car design
- ☐ Clothing design
- ☐ Textile design
- ☐ Conservator
- ☐ Interior designer
- ☐ Package design
- ☐ Bookbinding
- ☐ Toy designer
- ☐ Craftsperson
- ☐ Illustrator, zoo
- ☐ Graphic designer
- ☐ Costume painter
- ☐ Costume designer
- ☐ Art teacher
- ☐ Art curator
- ☐ Display and exhibit designer
- ☐ Props maker
- ☐ Botanical illustrator
- ☐ Medical illustrator

© Tuula Kyrölä

Do you like to get physical with your work—feel like you are really working?

- ☐ Dyer
- ☐ Woodcarver
- ☐ Tool designer
- ☐ Blacksmith
- ☐ Glass blower
- ☐ Stone carver
- ☐ Furniture maker
- ☐ Sculptor/craftsperson
- ☐ Mosaic artist
- ☐ Easel painter

Do you like fixing things?

- ☐ Photo retoucher
- ☐ Art therapist
- ☐ Arts-in-healthcare worker
- ☐ Interior designer
- ☐ Furniture painter
- ☐ Luthier
- ☐ Conservator
- ☐ Bookbinding

Do you like a little narrative with your work?

- ☐ Book jacket designer
- ☐ Comic book inker
- ☐ Caricaturist
- ☐ Calligrapher
- ☐ Letterpress printmaker
- ☐ Photographer
- ☐ Puppet maker

- ☐ Graphic novelist
- ☐ Cartooning
- ☐ Greeting card designer
- ☐ Animation
- ☐ App designer

Do you like pop culture?
- ☐ Album cover designer (j-cards for CDs)
- ☐ Photographer
- ☐ Stamp designer
- ☐ T-shirt designer/printer
- ☐ Toy designer
- ☐ Cartooning
- ☐ Animation
- ☐ Greeting card designer
- ☐ App designer
- ☐ Graphic designer
- ☐ Costume designer

Do you like to work big?
- ☐ Diorama artist
- ☐ Sign painter
- ☐ Interior designer
- ☐ Furniture painter
- ☐ Muralist
- ☐ Blacksmith
- ☐ Conservator
- ☐ Sculptor/craftsperson
- ☐ Mosaic artist
- ☐ Costume painter
- ☐ Costume designer
- ☐ Display and exhibit designer
- ☐ Painter

Do you like to do tiny or meticulous work?
- ☐ Sculptor/craftsperson
- ☐ Mosaic artist
- ☐ Letterpress printmaker
- ☐ Model maker
- ☐ Jewelry designer
- ☐ Stamp designer
- ☐ Luthier
- ☐ Milliner
- ☐ Bookbinding
- ☐ Toy designer
- ☐ Cartooning
- ☐ Animation
- ☐ Botanical illustrator
- ☐ Medical illustrator
- ☐ Painter

Do you like fabric or sewing?
- ☐ Dyer
- ☐ Art quilter
- ☐ Fiber artist
- ☐ T-shirt designer/printer
- ☐ Puppet maker
- ☐ Milliner
- ☐ Clothing design
- ☐ Conservator
- ☐ Interior designer
- ☐ Bookbinding
- ☐ Costume painter
- ☐ Costume designer

Do you like to draw things?
- ☐ Animal portraits
- ☐ Portrait artist
- ☐ Stamp designer
- ☐ Forensic artist
- ☐ Police artist
- ☐ Drawing books, instructional books
- ☐ Graphic novelist
- ☐ Dinnerware design
- ☐ Industrial design
- ☐ Technical drawing
- ☐ Car design
- ☐ Toy designer
- ☐ Cartooning
- ☐ Animation
- ☐ Illustrator, zoo
- ☐ Greeting card designer
- ☐ Mosaic artist
- ☐ Graphic designer
- ☐ Costume painter
- ☐ Costume designer
- ☐ Display and exhibit designer
- ☐ Botanical illustrator
- ☐ Medical illustrator
- ☐ Painter

Do you like words?
- ☐ Calligrapher
- ☐ Letterpress printmaker
- ☐ Art critic
- ☐ Art historian

- ☐ Drawing books, instructional books
- ☐ Graphic novelist
- ☐ Animation
- ☐ Greeting card designer
- ☐ App designer
- ☐ Art teacher
- ☐ Art curator

Do you like to make things?
- ☐ Woodcarver
- ☐ Model maker
- ☐ Potter
- ☐ Jewelry designer
- ☐ Wig designer
- ☐ Mask maker
- ☐ Furniture painter
- ☐ Blacksmith
- ☐ Art quilter
- ☐ Fiber artist
- ☐ T-shirt designer/printer
- ☐ Retail—selling on Elsy
- ☐ Puppet maker
- ☐ Luthier
- ☐ Milliner
- ☐ Glass blower
- ☐ Stained glass artist
- ☐ Stone carver
- ☐ Furniture maker
- ☐ Toy designer
- ☐ Sculptor/craftsperson
- ☐ Greeting card designer

- ☐ Mosaic artist
- ☐ Costume painter
- ☐ Costume designer
- ☐ Props maker

Do you like organizing spaces?
- ☐ Architect
- ☐ Muralist
- ☐ Industrial design
- ☐ Car design
- ☐ Interior designer
- ☐ Display and exhibit designer

Do you like color?
- ☐ Dyer
- ☐ Color consultant
- ☐ Furniture painter
- ☐ Glass blower
- ☐ Stained glass artist
- ☐ Illustrator, zoo
- ☐ Photographer
- ☐ Ceramic tile designer
- ☐ Make-up artist
- ☐ Wig designer
- ☐ Interior designer
- ☐ Muralist
- ☐ Art quilter
- ☐ Fiber artist
- ☐ T-shirt designer/printer
- ☐ Dinnerware design
- ☐ Clothing design
- ☐ Textile design
- ☐ Package design

- ☐ Toy designer
- ☐ Cartooning
- ☐ Animation
- ☐ Greeting card designer
- ☐ Mosaic artist
- ☐ App designer
- ☐ Graphic designer
- ☐ Costume painter
- ☐ Costume designer
- ☐ Botanical illustrator
- ☐ Painter

Do you like black and white?
- ☐ Photographer
- ☐ Illustrator, zoo
- ☐ Greeting card designer
- ☐ Mosaic artist
- ☐ Botanical illustrator
- ☐ Medical illustrator
- ☐ Technical drawing
- ☐ Painter

Do you like to think about/talk about art?
- ☐ Docent
- ☐ Art critic
- ☐ Art historian
- ☐ Art teacher
- ☐ Art curator

Do you like to write about art?
- ☐ Art critic
- ☐ Art historian
- ☐ Art teacher
- ☐ Art curator

Do you like solving problems?

- [] Visual aids artist
- [] Dyer
- [] Tool designer
- [] Letterpress printmaker
- [] Art therapist
- [] Arts-in-healthcare worker
- [] Make-up artist
- [] Wig designer
- [] Mask maker
- [] Interior designer
- [] Muralist
- [] Blacksmith
- [] Forensic artist
- [] Police artist
- [] Luthier
- [] Milliner
- [] Dinnerware design
- [] Industrial design
- [] Technical drawing
- [] Car design
- [] Clothing design
- [] Textile design
- [] Conservator
- [] Package design
- [] Bookbinding
- [] Toy designer
- [] Cartooning
- [] Animation
- [] Sculptor/craftsperson

- [] Mosaic artist
- [] App designer
- [] Graphic designer
- [] Costume painter
- [] Costume designer
- [] Art teacher
- [] Art curator
- [] Display and exhibit designer
- [] Props maker
- [] Painter

Do you like animals?

- [] Animal portraits
- [] Toy designer
- [] Cartooning
- [] Animation
- [] Illustrator, zoo
- [] Greeting card designer
- [] Mosaic artist

Do you like printmaking?

- [] Lithographer
- [] Letterpress printmaker
- [] T-shirt designer/printer

Do you like to laugh?

- [] Caricaturist
- [] Toy designer
- [] Cartooning
- [] Animation
- [] Art teacher

Do you like to work with others?

- [] Letterpress printmaker
- [] Model maker
- [] Landscape artist
- [] Art therapist
- [] Arts-in-healthcare worker
- [] Portrait artist
- [] Make-up artist
- [] Wig designer
- [] Mask maker
- [] Interior designer
- [] Muralist
- [] Forensic Artist
- [] Police Artist
- [] Drawing Books, Instructional Books
- [] Dinnerware Design
- [] Industrial Design
- [] Technical Drawing
- [] Car Design
- [] Toy Designer
- [] Cartooning
- [] Animation
- [] Sculptor/Crafts person
- [] Illustrator, Zoo

- [] Greeting Card Designer
- [] Mosaic Artist
- [] Art teacher
- [] Art Curator
- [] App Designer
- [] Graphic Designer
- [] Costume Painter
- [] Costume Designer
- [] Display and Exhibit Designer
- [] Props maker
- [] Botanical Illustrator
- [] Medical Illustrator

Do you like to work alone?

- [] Letterpress printmaker
- [] Retail—selling on Etsy
- [] Blacksmith
- [] Graphic Novelist
- [] Sculptor/Crafts person
- [] App Designer
- [] Botanical Illustrator
- [] Medical Illustrator
- [] Painter

INTERVIEW: MICHAEL BENDELE, ARCHITECTURAL BLACKSMITH

Michael Bendele is an architectural blacksmith whose work appears in private and public collections and installations throughout the United States. He works with iron, copper, brass and bronze, creating everything from decorative bowls to a one-ton chandelier for a museum.

How would you describe what you do?

It has always been difficult for me to describe what I do to anyone who is not familiar with my work. I am a blacksmith but much of my work is in copper, brass or bronze. I work directly and deliberately with metal, heating, hammering and bending to create form.

What training do you have? What paths did you follow to get to do what you do?

When I started there was nowhere to go to study how to or why to forge iron. There was, though, a lot of existing work that, when studied, revealed the possibilities and that led to the intrigue. Iron is cold lifeless thing but with practiced heating and hammering it can be brought to life. I think that my path has been an ongoing exploration of this juxtaposition.

Did you always want to be an artist? Or did it evolve from something else?

I have always been drawn to tangible objects that are well crafted, tell a story, or on some level engage the imagination. Finishing a piece or project that has taken a long time to make or develop is briefly like discovering an ancient relic.

Do you have an art-making practice that is separate from what you do for a living?

I am fortunate that my work overall has become a way of life. The large majority of my work is sold before I make it, so I have always incorporated experimentation within each project.

The Great Doors, Michael Bendele
Copper repousse doors, Saint John the Baptist Evangelical Catholic Church, Delphos, Ohio
Among many projects created in his thirty years of experience, Michael designed and fabricated these copper repousse doors, forged a bench for the Ohio Governor's Residence in Columbus, Ohio, created a repousse relief sculpture for the library in Delphos, Ohio, and chairs for the "Chair Forms" exhibit at the Ohio Craft Museum.

How do you balance the business of art with art-making?

The business of art is what pushes me into the studio every day, but once I get there I am usually only concerned with the doing.

How much time do you devote to art business (correspondence, emails, marketing yourself) each week?

My current approach to promotion, if you can call it that, is simply to continue to do good work and build solid relationships. I have a website, of course, as everyone does, but I view it more as a tool to more easily share with prospective clients who may not be as familiar with my work overall. The contact comes first and then the referral to the website, not the other way around.

I am sure that I spend on average a solid fifteen hours a week communicating with architects, designers and homeowners. Every ongoing or prospective commission is different though. Even the time spent interacting with committees can vary greatly. Some projects of the same relative size may take several months of meetings with one committee, while another with a different committee may only require one meeting to achieve the same result.

Giving the proper balance of time to both the business of art and the making of it is critical. You cannot have one without the other. I will say though, that while taking care of the business part, I constantly feel I should hurry up and get to work on the art-making part. The opposite is rarely true.

Generally, I have enough, or more, work than I can do in a reasonable time frame. I think some of the reason for this is just being around long enough to have credibility—or it might just be the gray hair!

What keeps you motivated? Where do you go, what do you do to get inspired?

Books, a little traveling, looking to nature are all good for rejuvenation and inspiration. It seems like the best ideas, though, come while I am in the studio or shortly after, or just before.

What advice would you give to an artist starting out?

Start from the beginning doing your work, your way. Don't start with a compromise approach until you "get recognized". As artists we get recognized for what we do, not what we wish we were doing. This makes starting hard, but you will slowly feel you are getting somewhere.

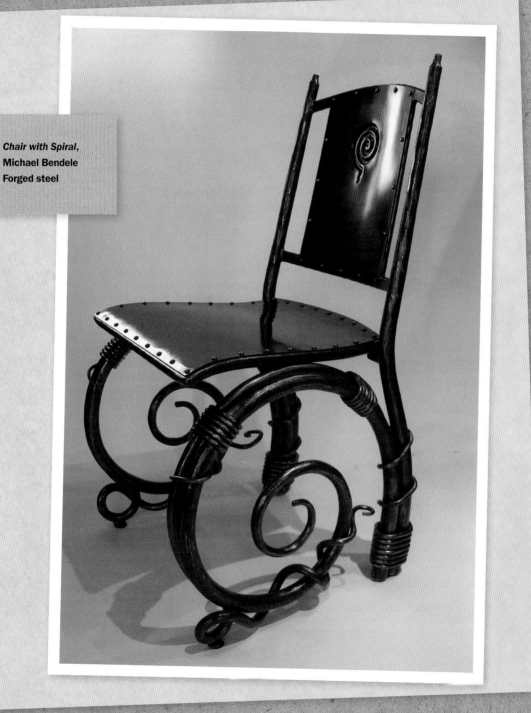

Chair with Spiral,
Michael Bendele
Forged steel

GENERAL JOB DESCRIPTIONS

Here is a more comprehensive list of some interesting art jobs and their descriptions:

Album Cover Designer

An album cover designer is a kind of graphic artist who combines type and imagery to decorate the packaging of a CD.

Animal Portrait Artist

An animal portrait artist paints portraits of pets, race horses, prize bulls, etc., for animal enthusiasts.

Animator

An animator makes still drawings come to life by drawing sequences of movement, either by hand, with a computer or both. Animators work for film, television and video games.

There are multiple kinds of animation artists, including layout artists who design background and lighting for an animated film, background artists who paint the scenery, and storyboard artists who draw action panels that are used as a map for the whole film.

App Designer

An app designer designs applications for handheld devices, such as the iPad and iPhone.

Architect

An architect designs and plans interior and exterior space, and oversees construction of buildings.

Art Critic

An art critic uses a knowledge of art history and aesthetics to evaluate visual art, usually for print media.

Art Curator

An art curator makes decisions about the objects in a collection: what to acquire, how to care for the objects, how to present them, often for an institutional setting.

Art Historian

An art historian studies art in historical context, observing style development and making comparative analyses.

Artist Blacksmith

An artist blacksmith uses traditional means of forging metals, combined with some engineering know-how and aesthetic sense, to make sculpture or functional artwork such as furniture, gates and jewelry. (See Michael Bendele interview, chapter 6.)

Artist Metalworker

An artist metalworker designs and makes objects out of metal, such as teapots, lighting fixtures, bowls, jewelry and sculpture.

Arts-in-Healthcare Artist

An arts-in-healthcare artist may or may not have a medical or social-work degree, but uses art-making of all sorts in hospital and outpatient settings as a tool for healing.

Art Teacher

An art teacher teaches art to children and adults—in schools, institutions and private settings. (See Catherine Redmond and Ardis Macaulay interviews, chapter 7.)

Art Therapist

An art therapist combines traditional psycho-therapy techniques with the use of various art materials for emotional and psychological understanding and healing.

Author, Drawing Books, Instructional Books

An artist can also be an author of how-to books, describing step-by-step methods for making art.

Bookbinder

A bookbinder assembles sheets of paper into a text block and attaches covers. Bookbinders can also build boxes and make alternative structures, such as scrolls or accordion-fold books, to suit the message contained within the pages to be bound.

Book Jacket Designer

A book jacket designer is a kind of graphic artist who combines type and imagery to decorate the packaging of a book.

Botanical Illustrator

A botanical illustrator makes technical drawings and paintings of plants, with attention to minute scientific detail—often for use in study and educating the public.

Calligrapher

A calligrapher uses traditional techniques and special pens to do fancy lettering for invitations, decorated marriage certificates, special-event memorabilia, and also for book arts and fine art.

Car Design

A car designer combines art and science to make usable, ergonomic and aesthetically pleasing vehicles.

Caricaturist

A caricaturist draws portraits (sometimes of celebrities) for retail or print media where the subject's distinguishing features—crooked nose, beady eyes, large ears, etc.—are emphasized or enhanced for the sake of humor or editorialization.

Cartoonist

A cartoonist draws cartoons for print media.

Ceramic Tile Designer

A ceramic tile designer designs tiles for manufacture, or paints and fires ceramic tiles for use in interior design or artwork.

Children's Book Illustrator

A children's book illustrator provides drawn, painted or printed imagery that corresponds, enhances or explains text in a children's book. Sometimes the illustration exists without text, but almost always involves narrative. (See Jennifer Sattler interview, chapter 4.)

Clothing Designer

A clothing or fashion designer conceives of the shape, drape, color and movement of garments, shoes and other accessories.

Color Consultant

A color consultant chooses combinations of colors for interiors, homes and fashion, suiting palettes to situations or personalities. They also can predict color trends for manufacturers.

Comic-Book Artist

A comic-book artist draws in pencil what a comic page should look like, sketching in action and arranging the page prior to passing it on to an inker.

Comic-Book Inker

A comic-book inker goes over the comic-book artist's lines with ink, adding drama with line weight variation and texture.

Conservator

A conservator is an artist who does historic preservation of artworks, murals, fabric, painted furniture and objects. They clean, preserve and protect the work without changing its essence.

Costume Painter

A costume painter paints fabric for costumes to realize a specific effect on a costume designer's sketch—such as fur, feathers, a kimono with a peacock on the back, graphic cartooning on street clothes or aging a war-

rior who has been in a terrific battle. (See Advice from Virginia Clow, chapter 1 and About the Author.)

Costume Designer

A costume designer designs, draws, plans and organizes what people wear for film, television, theater, dance and the circus.

Courtroom Sketch Artist

A courtroom sketch artist draws to depict the action and individuals in a courtroom where cameras are not permitted.

Dinnerware Design

A dinnerware designer plans the sculptural, color and pattern appearance of plates, bowls, cups and flatware.

Diorama Artist

A diorama artist paints murals behind a three-dimensional scene, such as in a natural history museum or a zoo.

Display and Exhibit Designer

A display and exhibit designer designs and draws displays for conventions, museums, in-store marketing and showrooms.

Docent

A docent is a tour guide at a museum.

Dressmaker

A dressmaker designs and drapes fabric to make dresses for fashion, theater, film, television or retail sale.

Dyer

A dyer dyes fabrics, yarns, beads, plastics and other materials for theater, fashion houses for sample-making, for interior designers, or materials for fine arts.

Embroiderer

An embroiderer adds texture or imagery to fabric using needle and colored thread. Embroiderers work with clothing designers, theater, film and television, as well as to create fiber-art works.

Fiber Artist

A fiber artist uses textiles and other natural and synthetic fibers to make artwork: paintings, sculptures, hangings, art quilts. They can use traditional means of manipulating fibers, such as sewing, weaving, knitting and painting, and combine them with innovative techniques and fibers. (See Joanie San Chirico interview, chapter 3.)

Forensic Artist

A forensic artist combines visual skills with medical knowledge and works with law

enforcement to identify missing persons or remains, or to apprehend criminals. Forensic artists can do age modification of an individual from a photograph and postmortem facial reconstruction from a skull, either by hand or aided by a computer.

Furniture Maker
A furniture maker combines engineering, visual skill and knowledge of a variety of materials, to make ergonomic and aesthetically pleasing furniture—beds, chairs, tables.

Furniture Painter
A furniture painter prepares and paints furniture for retail sales or for an interior designer. They can do faux finishes, aging, pickling, textural finishes or whimsical imagery.

Glassblower
A glassblower blows air into molten glass through a long blowpipe to form vessels or sculpture.

Graphic Designer
A graphic designer puts together images and type to make a design for print, advertising, brochures and logos. (See Margaret Janik interview, chapter 2.)

Graphic Novelist
A graphic novelist is a cartoonist and writer whose cartoons realize a narrative in a novel-length form. (See GB Tran interview, chapter 4.)

Greeting Card Designer
A greeting card designer is a graphic designer who uses imagery, type and paper technology (pop-ups, for example) to plan greeting cards.

Illustrator
An illustrator provides drawn, painted or printed imagery that corresponds, enhances or explains text. Sometimes illustration exists without text but almost always involves narrative. (See Marshall Arisman interview, chapter 5.)

Industrial Design
An industrial designer combines art and science to make usable, ergonomic and aesthetically pleasing objects or environments.

Interior Designer
An interior designer pulls together color, light, space and furniture to plan the appearance and funtionality of an interior space, like a home or office.

Jeweler, Jewelry Designer

A jewelry designer uses a variety of traditional and nontraditional materials and techniques to design ornament (bracelets, necklaces, rings) for manufacture, or to make one-of-a-kind ornaments for sale.

Letterpress Printmaker

A letterpress printmaker uses traditional methods to set metal type by hand to print fine-art books, artworks, and also wedding invitations, stationery and limited-edition chapbooks.

Luthier

A luthier makes and repairs stringed instruments.

Makeup Artist

A makeup artist designs enhancing or disguising effects with make up to apply to a human for theater, film, television or print media, sometimes designing and building prosthetics, too.

Mask Maker

A mask maker designs face coverings for theater, film, television or print media, or for sale as artwork, using a variety of materials and techniques.

Medical Illustrator

A medical illustrator draws the human body and parts of the human body with scientific attention and super-real detail, often as cutaways to show inside the body. The medical illustrator can help us imagine what a computer might not be able to—such as imagining a trip through the circulatory system.

Milliner

A milliner makes hats—designs and builds the base structures to conform to a human head, and trims them for sale or for theater and film.

Model Maker

A model maker combines engineering and visual skills to make a three-dimensional representation of a design.

Mosaic Artist

A mosaic artist makes pictures with pieces of glass, ceramic and tile. The work can be small, like a handheld bowl or box, or large, such as a kitchen backsplash or an MTA subway platform installation.

Muralist

A muralist designs and paints on a large, usually permanent surface. A muralist is

also sometimes called an interior decorative painter, and can execute faux finishes on interior surfaces such as walls, furniture, stairs and floors. (See Parmelee Welles Tolkan interview, chapter 1.)

Package Designer

A package designer combines engineering with visual art to create enclosures for objects for distribution, sales or shipping.

Painter

A painter is an artist who applies paint to a surface. Paintings may be representational, such as a landscape or portrait, abstract, narrative and political. Painters are engaged not just in covering a surface with paint, but also in the act of expressing emotion or content that is not sayable in words. Painters may paint for a gallery (retail) or on commission. (See Jeanne Gentry Keck and Catherine Redmond interviews, chapters 3 and 7.)

Photographer

A photographer takes pictures with a camera for use in print media, as artwork, for portraiture, for recording of events and for news.

Photo Retoucher

A photo retoucher alters photos with a computer, airbrush or brushes to alter the appearance of a photograph, to enhance photographs for print media or to disguise flaws in a photograph. Photo retouchers also sometimes do photo conservation.

Police Sketch Artist

A police sketch artist draws or paints an eyewitness' memory of a face.

Potter

A potter is someone who makes pottery, usually from clay. A potter can make functional objects, sculptural vessels or relief sculpture for retail sale or to be replicated for mass manufacture.

Printmaker

A printmaker uses traditional techniques, such as lithography, woodcuts, silkscreening and etching, to print images on paper or fabric. Printmakers can print their own images for sale, or work with other artists to realize their designs/images in print form. (See April Vollmer and Annie Sessler interviews, chapters 2 and 6.)

Props Maker

A props maker makes objects, such as masks, models, weapons, body parts, fake food and animatronic animals for film, commercials and theater. (I once spent a week making

lemons with chicken feet for a dish soap commercial. The hardest thing was figuring out how to get the texture of a real lemon onto the plastic lemons!)

Puppet Maker

A puppet maker combines a variety of materials to make animated creatures or figures for use in theater, film and television, or for sale.

Rug Designer

A rug designer designs texture, imagery and colors for floor covering for manufacture.

Scenic Artist

A scenic artist paints backdrops, scenery and other objects or elements for theater, television and film, working from a set designer's paint elevations.

Set Designer

A set designer designs the place where action takes place for theater, film and television, using a combination of engineering skills and visual and narrative sense.

Sign Maker/Sign Painter

A sign maker uses a variety of materials (plastic, wood, light, paint, vinyl cutting, printing) to make signage for businesses, display and film.

Stained Glass Artist

A stained glass artist combines pieces of colored glass into a design that is held together in a rigid metal or wood frame. Sometimes an artist will paint on the glass, and the paint and glass are fused together in a kiln. Stained glass is traditionally used for windows, but can also be used for smaller artworks.

Stamp Designer

A graphic designer who arranges images and type in the design of postage stamps.

Stone Carver

A stone carver shapes images, designs, creatures and architectural ornament by the process of removing stone from a natural block of stone.

Technical Draftsman

A technical draftsman does technical drawings to aid in building and manufacturing.

Textile Designer

A textile designer paints or draws what fabric will look like: whether it is a print, a woven Jaiquard or a tonal weaving. This used to all be done by hand as paintings on paper, but now is done almost exclusively on computers.

Toy Designer

A toy designer draws plans, builds physical or computer models to imagine how a toy is played with and manufactured.

T-shirt Designer/Printer

A T-shirt designer is a kind of graphic designer who combines images and/or text for printing on a T-shirt. T-shirt designers can also silkscreen their own shirts, as well as altering the base by dyeing, shredding or cutting.

Weaver

A weaver is a person who weaves fabric.

Wig Designer

A wig designer designs hair for a human head for theater, film, television and print media, using a variety of materials, including real and synthetic fibers, and latex.

Woodcarver

A woodcarver uses traditional tools and machines to take away wood from an existing block of wood to make functional items such as furniture, architectural detail, vessels, or to make sculpture.

Zoological Illustrator

A zoological illustrator makes technical drawings of animals and insects.

YOU, YES YOU!

As a younger artist, I looked at what successful artists did—their artwork, their art book, their illustrations—and I thought, "If I could just do that, I would be successful, too!" And I spent a lot of time doing imitative work. I think that when you imitate, you learn, so the time was not wasted totally.

But what I have learned about successful artists since that time is this: Everyone who has a success story has found a way to make art that is deeply meaningful to them. That, in turn, affects and moves other people. They did not try to figure out what moved other people first, and then make their art to suit that market. I have never come across an exception to this.

It is you—the combination of experiences, genetic material, interests and loves that makes you who you are—that will drive your successful art life.

WORDS OF WISDOM

"Choose a job you love and you will never have to work a day in your life."
—*unknown*

"It's not written anywhere that an artist should starve."
—*Bob Ragland*

"Every man is the architect of his own fortune."
—*Appius Claudius Caecus*

"I've learned that making a 'living' is not the same thing as making a 'life.' "
—*Maya Angelou*

7 GETTING TO WORK

Your studio is your place of process, solace, and personal discoveries from the discouraging to the triumphant. It is a place to keep your stuff, to have adventures, to have *a space of your own*. It can be a table in your apartment or the loft floor of your converted barn. But the bottom line is this: You need to have a studio.

None of the art-making you want to do can happen without an art-making space. Making art requires a place to work, and some ways to prioritize your life so that making artwork is a daily part of that life. Without personal space and a clear inner sense of priority, family responsibilities and work commitments can sometimes push art-making to the wayside.

In this chapter, we will find space and time for you to work on your art. Even if you have an art-related job, carving out space in your life for your own personal exploration is crucial to your growth as an artist.

Genii, Margaret Peot
India ink and colored pencil on Rives BFK
22" × 30" (56cm × 76cm)
I have made and drawn into hundreds of inkblots since I learned how to do it in high school. It is a method I have used for years to jump-start creativity. My book, *Inkblot: Drip, Splat and Squish Your Way to Creativity* (an art technique and creativity book for ages ten to one hundred) was born out of these many inkblots. If you have a particular expertise, you might consider writing a book about it that describes the history of the technique, or perhaps a how-to instruction book.

SKETCHBOOK

For your first step in making a space to work, consider buying a sketchbook. It can be your portable studio. Write everything in it—ideas for projects, to-do lists (even if they aren't art-related), drawing, doodles, etc. Date the pages. All of the things you write will remind you of where you were when you did the drawings, and had the ideas within. Soon you will have a library full of ideas, and you will have become accustomed to writing stuff down—creating in a particular place.

Your sketchbook should be small enough to carry with you in your backpack or shoulder bag, but not so small that there is no room for your ideas—say, not any smaller than 6" × 8" (15cm × 20cm). It should have white or off-white pages, preferably unlined, and lay flat by itself when open. It should say "acid-free" or "archival" somewhere on it. Otherwise, the pages can yellow, become brittle in a short period of time and deteriorate. (Think of a not-so-old newspaper.)

Stick your sketchbook in your bag along with a zippered pencil case that contains a couple of pencils, an eraser, three colored pencils and a pen. (Many gel pens will be labeled as "fade-free" or "acid-free." This is what you want to use.)

When you have a sketchbook, your studio is everywhere—the dentist's office, your car, your kid's soccer practice, the subway, the bus. And all that nebulous, in-between time spent waiting becomes pure gold.

> "When you have a sketchbook, your studio is everywhere…"

A PLACE TO WORK

A studio can be many things. The kind of art you want to be engaged in will determine the kind of studio you need to have. If you are a muralist, you need a place big enough to do paint elevations and also samples of techniques to show your clients. If you are a glass blower or blacksmith and don't have a place to do this in your one-bedroom apartment, you will have to seek space to work elsewhere, at a university or local club. If you are an animator, maybe you just need a computer on a desk.

Your ideal studio space should be a place where you can leave a mess and come back to it the next day (you should not have to clean up your studio in order to serve dinner there). It can be quite small. You can even convert a closet in your house into a studio with lights, built-in shelves and a worktable. (You can make a worktable from a hollow-core door set on bricks.) You need good light and a place to store materials.

Finally, it is nice to have a place where you can pin up work to look at it, work on it, be with it. You can buy a bulletin board cheaply, or you can mount a 4" × 4" (10cm × 10cm) piece of Homosote wall board on your wall and paint it white. You do not need an easel. The footprint of an easel tends to take up a lot of space.

WORDS OF WISDOM

"If we develop the notion of space fully and properly, we begin to find that there is no burden, no load.… We begin to realize that an extraordinary openness takes place in our lives—in the way we move, the way we eat, the way we sleep, and the way we create a work of art. Tremendous freedom takes place in that basic space. Such freedom is not a product of the creation of art; it is preproduction freedom.… Before we produce anything at all, we have to have a sense of free and open space with no obstacles of any kind."

—Chögyam Trungpa,
True Perception: The Path of Dharma Art

WORKSHEET: YOUR IDEAL STUDIO

Every artist has different needs. You might be exploring a medium that needs ventilation, huge space, fire, a kiln, lots of outlets for sewing machines or Dremels, or perhaps very bright light.

The following questions will help you figure out exactly what your perfect studio might be and how to have it. Answer the questions as if you had no constraints at all—of time, money or other.

What do you make, or want to make?_____

What tools and materials do you need to do this?_____

What kind of worktable do you need? How high should it be? Do you work sitting or standing?

What shelving or storage do you need? _____

© Barry Weatherall,
widdesign

What kind of light do you want? Track lights, magnifying lights, fluorescent light...?

What special requirements does your work present? Do you need machinery, a kiln, extra outlets?

Do you want to work in your home? Can you? Or do you have to have a space outside the home?

Now that you have answered the questions, go through your responses, and beside each item that you have listed, put the approximate cost. If the figure is too high for your budget at the moment, go through the answers with a different color pen and prioritize what you need—1, 2, 3. How much would your minimum requirements cost? How are you going to set this up? Once you start figuring out exactly what you need and want, it will be easier to obtain.

© Sarah Vaughan

INTERVIEW: CATHERINE REDMOND, PAINTER

Painter Catherine Redmond is a New York artist living and working in the Garment District in midtown Manhattan. She has devoted herself to formal queries into the tensions and unexpected adhesions between the internal and the external psychic stage. "Whether it has the appearance of the city or the simulation of the interior, this is where it all plays out, all the dramas," she acknowledges. Catherine's work has been shown extensively in galleries and museums across the country. Her work is in public and private collections internationally and in the United States.

Did you always want to be an artist?

I always knew I was an artist but I didn't always want to be one. I drew on the sheets and on the walls as a kid, and got spanked for the wall drawings, but was fully encouraged otherwise, and it seemed completely natural to me to make things. But, I found it more of a burden than anything during a certain period in adolescence. I wanted to do something else that would be rational. I wanted to be a musician (no talent), a scientist (a mote of talent), and I went through a period where I wanted to be anything but an artist. I hated the idea that my destiny had already been determined.

What training do you have? What path did you follow to get to do what you do for a living?

There is nothing remarkable about my training—a BA in literature from Harpur College, SUNY Binghamton, while taking all the studio courses available to me, and five years of intensive study in painting and drawing at The Art Students League of New York, an atelier system that was perfect for my needs. I waited a few years after college to go to art school, so by the time I began I was hungry and ready.

Now there is background to this: I started out at Cornell in industrial and labor relations because I thought I wanted to be a labor mediator. I had graduated from a small

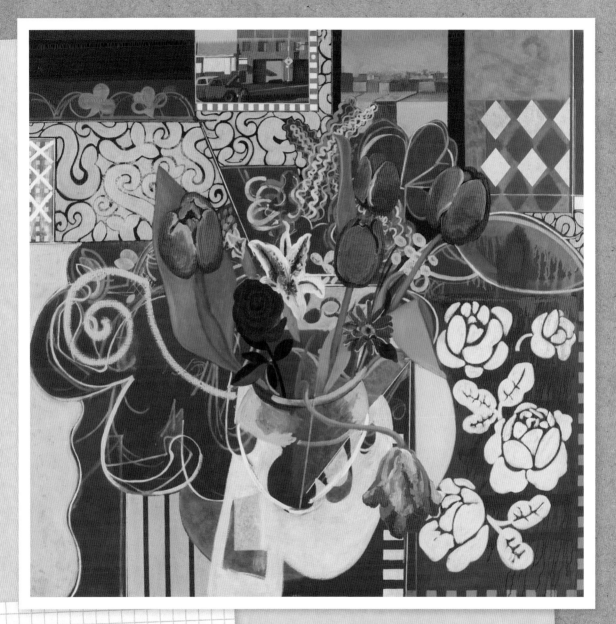

Easy Street, Catherine Redmond
Oil on canvas, 60" × 60" (152cm × 152cm)

centralized school district in Western New York State where college preparation and guidance were minimal. I only applied to one school and it was to the Cornell program because they only took ten women out of 150 total (a very bad reason to apply), and because I liked the way factories looked (almost as bad a reason, though with an obtuse logic I would later discover).

My maladaptive choice had a veiled truth that took me years to understand—both the quality of those glum factories and the challenge of mediation would be two important ideas in my future work. I was compelled by these but didn't translate my obsession into the direction where they found place until I started to paint seriously in a summer program at the Chautauqua Institution. I earned a full-time summer scholarship and studied with a former student of Gorky's. Everything changed.

So, my seeming error in picking the wrong major, having to face my mistake and pick up and go on—I flunked out of Cornell after the first year—was what actually set me on my path. Having lost my direction, feeling terrifically shamed, I had to wake up.

After art school I did various things—a guilder's apprentice, a long stint as a temp manuscript typist in offices all over Manhattan, working on the main floor of Saks at Christmas. I had many odd jobs. I wrote for people, did editing now and then, and conducted private workshops in my studio and out on the land. I consulted to people who were creatively blocked. I taught in summer programs on the street in poor neighborhoods. I taught in a community college in Vermont and as an artist-in-residence for the Vermont Council on the Arts. I taught in art schools, in Cleveland and then in New York. But, I never taught more than two days a week so my time was reserved for the studio. And I never had enough money.

I also never viewed painting as a way that I could support myself. It is a calling, and I did it because I had no choice. It didn't particularly bother me that it was this way and I remain amused that so many think that the marketplace is anything but a place where wares are bought and sold and where the requirements enforce certain conditions on the product.

I just looked around when I was in art school in the '70s and it was obvious that with very rare exceptions, few living painters were able to support themselves consistently from sales alone year after year.

Everyone did something else. There are notable exceptions that we read about, but they were statistically so rare that it didn't appeal to me to gear myself for a life I didn't want. All of us have some very good years and

many lean ones. Some years one sells a lot of work and then another year sales fall. I wanted freedom more than I wanted money. I wanted freedom to paint what I wanted without any constraint. And I most certainly didn't want to feel the need to have a branded product with a look so simplified that it was recognizable by anything other than my vision.

My work, my studio is the place where I felt completely free. I wanted nothing to hamper that. This is not the luxury that it sounds. The right conditions for an artist are highly individual and there is no size that fits all. The test is how it makes one feel. If it helps the work, it's the right way; if not, one reassesses and makes changes.

Does teaching inform your art work?

No, it's the other way around. My work informs my teaching. I would have nothing to say to my students if I weren't in the studio wrestling with the same problems of turning materials into transporters of meaning as they are starting to do. I have been very lucky in that my students are exceptional, always a little quirky and singular, and not surprisingly many have gone on to have professional lives. I hope that now and then I can turn on a light at a time they need it and that I can give back to them so they won't feel so alone on their paths.

How do you balance the business of art with art-making?

I don't fully engage the idea of the Business of Art. I am dutiful about keeping records but I have no illusions about my business acumen beyond basic sense. In fact, I am concerned that so much effort has been spent on giving young artists business information when they lack even the basic studio skills. The latter will be better long-term equipment than a course in how to create a package to submit to a gallery.

I am particularly against this because it demonstrates a profound loss of faith in Art itself. Art has the power to transcend the worst cover letter, the bleariest statement and the most ineptly formatted CV. If the work is good, if the work has power, if the viewer is compelled by what he sees, the trappings around it do not matter; whereas, no slick presentation will save a weak painting.

I suspect that one of the reasons there is so much institutional emphasis on this now is because it is easy to teach and gives the innocent a sense that this is the arcane knowledge that stands between him and success. The two are irreconcilable as they stand now—the gift of creation in a market ruled by fashion and commodity. Art is a transformation object the culture requires if it is to survive. As creators, our necessity must answer that need.

My focus is on the work and what goes on in my head and I have proceeded with trust that I will find a way through life following this. It is the template by which I have made all my decisions. If it's good for the work, it will be good for me. Until recently, circumstances were very difficult for me. Time and time again, I have had people appear in my life who helped me and guided me through difficult times so I could continue to paint. They have been other friends, artists, landlords, collectors, dealers and sometimes even strangers. There are helpers all along an artist's way and one must proceed with trust about the rightness of purpose. If you are on your path, the way will be cleared for you because you must return your gift.

However, one cannot be an artist without the willingness to sacrifice. Sacrifice comes in many guises. The best business practice is to do the best work you can possibly do and let others experience it. There is something inside us that knows the truth, the truth of our lives, and if we can still ourselves and listen, we will never make a mistake we can't right and will stay on our path.

How do you schedule your work day?
I wake up and walk Molly, make coffee, read the papers online, watch the news on TV and then begin to write. I usually write all morning—general writing, without fail, and correspondence/emails. I don't think of it as business so much as being in touch with others and myself. What is set in me is that I need to drop the words out of me before I start work in the studio. I read and I think.

After lunch I pick up a brush and start my painting and drawing. My earliest memory is drawing with my dog beside me with the radio on. So I repeat those circumstances and have either music playing or the TV news on because I like some sound that keeps my conscious mind occupied. Sometimes I see a friend for dinner or fix dinner for myself and go back to work until bedtime.

Was there a significant, life-changing thing that happened, or something someone said that you hold in your heart or remember while working in your studio?
In 1984 I left my marriage. What I did not know was that I was pregnant. Three weeks later, my beloved niece came to visit me. I was living fifteen minutes away from my downtown studio.

After a full day of work, we drove to my new apartment and ran up the stairs. The ectopic pregnancy ruptured, and I started to hemorrhage. I was going into shock—there in a place with an address unknown to my niece. My niece called the operator who found the

address, and shortly the EMS was there. Had she not decided to visit me, I would have been at work alone at that hour in an almost empty building downtown. As it was, what Jung called "the benign protective guardian" appeared in the person of my cool-headed niece.

I almost died twice in the ER, lost half my blood, and kept going in and out of consciousness. When they finally stabilized me enough to go into surgery, the surgeon appeared and took a quick history, then asked if I had any questions. And here is the point of my story: I knew I was dying because I recognized the way all those people around me were acting and yelling orders and running unit after unit of blood into me.

As we were about to go into the elevator, the surgeon asked me again if I had questions. I wanted to tell him that I had to live because I hadn't made enough paintings. There were so many paintings I needed to do. That was all I could think about. But, I didn't tell him. I thought that he wouldn't know what to say if a patient said that, and I didn't want to upset him before he started his work. I remember that moment every day of my life.

What keeps you motivated? Where do you go, what do you do to get inspired?

The life in the studio is my life so it's really the motivation to take the next breath. Making things and thinking about making things is always playing in the background, louder or softer, but always present. It isn't compartmentalized or complicated. It isn't inspiration, it's just doing a lot of work and being with it. Ideas sprout when they are welcome. Life experiences, music, reading, writing, a chance meeting of two colors in an odd configuration when I'm walking Molly or looking out the window—these are ways to move an idea around, but I don't think I think that way. I just do whatever keeps me interested.

What advice would you give to an artist starting out?

Know what makes you feel right. If you can get lost in it and feel yourself move into it, no matter how idiotic it may seem to others, how unfashionable, how embarrassed you feel, how out of step with the norm you are, then follow where it leads. Trust your muse. The sense of internal rightness is your guide in your work. Pay attention to that. It will never lead you astray. Otherwise, you will always be late, always living on second-hand information because you aren't brave enough to take the risk your voice demands.

MYSTERIOUS WAYS

The universe works in mysterious ways. When you decide exactly what you want, I think it makes a little magic in the air, somehow.

When I decided years ago that I was working too large for my apartment studio to bear, I started looking around for a studio outside the home. I knew what I wanted, and I could only spend $300 a month—pretty small potatoes. But as soon as I figured out what I needed, a friend of mine called up out of the blue and mentioned that he had a studio space in a building he was occupying and overseeing and did I want it? It was exactly the right size and price—low because it had no windows!

I moved my studio back home after my son was born. Later, I moved my home studio into a smaller space—my son's room after it got too small for him. My husband did the measurements for what wood he would need to craft me a built-in, L-shaped tabletop. The measurements had to be exact, as the room was a curious shape.

On the very same day he was going to order the lumber, my husband found all the wood he needed laying out on the street with the garbage. It was in a neat stack, clean, and painted off-white. But most importantly—he didn't have to cut it at all. The pieces were perfect, almost as if someone had cut them for us and delivered them.

So, make the list of what you need and open your heart and mind to the possibility of your studio being exactly how you would like it to be. It is attainable.

PROCRASTINATION

"Procrastinate" has its root in the Latin word *crastinus*, which means "belonging to tomorrow." Procrastination, as we all know, is putting off until tomorrow (or another time altogether) what we could or should do today. Or, filling time with something unimportant while an important task is left undone.

Why do we procrastinate? Sometimes procrastination is OK—we work on something fairly mindless like stretching canvasses or sorting socks while our creative subconscious turns a difficult problem around. But what about when the sorting socks takes over, and we never get to our studios to work? This is when procrastination can be debilitating. This kind of procrastination is when we are paralyzed with anxiety and can't move forwards or backwards.

When we have a task ahead of us that has no foreseeable structure or outcome; when there isn't a particular urgency or order in which tasks must be accomplished, nor length of time in which they must be completed, the anxiety that makes us procrastinate might occur.

Making art can feel like beginning a hike in unfamiliar and unmapped woods. We know we enjoy woods and walking, but are not sure where the various paths cross or diverge, how long of a walk we are going on, if there will be steep hills, or rain, or if we have the right shoes.

As an artist, you need to cultivate your willingness to step into an unknown process. Perhaps the greatest antidote to procrastination is the knowledge, based on repeated experience, that you can even go beyond merely tolerating not knowing to embracing it. You can actually look forward to the variables and unexpected things that will arise, plan or no plan, positive and negative alike. This is your home turf—no need to avoid it. Trust that you have all the tools you need.

"...cultivate your willingness to step into an unknown process."

MAKE TIME TO MAKE ART

There is time in your life to make your art without giving any of your responsibilities short shrift. If you can find a little time here, a little there, you might end up with an hour a day that you didn't know you had! Here are some ways to find a little extra time.

1. Turn off the television (or limit your television watching to your favorite shows, instead of using TV as your wind-down thing).

2. Limit your personal time online to a half an hour a day.

3. Check your personal email only once or twice a day.

4. After dinner, make a cup of tea and sit down to work, even if you are tired. Sometimes you will get a burst of energy you didn't know you had in you.

5. Get up an hour earlier in the morning. This will seem really hard at first, and then you will become adjusted to it, like a time change.

6. Do your family cooking on Sunday, so that the week is not filled with your scrambling to gather and prepare food.

7. Work in your sketchbook when you are not in your studio, making all those hours waiting for stuff to happen useful.

8. Don't answer the phone all the time. You can call anyone back.

9. Watch the clock to figure out how long things really take. If you are dreading emptying the dishwasher, and are using that as your excuse for not having time to work in your studio, time yourself doing it. It doesn't take as long as you think. When you know how long your daily tasks take to do, you will start to have a better sense of how much time you really have.

10. Write your studio time into your calendar.

FIDDLING AROUND

The wonderful writing teacher Brenda Ueland said in her book, *If You Want to Write*, "… the imagination needs idling,—long, inefficient, happy dawdling and puttering. These people who are always briskly doing something and are as busy as waltzing mice, have no slow, big ideas."

Schedule time to let yourself putter in your studio, and have confidence that it is time well spent. You will connect to that great river of lovely ideas that is running through you all the time. It was there when you were born and it doesn't ever go away or lessen. Just calm down and dip your toe in.

FIVE TIPS TO COMBAT PROCRASTINATION

1. Set a time to work with a beginning and end.

2. Set a goal for what you want to accomplish in the time you have allotted yourself—not a tight goal, but a loose one—"I want to look at my Walton Ford book," or "I want to trim some paper into squares."

3. Like Hemingway, who would often leave a sentence half written when he left his writing table for the day, leave a bit of the task undone at the end of your time in your studio so that you have something to come back to.

4. Before you go to the studio, make a list of what you think you might need so lack of proper materials doesn't deter you.

5. Try to leave your studio with a joyful spirit. You are not in control of your feelings as they happen, of course. But if you practice leaving your studio in a positive frame of mind, you will be all the more likely to come back the next time.

INTERVIEW: ARDIS MACAULAY, ART THERAPIST, VISUAL ARTIST

Ardis Macaulay was a high school art teacher for twenty years, an art therapist in a psychiatric facility for troubled teens, an art and art therapy workshop facilitator, and a visual artist since she could hold a pencil. She has exhibited extensively. Her artwork, and indeed, her life, is influenced by her personal inquiry into the works of Carl Jung and through ongoing research of cross-cultural symbolism.

Did you always know you would be an artist?

Yes. When I was twelve years old, my mother enrolled me in at the Junior School of the Chicago Art Institute. I felt like I had arrived at my second home. I had similar feelings while reading books in the downtown branch of the Chicago Public Library. It was there that I discovered my first book on art therapy.

In the early '70s, a friend gave me the book, *Memories, Dreams, Reflections*, a biography on Swiss psychologist Carl Gustav Jung. I was inspired and read everything else of his I could. This led to many years of designing and presenting Jungian-based art workshops to art, psychology, religious and educational institutions.

What background and training have you had to pursue your careers?

I received a BA as a fine arts major, with K-12 art-teaching credentials from Saint Olaf College in 1969. It wasn't the art instruction per se, but instead the St. Olaf Honor Code that had the biggest impact on my artwork.

The Honor Code established that no matter what the course of study, no professor was to be present during an exam. Students signed a statement at the end of each test stating they had not cheated nor did they witness cheating by any fellow classmate.

The climate set forth by this code permeated the college's atmosphere. As art students, we were expected to do our best and push ourselves to discover our unique style of expression. That code has become an empowering, life-defining directive.

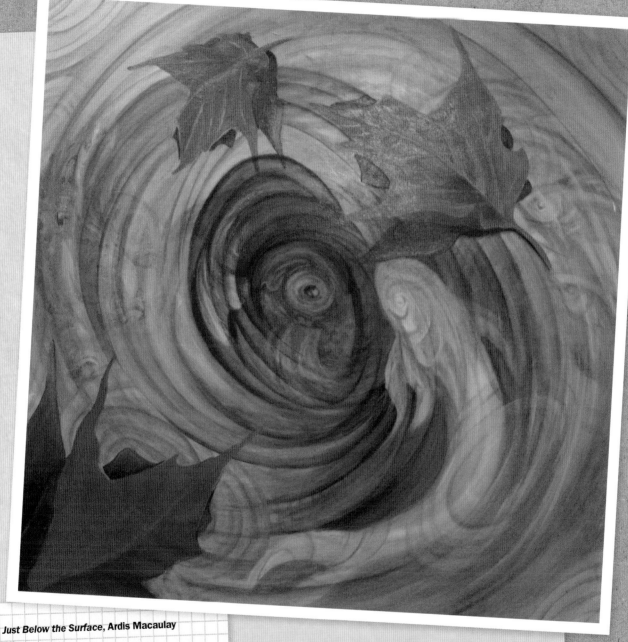

Just Below the Surface, Ardis Macaulay
Oil on canvas
34" x 34" (86cm x 86cm)

I received my masters of Art Therapy degree from Wright State University in 1983, and became a registered art therapist while working for Dartmouth Psychiatric Hospital in Kettering, Ohio.

What do you do to get inspired?

Carl Jung once said, "Your vision will become clear when you look into your heart. Who looks outside, dreams. Who looks inside, awakens."

I use process-oriented, active meditation drawing techniques to allow spontaneous imagery to flow. I use these techniques frequently to unearth archetypal symbols and energies. Images once hidden are now outside on paper or canvas.

Dream images is another potent method I turn to for integrating intuitive wisdom from my unconscious. Think of it this way: Not taking the time to decipher an important dream is like receiving a letter from your best friend and refusing to read it. The world of dreams provides rich imagery to investigate through drawing, painting, sculpting or photography.

How has your spiritual journey shaped your art?

Since early childhood my daydreams and night dreams have always been vivid. I discovered that drawing, painting, molding clay or carving were all ways to visually articulate an otherwise invisible interior world.

I was an only child of two working parents. Art-making emerged as my favorite pastime, as it turned my alone time into positive and productive explorations of inner aspects of "me, myself and I." (Remember, I was keeping myself company.) Early in life, I began using a sketchbook for visual journeying.

Trees were my first allies. I recall singing morning greetings to the large tree outside my bedroom window. The changing of the seasons prompted ongoing fantasy dialogues and adventures. In the summer my tree cloaked a leafy giant who appeared to reside there, in the winter bare branches revealed the structure of a marvelous horse.

My initial relationship with the trees led me to broaden my conversations to include intimate dialogues with the universe. As a child I saw myself included in the structure of this larger world and I knew I was not alone. This experience of inclusion in the universe has been the foundational filter of my life. By asking questions and requesting help from energies outside myself, I learned to make honest assessments of my sincere desires.

For example: I do not like to job hunt. I have always believed that jobs will just come to me, and this expectation has been realized over and over in my adult life. This was paired with the fact that I wasn't given an allowance for the multitude of household chores I was

responsible for as a child, nor did I receive a paycheck when I was old enough to work at the family store. I was expected to do these things as a contributing part of the family, to gain satisfaction from a "job well done."

I brought into adulthood the notion that if I pursued meaningful work, my alliance with the universe would provide me with a means of support. The paycheck was a side benefit.

What advice would you give to an artist starting out?

Do not be lulled into complacency and sleep-walk through your life. If you find yourself in a state of continual compromise in order to retain or obtain a certain "ideal" job, then you are not pursuing the right job! It belongs to someone else. Get yourself out of their way so they can be hired or advance. Then your real job during these periods is to dig deeper to uncover the inner guidance resonating within you, to find your true calling.

Ask yourself: What are the specifics that need to be present in my life/job? Take the time to formulate a visual image and an actual list of what is needed to create quality job/life experiences. A need to maintain an intrinsically balanced feeling during the day, for example, may require a pleasant drive or comfortable commute to and from work. A degree of autonomy on the job may be integral to your happiness. Honor that.

When you are awake and mentally show up, anything is possible. If you are following your inner compass, you will be filled with visions and daydreams of how to continue improving your skills. Personal experience has shown me that when I am following my inner compass, magical things happen—doors swing open, people and situations miraculously arrive, often without being asked. Life at its foundation is meant to be win-win. When you are following your inner compass your expectations will be realized. Focus on what is best for yourself and others and be prepared to be amazed!

I once gained surprising insight from an observation my son, Ian, shared with me. He had watched as I engaged in a social interaction where I was invited to join a group event. When I returned to him, I shared my surprise at the invitation. His response was, "I don't know why you were surprised. The energy that surrounded you while your were talking to them already expected inclusion." My energy? His comment stopped me in my tracks. I had to think about it for a moment, then concluded that he was right. The energy I brought to the discussion was expectant—my body posture, my responses and questions were all inclusive.

TEN FUN WAYS TO HELP YOU RECONNECT WITH YOUR INNER RIVER OF IDEAS

Just as muscles become stiff from not using them on a regular basis, so do our art-making "chops." Staying connected not only with our inner river, but also with our ability to be a reliable conduit of those ideas to a blank page, requires regular attendance in our studio. Sometimes we show up in the studio, and our left brain (who wants to see some meaningful activity, productivity and goals met in a timely manner) gets in the way of our flowing creative thoughts. Here are ten fun things to do to sidestep logic and reconnect with your inner river of ideas.

1. If you are accustomed to working at an easel or a table, sit on the floor in your studio and draw.

2. Look through art books, especially ones that don't relate to things you specifically make.

3. Set a task for yourself with rules, like make a tiny painting a day for one month. Let's also say the painting must be on paper, you can only use black-and-white media, and all the paintings must depict one kind of thing (flowers, rabbits, buildings). Something about rules can make for great freedom.

4. Do set-up—cut paper, organize your space, stretch a canvas, sort your pencils by color, or sharpen them.

5. Make a box for things that inspire you—photos, small objects, postcards, fabric, feathers, nuts and bolts. You can add and subtract from the box, but collecting these things into one spot is a creative, decisive act. And you can go through the box on other days to get inspired.

6. Mess up your paper before you start drawing or painting. Flick ink on it, soak it in tea and let it dry, dye it, splash coffee on it.

7. Draw or paint with your non-dominant hand.

8. Try taping a piece of paper on the floor, slip your brush into a bamboo stick (a florist shop staple), wrapping the join with tape to make it super secure. Then try doing ink-wash paintings with this long brush.

9. If you usually work tiny, work big. If you like to work big, try tiny.

10. Set time limits. Use a timer! If you have an hour in your studio, cut four pieces of paper to the same size, and fill them one by one, in fifteen-minute increments. Fill them with scribbles, blobs, writing, anything. Stop when the timer goes off.

FIVE RANDOM MARK-MAKING TECHNIQUES TO GET YOUR HANDS AND MIND CREATING

Now that you've reconnected with your inner river, try these fun mark-making techniques to get your creative juices flowing. (All of these are best done on a table that is protected, and you should wear an apron or old clothes.)

1. Inkblots: Drip ink and water on medium-weight paper, fold and unfold.

2. Mess up your paper: Wet a paper towel with water and ink or brown watercolor, and rub it into your medium-weight paper. Drip more water on it, puddle ink. Let it dry.

3. Lemon juice: Drip, spatter or paint lemon juice on paper and then bake it in the oven until golden brown.

4. Gouache resist: Paint white gouache on white heavy-weight paper. Let it dry, then coat the whole paper with India ink and let that dry. Now wash the paper under running water in the sink.

5. Wet an old feather duster with ink and water. Make splats and swooshes on large pieces of paper. Let it dry.

What do you see? What can you do with these things you have made? Cut them up? Mount them on canvas or wood? Draw into them? Print on them? Be creative!

NOW OFF YOU GO!

In the summer when I was a kid, I would put an apple in my pocket and go outside and play. The days were long and airy, the yard was whatever I could imagine it to be—Egypt, Mount Olympus, the Wild West—and I was anyone I wanted to be—Laura Ingalls, a goddess, a small mouse, a horse trainer. The summer stretched on into an infinity of languid, golden days, and if there were storms, they came from a long way off and you could see them coming. Anything was possible.

Even if that wasn't your particular experience growing up, take some of that summer child into your studio with you. Imagine flinging open the screen door, hearing it bang satisfyingly behind you, and step into that place of confident creativity. It's right there, waiting for you.

USEFUL ORGANIZATIONS

The following organizations provide artists with services, information, access to group health insurance, art-related jobs and other opportunities.

ARTSEARCH

The main go-to source for jobs in theater and stage arts.

> Theatre Communications Group
> 520 Eighth Ave., 24th Floor
> New York, NY 10018-4156
> (212) 609-5900
> www.tcg.org/artsearch

The Center for Book Arts

The Center for Book Arts offers over 100 classes and workshops in bookbinding, letterpress printing, paper marbling, typography and related fields. The Center has mounted over 140 exhibitions during the last thirty years. CBA also has an internship program, where you can work learning letterpress printing and bookbinding.

> 28 W. 27th St., 3rd Floor
> New York, NY 10001
> (212) 481-0295
> www.centerforthearts.com

College Art Association (CAA)

The College Art Association is a group founded in 1911 to promote excellence in teaching and study of the visual arts, design and art history. They publish a journal for scholarly writing about visual arts, criticism and writing by artists. They have a wonderful conference every year at which artists, scholars, teachers, writers, art publishers, designers and other arts professionals involved specifically in the visual arts can network and look for jobs.

> 50 Broadway, 21st Floor
> New York, NY 10004
> (212) 691-1051
> www.collegeart.org

EFA—The Elizabeth Foundation for the Arts

EFA Mission Statement: "EFA is dedicated to providing artists across all disciplines with space, tools and a cooperative forum for the development of individual practice. We are a catalyst for cultural growth, stimulating new interactions between artists, creative communities and the public." Also home and host to the Robert Blackburn Printmaking Workshop, a cooperative printmaking workspace.

> 323 W. 39th St., 3rd Floor
> New York, NY 10018
> (212) 563-5855
> www.efanyc.org

The Freelancers Union: Working Today

Working Today is a union whose sole purpose, is to provide low-cost healthcare to its members. As a prospective member, you have to prove, by a very rigorous standard, that you make a certain amount of money as a freelancer (working for yourself and not an employer, i.e., all of your income reported on 1099 forms to the government) over a set period of time. Then you can join the group in order to get group rates on healthcare.

> 20 Jay St., Suite 700
> Brooklyn, NY 11201
> (718) 532-1515
> www.freelancersunion.org

The Graphic Artists Guild

The Graphic Artists Guild is a national union of illustrators, designers, web creators, production artists, surface designers and other creatives who have come together to pursue common goals, share their experience, raise industry standards, and improve the ability of visual creators to achieve satisfying and rewarding careers. When you need information about copyright, contracts, industry pricing or trade practices, chances are you will turn to the Graphic Artists Guild's *Handbook of Pricing & Ethical Guidelines*.

> 32 Broadway, Suite 1114
> New York, NY 10004
> (212) 791-3400
> www.gag.org

International Print Center New York (IPCNY)

IPCNY is an organization devoted exclusively to the study and exhibition of fine-art prints. They host four shows of new prints per year, and provide educational programs for artists and collectors.

> 508 W. 26th St., Room 5A
> New York, NY 10001
> (212) 989-5090
> www.ipcny.org

Mid-Atlantic Arts Foundation

The Mid-Atlantic Arts Foundation provides access and information about arts resources in Delaware, the District of Columbia, Maryland, New Jersey, New York, Pennsylvania, Virginia, West Virginia and the U.S. Virgin Islands.

> 201 N. Charles St., Suite 401
> Baltimore, MD 21201
> (410) 539-6656
> www.midatlanticarts.org

National Art Education Association (NAEA)

A professional organization for visual arts educators, including elementary, middle and high school visual arts teachers, museum educators, college and university professors, and art education students.

> 1806 Robert Fulton Drive, Suite 300
> Reston, VA 20191
> (703) 860-8000
> www.arteducators.org

New York Foundation for the Arts (NYFA)

A New York institution that provides multiple resources for artists, including fellowships, job searches and business-of-arts articles.

> 20 Jay St., 7th Floor
> Brooklyn, NY 11201
> (212) 366-6900
> www.nyfa.org

The Pollock-Krasner Foundation, Inc.

The Pollock-Krasner Foundation was established by Lee Krasner, abstract expressionist painter and widow of painter Jackson Pollock, to help visual artists financially. Visual artists (for this grant, only painters, sculptors and printmakers) must show artistic merit and financial need.

The Pollock-Krasner Foundation
863 Park Avenue
New York, NY 10075
(212) 517-5400
www.pkf.org

Professional Artist

Professional Artist (formerly Art Calendar) is an organization that publishes a magazine for artists with interviews and articles on common practices, business planning for artists, and information on grants, residencies, art fairs, galleries representation, museums, conferences, techniques and more.

1500 Park Center Drive
Orlando, FL 32835
(407) 563-7000
www.professionalartistmag.com

Society for the Arts in Healthcare

An organization that works to provide arts (not art therapy, necessarily, but participation in arts), including visual arts, creative writing, dance and music to people who are chronically ill or disabled. They provide information about participating as an artist within a nonprofit organization, or about setting up a nonprofit organization to provide art experiences in an under served area.

2647 Connecticut Ave., NW, Suite 200
Washington, DC 20008
(202) 299-9770
www.thesah.org

Society for Illustrators

Information and career guidance for illustrators. They sponsor shows, book signings and educational events. They also have a tremendously successful Model Night once a month where people can hang out, draw from one or two nude models, and schmooze and network at the bar.

128 E. 63rd St., New York, NY 10065
(212) 838-2560
www.societyillustrators.org

United Scenic Artists

A union for set, lighting and costume designers as well as scenic artists (who paint scenery for stage, film and television). Members in good standing get healthcare, and employers contribute to a pension for that employee.

New York Office:
29 W. 38th St., 15th Floor
New York, NY 10018
(212) 581-0300
www.usa829.org

Volunteer Lawyers for the Arts (VLA)

Volunteer Lawyers for the Arts helps artists with legal issues, providing free services and information. There are VLA offices in Boston, Seattle, Los Angeles, Chicago and New York, among other places. Visit the website to find out how to meet with or secure the assistance of a volunteer lawyer.

1 E. 53rd St., 6th Floor
New York, NY 10022
(212) 319-ARTS, ext. 2787
www.vlany.org

WEB AND SOCIAL MEDIA LINKS

This is an incomplete list of wonderful online resources that are useful for artists.

Social Media Sites for Making Personal and Business Connections
Facebook www.facebook.com
LinkedIn www.linkedin.com
Twitter www.twitter.com

Portfolio Links
ARTslant www.artslant.com
FolioLink www.foliolink.com
WordPress www.wordpress.org,
www.wordpress.com

Selling Art, Crafts and Art-Related Items
Etsy www.etsy.com

Sites for Paper Materials, Business Cards, Postcards
Modern Postcard www.modernpostcard.com
MOO www.moo.com

Other Web Links:
Blogger www.blogger.com
Flickr www.flickr.com

FURTHER READING

The following is a list of interesting things to read that provide information and/or encouragement.

Artist's & Graphic Designer's Market
By Writers Digest Books; 2008
This book is strictly a list of resources for art markets for illustrators and artists, including greeting card companies, magazine and book publishers, galleries, art fairs and ad agencies.

"Artists in the Workforce: 1990–2005"
By the National Endowment for the Arts, Office of Research and Analysis, Tom Bradshaw, Senior Research Officer
This is a study conducted by the National Endowment for the Arts describing the artist workforce in America: Occupation data, geographic and demographic trends, employment levels and income. It sounds pretty dry, but it is an exhilarating read, showing over and over, in plain facts, that artists are productive members of society, and are part of a powerfully large cross section of society. A PDF of the study is downloadable for free at: arts.endow.gov/research/artistsinworkforce.pdf.

Art Marketing 101: A Handbook for the Fine Artist
By Constance Smith
ArtNetwork; 3 edition, 2007
Practical advice about taxes, legal rights and how to become better business people.

ART/WORK: Everything You Need to Know (and Do) As You Pursue Your Art Career
By Heather Darcy Bhandari and Jonathan Melber
Free Press, 2009
This book shows you how to act as your own manager and agent. It shares tips on prepping invoices, tracking inventory—seeing your art-making as a business venture.

A Whole New Mind: Why Right-Brainers Will Rule the Future
By Daniel H. Pink
Riverhead Trade, 2006
A business-oriented but fun text arguing that the marketplace will be dominated by right-brained thinkers (you!). Super fun to read and inspiring.

The Blank Canvas: Inviting the Muse

By Anna Held Audette

Shambhala Publications, 1993

This is a wonderful book for artists who are in transition—from college to "real life," from a non-art job to one that is more closely associated with their art. Audette offers ideas for breaking out of artists blocks and setting up a studio, while offering helpful quotes and thoughts from artists.

The Career Guide for Creative and Unconventional People

By Carol Eikleberry, Ph.D.

Ten Speed Press, 2007

This is a great resource for artists of all sorts, from performers to visual artists, but also for "unconventional thinkers" of all kinds. Career counselor Carol Eikleberry offers advice on shaping an artistic life, and lists over 240 career descriptions as options for creative people.

Creative Time and Space: Making Room for Making Art

By Rice Freeman-Zachery

North Light Books, 2010

This entire book is devoted to making a space to work: Making time to work, setting up a physical space to work, and carving out mental and emotional space to work. It includes interviews with other artists about how they make space along with their work examples.

The Forest for the Trees: An Editor's Advice to Writers

By Betsy Lerner

Riverhead, 2000

This is a book that is focused on writers. It is a sensible guide to being creative and realistic with your expectations. It is a bit of a wet blanket but includes a good section about how you don't have to be dependent on self-destructive behavior to be a successful artist.

The Gift: Imagination and the Erotic Life of Property

By Lewis Hyde

Vintage Books, 1979

This is a fascinating book about how art fits into the world of commerce. Artists often struggle with pricing their art—price and art seem like mutually exclusive ideas. This extremely beautiful and dense text examines the gift of art across cultures.

I'd Rather Be in the Studio!: The Artist's No-Excuse Guide to Self-Promotion

By Alyson B. Stanfield

Pentas Press, 2008

Practical advice (how to introduce yourself, market your art, take advantage of your website and blog to build an audience for your work) on how to build your career and sell more art. The author, an art-marketing expert, shares self-promotion tools to get your art into galleries and museums.

If You Want to Write: A Book About Art, Independence and Spirit

By Brenda Ueland

G.P. Putnam's sons, 1938, re-released by Graywolf Press, 1987

Writing instructor Brenda Ueland's 1938 guide to writers, filled with practical advice and warm reassurance, useful for artists of any stripe.

Inkblot: Drip, Splat and Squish Your Way to Creativity

By Margaret Peot

Boyds Mills Press, 2011

This book is a complete exploration of inkblots as a way to jump-start creative thought.

Inside the Business of Illustration

By Steven Heller and Marshall Arisman

Allworth Press, 2004

This is a useful guide to what illustrators can expect in their marketplace from two pros. Many of the tips can be applied to the business of artmaking in general, but it is very focused on the illustration world.

Letters to a Young Artist

Edited by Peter Nesbett, Sarah Andress and Shelly Bancroft

Darte Publishing, LLC, 2006

This is a wonderful book that every young artist should read. It comprised of twenty-four letters from established artists to a fictitious "young artist," a recent art-school graduate who is struggling with the moral and practical implications of being an artist in New York.

The "young artist" asked a selection of his heroes, "Is it possible to maintain one's integrity and freedom of thought and still participate in the art world?"

Living the Creative Life: Ideas and Inspirations from Working Artists

By Rice Freeman-Zachery

North Light Books, 2007

Interviews with fifteen successful artists about where they get their inspiration.

Make Your Mark: Explore Your Creativity and Discover Your Inner Artist

By Margaret Peot

Chronicle Books, 2004

Written by the fabulous author of the book you hold in your hand, this book contains tips for setting up your studio space, as well as many fun ways to make marks on paper. No art experience necessary.

Rework

By Jason Fried and David Heinemeier Hansson

Crown Business, 2010

Rework is an irreverent book about starting your own business, that happily goes against everything you have ever read about starting a business—it is sensible, tough, and powerfully written. It is not particularly for artists, but would be of interest to an artist who was starting her own business providing design-related services, or to an artist who is looking to make a career out of art making.

Taking the Leap: Building a Career as a Visual Artist
By Cay Lang
Chronicle Books, 2006
This book helps artists in the business of exhibiting and selling their work, including advice on finding and dealing with galleries and handling rights, royalties and taxes.

Tender Is the Night
By F. Scott Fitzgerald
Charles Scribner, 1934
A tragedy of the jazz age, which includes the passage on repose, quoted in chapter 5.

This Time I Dance!: Creating the Work You Love
By Tama J. Kieves
Tarcher, 2006
This book is written from the point of view of a life coach, directed at people who are unhappy in their careers and need to make a change.

True Perception: The Path of Dharma Art
By Chögyam Trungpa
Shambhala Publications, 2008
Trungpa shows how the principles of dharma art extend to everyday life, and how any activity can provide an opportunity to relax and open our senses to the phenomenal world. Contains the quote that appears at the beginning of chapter 8.

Working Identity: Unconventional Strategies for Reinventing Your Career
By Herminia Ibarra
Harvard Business School Press, 2003
This is a book for people in mid-career, who are dissatisfied with the their chosen career and want to reorient their path so it is closer to their inner template. It is not about artists, but the positive, interesting stories of thirty-nine people who changed their lives and careers completely, are inspiring to read.

BUSINESS BASICS: HOW TO STAY ON TRACK AND GET PAID

As you launch your artistic career, be aware that you are actually starting a small business. It is crucial that you keep track of the details, or your business will not last very long. The most important rule of all is to find a system to keep your business organized and stick with it.

Every artist needs to keep a daily record of art-making and marketing activities. Before you do anything else, visit an office supply store and pick out the items listed below (or your own variations of these items). Keep it simple so you can remember your system and use it on automatic pilot whenever you make a business transaction.

What you'll need:

- A packet of colorful file folders or a basic Personal Information Manager on your computer or personal digital assistant (PDA)
- A notebook or legal pads to serve as a log or journal to keep track of your daily art-making and art-marketing activities.
- A small pocket notebook to keep in your car to track mileage and gas expenses.

How to start your system

Designate a permanent location in your studio or home office for two file folders and your notebook. Label one red file folder "Expenses." Label one green file folder "Income." Write in your daily log book each and every day.

Every time you purchase anything for your business, such as envelopes or art supplies, place the receipt in your red Expenses folder. When you receive payment for an assignment or painting, photocopy the check or place the receipt in your green Income folder.

Keep track of assignments

Whether you're an illustrator or fine artist, you should devise a system for keeping track of assignments and artworks. Most illustrators assign a job number to each assignment they receive and create a file folder for each job. Some arrange these folders by client name; others keep them in numerical order. The important thing is to keep all correspondence for each assignment in a spot where you can easily find it.

Pricing illustration and design

One of the hardest things to master is what to charge for your work. It's difficult to make blanket statements on this topic. Every slice of the market is somewhat different. Nevertheless, there is one recurring pattern: Hourly rates are generally only paid to designers working in-house on a client's equipment. Freelance illustrators working out of their own studios are almost always paid a flat fee or an advance against royalties.

If you don't know what to charge, begin by devising an hourly rate, taking into consideration the cost of materials and overhead as well as what you think your time is worth. If you're a designer, determine what the average salary would be for a full-time employee doing the same job. Then estimate how many hours the job will take and quote a flat fee based on these calculations.

There is a distinct difference between giving the client a job estimate and a job quote. An estimate is a ballpark figure of what the job will cost but is subject to change. A quote is a set fee which, once agreed upon, is pretty much carved in stone. Make sure the client understands which you are negotiating.

Estimates are often used as a preliminary step in itemizing costs for a combination of design services such as concepting, typesetting and printing. Flat quotes are generally used by illustrators, as there are fewer factors involved in arriving at fees.

For recommended fees for different services, refer to the *Graphic Artists Guild Handbook of Pricing & Ethical Guidelines* (www.gag.org). Many artists' organizations have standard pay rates listed on their websites.

As you set fees, certain stipulations call for higher rates. Consider these bargaining points:

- **Usage (rights).** The more rights purchased, the more you can charge. For example, if the client asks for a "buyout" (to buy all rights), you can charge more, because by relinquishing all rights to future use of your work, you will be losing out on resale potential.

- **Turnaround time.** If you are asked to turn the job around quickly, charge more.
- **Budget.** Don't be afraid to ask about a project's budget before offering a quote. You won't want to charge $500 for a print ad illustration if the ad agency has a budget of $40,000 for that ad. If the budget is that big, ask for higher payment.
- **Reputation.** The more well known you are, the more you can charge. As you become established, periodically raise your rates (in small steps) and see what happens.

© Margarit.Ralev.com

Pricing your fine art

There are no hard-and-fast rules for pricing your fine artwork. Most artists and galleries base prices on market value—what the buying public is currently paying for similar work. Learn the market value by visiting galleries and checking prices of works similar to yours. When you're starting out, don't compare your prices to established artists but to emerging talent in your region. Consider these factors when determining price:

- **Medium.** Oils and acrylics cost more than watercolors by the same artist. Price paintings higher than drawings.
- **Expense of materials.** Charge more for work done on expensive paper than for work of a similar size on a lesser grade paper.
- **Size.** Though a large work isn't necessarily better than a small one, as a rule of thumb you can charge more for the larger work.
- **Scarcity.** Charge more for one-of-a-kind works like paintings and drawings, than for limited editions such as lithographs and woodcuts.
- **Status of artist.** Established artists can charge more than lesser-known artists.
- **Status of gallery.** Prestigious galleries can charge higher prices.
- **Region.** Works usually sell for more in larger cities like New York and Chicago.
- **Gallery commission.** The gallery will charge from 30 to 50 percent commission. Your cut must cover the cost of materials, studio space, taxes and perhaps shipping and insurance, as well as enough extra to make a profit. If materials for a painting cost $25, matting and framing cost $37, and you spent five hours working on it, make sure you get at least the cost of material and labor back before the gallery takes its share. Once you set your price, stick

to the same price structure wherever you show your work. A $500 painting by you should cost $500 whether it is bought in a gallery or directly from you. To do otherwise is not fair to the gallery and devalues your work.

As you establish a reputation, begin to raise your prices—but do so cautiously. Each time you graduate to a new price level, it will be that much harder to revert to former prices.

What goes in a contract?

Contracts are simply business tools used to make sure everyone agrees on the terms of a project. Ask for one any time you enter into a business agreement. Be sure to arrange for the specifics in writing or provide your own. A letter stating the terms of agreement signed by both parties can serve as an informal contract. Several excellent books, such as *Legal Guide for the Visual Artist* and *Business and Legal Forms for Illustrators*, both by Tad Crawford (Allworth Press), contain negotiation checklists and tear-out forms, and provide sample contracts you can copy. The sample contracts in those books cover practically any situation you might encounter.

The items specified in your contract will vary according to the market you're dealing with and the complexity of the project. Nevertheless, here are some basic points you'll want to cover:

Commercial contracts

- **Description** of the service(s) you're providing.
- **Deadlines** for finished work.
- **Rights sold.** Your fee. Hourly rate, flat fee or royalty.
- **Kill fee.** Compensatory payment received by you if the project is cancelled.
- **Changes fees.** Penalty fees to be paid by the client for last-minute changes.
- **Advances.** Any funds paid to you before you begin working on the project.
- **Payment schedule.** When and how often you will be paid for the assignment.
- **Statement regarding return of original art.** Unless you're doing work for hire, your artwork should always be returned to you.

Gallery contracts

- **Terms of acquisition or representation.** Will the work be handled on consignment? What is the gallery's commission?

- **Nature of the show(s).** Will the work be exhibited in group or solo shows or both?
- **Time frames.** If a work is sold, when will you be paid? At what point will the gallery return unsold works to you? When will the contract cease to be in effect?
- **Promotion.** Who will coordinate and pay for promotion? What does promotion entail? Who pays for printing and mailing of invitations? If costs are shared, what is the breakdown?
- **Insurance.** Will the gallery insure the work while it is being exhibited and/or while it is being shipped to or from the gallery?
- **Shipping.** Who will pay for shipping costs to and from the gallery?
- **Geographic restrictions.** If you sign with this gallery, will you relinquish the rights to show your work elsewhere in a specified area? If so, what are the boundaries of this area?

How to send invoices

If you're a designer or illustrator, you will be responsible for sending invoices for your services. Clients generally will not issue checks without them, so mail or fax an invoice as soon as you've completed the assignment.

Illustrators are generally paid in full either upon receipt of illustration or on publication. Most graphic designers arrange to be paid in thirds, billing the first third before starting the project, the second after the client approves the initial roughs and the third upon completion of the project.

Standard invoice forms allow you to itemize your services. The more you spell out the charges, the easier it will be for your clients to understand what they're paying for. Most freelancers charge extra for changes made after approval of the initial layout. Keep a separate form for change orders and attach it to your invoice.

If you're an illustrator, your invoice can be much simpler, as you'll generally be charging a flat fee. It's helpful, in determining your quoted fee, to itemize charges according to time, materials and expenses. (The client need not see this itemization; it is for your own purposes.)

Most businesses require your social security number or tax ID number before they can cut a check, so include this information in your bill. Be sure to put a due date on each invoice; include the phrase "payable within 30 days" (or other preferred time frame) directly on your invoice. Most freelancers ask for payment within ten to thirty days. Sample invoices are featured in *Business and Legal*

Forms for Illustrators and *Business and Legal Forms for Graphic Designers*, both by Tad Crawford (Allworth Press).

If you're working with a gallery, you will not need to send invoices. The gallery should send you a check each time one of your pieces is sold (generally within thirty days).

To ensure that you are paid in a timely manner, call the gallery periodically to touch base. Let the director or business manager know that you are keeping an eye on your work. When selling work independently of a gallery, give receipts to buyers and keep copies for your records.

Take advantage of tax deductions

You have the right to deduct legitimate business expenses from your taxable income. Art supplies, studio rent, printing costs and other business expenses are deductible against your gross art-related income. It is imperative to seek the help of an accountant or tax preparation service in filing your return. In the event your deductions exceed profits, the loss will lower your taxable income from other sources.

To guard against taxpayers fraudulently claiming hobby expenses as business losses, the IRS requires taxpayers to demonstrate a "profit motive." As a general rule, you must show a profit for three out of five years to retain a business status. If you are audited, the burden of proof will be on you to validate your work as a business and not a hobby.

If the IRS rules that you paint for pure enjoyment rather than profit, they will consider you a hobbyist. Complete and accurate records will demonstrate to the IRS that you take your business seriously.

Even if you are a "hobbyist," you can deduct expenses such as supplies on a Schedule A, but you can only take art-related deductions equal to art-related income. If you sold two $500 paintings, you can deduct expenses such as art supplies, art books and seminars only up to $1,000. Itemize deductions only if your total itemized deductions exceed your standard deduction. You will not be allowed to deduct a loss from other sources of income.

Figuring deductions

To deduct business expenses, you or your accountant will fill out a 1040 tax form (not 1040EZ) and prepare a Schedule C, which is a separate form used to calculate profit or loss from your business. The income (or loss) from Schedule C is then reported on the 1040 form. In regard to business expenses, the standard deduction does not come into play as it would for a hobbyist. The total of

your business expenses need not exceed the standard deduction.

There is a shorter form called Schedule C-EZ for self-employed people in service industries. It can be applicable to illustrators and designers who have receipts of $25,000 or less and deductible expenses of $2,000 or less. Check with your accountant to see if you qualify.

Deductible expenses include advertising costs, brochures, business cards, professional group dues, subscriptions to trade journals and arts magazines, legal and professional services, leased office equipment, office supplies, business travel expenses, etc. Your accountant can give you a list of all 100-percent and 50-percent deductible expenses. Don't forget to deduct the cost of this book!

As a self-employed "sole proprietor," there is no employer regularly taking tax out of your paycheck. Your accountant will help you put money away to meet your tax obligations and may advise you to estimate your tax and file quarterly returns.

Your accountant also will be knowledgeable about another annual tax called the Social Security Self-Employment tax. You must pay this tax if your net freelance income is $400 or more.

The fees of tax professionals are relatively low, and they are deductible. To find a good accountant, ask colleagues for recommendations, look for advertisements in trade publications, or ask your local Small Business Association.

Can I deduct my home studio?

If you freelance full time from your home and devote a separate area to your business, you may qualify for a home office deduction. If eligible, you can deduct a percentage of your rent or mortgage as well as utilities and expenses like office supplies and business-related telephone calls.

The IRS does not allow deductions if the space is used for purposes other than business. A studio or office in your home must meet three criteria:

- The space must be used exclusively for your business.
- The space must be used regularly as a place of business.
- The space must be your principle place of business.

The IRS might question a home office deduction if you are employed full time elsewhere and freelance from home. If you do claim a home office, the area must be clearly divided from your living area. A desk in your bedroom will not qualify.

To figure out the percentage of your home used for business, divide the total square footage of your home by the total square footage of your office. This will give you a percentage to work with when figuring deductions. If the home office is 10 percent of the square footage of your home, deduct 10 percent of expenses such as rent, heat and air conditioning.

The total home office deduction cannot exceed the gross income you derive from its business use. You cannot take a net business loss resulting from a home office deduction. Your business must be profitable three out of five years; otherwise, you will be classified as a hobbyist and will not be entitled to this deduction.

Consult a tax advisor before attempting to take this deduction, as its interpretations frequently change.

For additional information, refer to IRS Publication 587, Business Use of Your Home, which can be downloaded at www.irs.gov or ordered by calling (800) 829-3676.

Whenever possible, retain your independent contractor status

Some clients automatically classify freelancers as employees and require them to file Form W-4. If you are placed on employee status, you may be entitled to certain benefits, but a portion of your earnings will be withheld by the client until the end of the tax year and you could forfeit certain deductions. In short, you may end up taking home less than you would if you were classified as an independent contractor.

The IRS uses a list of twenty factors to determine whether a person should be classified as an independent contractor or an employee. This list can be found in IRS Publication 937. Note, however, that your client will be the first to decide how you'll be classified.

Report all income to Uncle Sam

Don't be tempted to sell artwork without reporting it on your income tax. You may think this saves money, but it can do real damage to your career and credibility—even if you are never audited by the IRS. Unless you report your income, the IRS will not categorize you as a professional, and you won't be able to deduct expenses.

And don't think you won't get caught if you neglect to report income. If you bill any client in excess of $600, the IRS requires the client to provide you with a Form 1099 at the end of the year. Your client must send one copy to the IRS and a copy to you to attach to your income tax return. Likewise, if you pay a freelancer over $600, you must issue a 1099 form. This procedure is one way the IRS cuts down on unreported income.

Register with the state sales tax department

Most states require a 2–7 percent sales tax on artwork you sell directly from your studio or at art fairs, or on work created for a client. You must register with the state sales tax department, which will issue you a sales permit or a resale number and send you appropriate forms and instructions for collecting the tax.

Getting a sales permit usually involves filling out a form and paying a small fee. Reporting sales tax is a relatively simple procedure. Record all sales taxes on invoices and in your sales journal. Every three months, total the taxes collected and send it to the state sales tax department.

In most states, if you sell to a customer outside of your sales tax area, you do not have to collect sales tax. However, this may not hold true for your state. You may also need a business license or permit. Call your state tax office to find out what is required.

Save money on art supplies

As long as you have the above sales permit number, you can buy art supplies without paying sales tax. You will probably have to fill out a tax-exempt form with your permit number at the sales desk where you buy materials. The reason you do not have to pay sales tax on art supplies is that sales tax is only charged on the final product. However, you must then add the cost of materials into the cost of your finished painting or the final artwork for your client. Keep all receipts in case of a tax audit. If the state discovers that you have not collected sales tax, you will be liable for tax and penalties.

If you sell all your work through galleries, they will charge sales tax, but you still need a sales permit number to get a tax exemption on supplies.

Some states claim "creativity" is a non-taxable service, while others view it as a product and therefore taxable. Be certain you understand the sales tax laws to avoid being held liable for uncollected money at tax time. Contact your state auditor for sales tax information.

Save money on postage

When you send out postcard samples or invitations to openings, you can save big bucks by mailing in bulk. Fine artists should send submissions via first class mail for quicker service and better handling. Package flat work between heavy cardboard or foam core, or roll it in a cardboard tube. Include your business card or a label with your name

and address on the outside of the packaging material in case the outer wrapper becomes separated from the inner packing in transit.

Protect larger works—particularly those that are matted or framed—with a strong outer surface, such as laminated cardboard, Masonite or light plywood. Wrap the work in polyfoam, heavy cloth or bubble wrap, and cushion it against the outer container with spacers to keep it from moving. Whenever possible, ship work before it is glassed. If the glass breaks en route, it may destroy your original image. If shipping large framed work, contact a museum in your area for more suggestions on packaging.

The U.S. Postal Service will not automatically insure your work, but you can purchase up to $5,000 worth of coverage. Artworks exceeding this value should be sent by registered mail, which can be insured for up to $25,000. Certified packages travel a little slower but are easier to track.

Consider special services offered by the post office, such as Priority Mail, Express Mail Next Day Service, and Special Delivery. For overnight delivery, check to see which air freight services are available in your area. Federal Express automatically insures packages for $100 and will ship art valued up to $500. Their 24-hour computer tracking system enables you to locate your package at any time.

The United Parcel Service automatically insures work for $100, but you can purchase additional insurance for work valued as high as $25,000 for items shipped by air (there is no limit for items sent on the ground). UPS cannot guarantee arrival dates but will track lost packages. It also offers Two-Day Blue Label Air Service within the U.S. and Next Day Service in specific zip code zones.

Before sending any original work, make sure you have a copy (photocopy, slide or transparency) in your files. Always make a quick address check by phone before putting your package in the mail.

* Excerpted from *2012 Artist's & Graphic Designer's Market* © 2011 by F+W Media, Inc. Used with the kind permission of North Light Books, an imprint of F+W Media, Inc. Visit northlightshop.com or call 1.800.289.0963 to obtain a copy.

COPYRIGHT BASICS

As creator of your artwork, you have certain inherent rights over your work and can control how each one of your works is used, until you sell your rights to someone else. The legal term for these rights is called copyright.

Technically, any original artwork you produce is automatically copyrighted as soon as you put it in tangible form.

To be automatically copyrighted, your artwork must fall within these guidelines:

- **It must be your original creation.** It cannot be a *copy* of somebody else's work.
- **It must be "pictorial, graphic or sculptural."** Utilitarian objects, such as lamps or toasters, are not covered, although you can copyright an illustration featured on a lamp or toaster.
- **It must be fixed in "any tangible medium, now known or later developed."** Your work, or at least a representation of a planned work, must be created in or on a medium you can see or touch, such as paper, canvas, clay, a sketch pad or even a website. It can't just be an idea in your head. An idea cannot be copyrighted.

Copyright lasts for your lifetime plus seventy years

Copyright is exclusive. When you create a work, the rights automatically belong to you and nobody else but you until those rights are sold to someone else. Works of art created on or after January 1978 are protected for your lifetime plus seventy years.

The artist's bundle of rights

One of the most important things you need to know about copyright is that it is not just a singular right. It is a bundle of rights you enjoy as creator of your artwork:

- **Reproduction rights.** You have the right to make copies of the original work.
- **Modification rights.** You have the right to create derivative works based on the original work.

- **Distribution rights.** You have the right to sell, rent or lease copies of your work.
- **Public performance rights.** You have the right to play, recite or otherwise perform a work. (This right is more applicable to written or musical art forms than to visual art.)
- **Public display rights.** You have the right to display your work in a public place. This bundle of rights can be divided up in a number of ways, so that you can sell all or part of any of those exclusive rights to one or more parties. The system of selling parts of your copyright bundle is sometimes referred to as divisible copyright. Just as a land owner can divide up his property and sell it to many different people, the artist can divide up his rights to an artwork and sell portions of those rights to different buyers.

Divisible copyright: divide and conquer

Why is divisible copyright so important? Because dividing up your bundle and selling parts of it to different buyers will help you get the most payment for each of your artworks.

For any one of your artworks, you can sell your entire bundle of rights at one time (not advisable!) or divide each bundle pertaining to that work into smaller portions and make more money as a result. You can grant one party the right to use your work on a greeting card and sell another party the right to print that same work on T-shirts.

Clients tend to use legal jargon to specify the rights they want to buy. The terms below are commonly used in contracts to indicate portions of your bundle of rights. Some terms are vague or general, such as "all rights." Other terms are more specific, such as "first North American rights." Make sure you know what each term means before signing a contract.

Divisible copyright terms

- **One-time rights.** Your client buys the right to use or publish your artwork or illustration on a one-time basis. One fee is paid for one use. Most magazine and book cover assignments fall under this category.
- **First rights.** This is almost the same as one-time rights, except that the buyer is also paying for the privilege of being the first to use your image. He may use it only once unless the other rights are negotiated. Sometimes first rights can be further broken down geographically. The buyer might ask to buy *first North American rights*, meaning he would

have the right to be the first to publish the work in North America.

- **Exclusive rights.** This guarantees the buyer's exclusive right to use the artwork in his particular market or for a particular product. Exclusive rights are frequently negotiated by greeting card and gift companies. One company might purchase the exclusive right to use your work as a greeting card, leaving you free to sell the exclusive rights to produce the image on a mug to another company.
- **Promotional rights.** These rights allow a publisher to use an artwork for promotion of a publication in which the artwork appears. For example, if *The New Yorker* bought promotional rights to your cartoon, they could also use it in a direct mail promotion.
- **Electronic rights.** These rights allow a buyer to place your work on electronic media such as websites. Often these rights are requested with print rights.
- **Work for hire.** Under the Copyright Act of 1976, section 101, a "work for hire" is defined as "(1) a work prepared by an employee within the scope of his or her employment; or (2) a work specially ordered or commissioned for use as a contribution to a collective work, as part of a motion picture or other audiovisual work . . . if the parties expressly agree in a written instrument signed by them that the work shall be considered a work made for hire." When the agreement is "work for hire," you surrender all rights to the image and can never resell that particular image again. If you agree to the terms, make sure the money you receive makes it well worth the arrangement.
- **All rights.** Again, be aware that this phrase means you will relinquish your entire copyright to a specific artwork. Before agreeing to the terms, make sure this is an arrangement you can live with. At the very least, arrange for the contract to expire after a specified date. Terms for all rights—including time period for usage and compensation—should be confirmed in a written agreement with the client.

Since legally your artwork is your property, when you create an illustration for a magazine you are, in effect, temporarily "leasing" your work to the client for publication.

Chances are you'll never hear an art director ask to lease or license your illustration, and he may not even realize he is leasing, not buying, your work. But most art directors know

that once the magazine is published, the art director has no further claims to your work and the rights revert back to you. If the art director wants to use your work a second or third time, he must ask permission and negotiate with you to determine any additional fees you want to charge. You are free to take that same artwork and sell it to another buyer.

However, if the art director buys "all rights," you cannot legally offer that same image to another client. If you agree to create the artwork as "work for hire," you relinquish your rights entirely.

What licensing agents know

The practice of leasing parts or groups of an artist's bundle of rights is often referred to as licensing, because (legally) the artist is granting someone a "license" to use his work for a limited time for a specific reason. As licensing agents have come to realize, it is the exclusivity of the rights and the ability to divide and sell them that make them valuable. Knowing exactly what rights you own, which you can sell, and in what combinations, will help you negotiate with your clients.

Don't sell conflicting rights to different clients

You also have to make sure the rights you sell to one client don't conflict with any of the rights sold to other clients. For example, you can't sell the exclusive right to use your image on greeting cards to two separate greeting card companies. You can sell the exclusive greeting card rights to one card company and the exclusive rights to use your artwork on mugs to a separate gift company. You should always get such agreements in writing and let both companies know your work will appear on other products.

When to use the Copyright © and credit lines

A copyright notice consists of the word "Copyright" or its symbol ©, the year the work was created or first published, and the full name of the copyright owner. It should be placed where it can easily be seen, on the front or back of an illustration or artwork. It's also common to print your copyright notice on slide mounts or onto labels on the back of photographs.

Under today's laws, placing the copyright symbol on your work isn't absolutely necessary to claim copyright infringement and take a plagiarist to court if he steals your work. If you browse through magazines, you will often see the illustrator's name in small print near the illustration, without the Copyright ©. This is common practice in the magazine industry. Even though the © is not printed,

the illustrator still owns the copyright unless the magazine purchased all rights to the work. Just make sure the art director gives you a credit line near the illustration.

Usually you will not see the artist's name or credit line next to advertisements for products. Advertising agencies often purchase all rights to the work for a specified time. They usually pay the artist generously for this privilege and spell out the terms clearly in the artist's contract.

How to register a copyright

The process of registering your work is simple. Visit the United States Copyright Office website at www.copyright.gov to file electronically. You can still register with paper forms, but this method requires a higher filing fee. To request paper forms, call (202)707-9100 or write to the Library of Congress, Copyright Office-COPUBS, 101 Independence Ave. SE, Washington, DC 20559-6304, Attn: Information Publications, Section LM0455 and ask for package 115 and circulars 40 and 40A. Cartoonists should ask for package 111 and circular 44. They will send you a package containing Form VA (for visual artists).

You can register an entire collection of your work rather than one work at a time. That way you will only have to pay one fee for an unlimited number of works. For example, if you have created a hundred works between 2010 and 2012, you can complete a copyright form to register "the collected works of Jane Smith, 2010–2012." But you will have to upload digital files or send either slides or photocopies of each of those works.

Why register?

It seems like a lot of time and trouble to complete the forms to register copyrights for all your artworks. It may not be necessary or worth it to you to register every artwork you create. After all, a work is copyrighted the moment it's created anyway, right?

The benefits of registering are basically to give you additional clout in case an infringement occurs and you decide to take the offender to court. Without a copyright registration, it probably wouldn't be economically feasible to file suit, because you'd be entitled to only your damages and the infringer's profits, which might not equal the cost of litigating the case. If the works are registered with the U.S. Copyright Office, it will be easier to prove your case and get reimbursed for your court costs.

Likewise, the big advantage of using the Copyright © also comes when and if you ever have to take an infringer to court. Since the Copyright © is the most clear warning

to potential plagiarizers, it is easier to collect damages if the © is in plain sight.

Register with the U.S. Copyright Office those works you fear are likely to be plagiarized before or shortly after they have been exhibited or published. That way, if anyone uses your work without permission, you can take action.

Deal swiftly with plagiarists

If you suspect your work has been plagiarized and you have not already registered it with the Copyright Office, register it immediately. You have to wait until it is registered before you can take legal action against the infringer.

Before taking the matter to court, however, your first course of action might be a well-phrased letter from your lawyer telling the offender to "cease and desist" using your work, because you have a registered copyright. Such a warning (especially if printed on your lawyer's letterhead) is often enough to get the offender to stop using your work.

Don't sell your rights too cheaply

Recently a controversy has been raging about whether or not artists should sell the rights to their works to stock illustration agencies. Many illustrators strongly believe selling rights to stock agencies hurts the illustration profession. They say artists who deal with stock agencies, especially those who sell royalty-free art, are giving up the rights to their work too cheaply.

Another pressing copyright concern is the issue of electronic rights. As technology makes it easier to download images, it is more important than ever for artists to protect their work against infringement.

Copyright resources

The U.S. Copyright website (www.copyright. gov), the official site of the U.S. Copyright Office, is very helpful and will answer just about any question you can think of. Information is also available by phone at (202)707-3000. Another great site, called the Copyright Website, is located at benedict.com.

A couple of great books on the subject are Legal Guide for the Visual Artist by Tad Crawford (Allworth Press) and The Business of Being an Artist by Daniel Grant (Allworth Press).

* Excerpted from *2012 Artist's & Graphic Designer's Market* © 2011 by F+W Media, Inc. Used with the kind permission of North Light Books, an imprint of F+W Media, Inc. Visit northlightshop.com or call 1.800.289.0963 to obtain a copy.

PROMOTING YOUR WORK

So, you're ready to launch your freelance art or gallery career. How do you let people know about your talent? One way is to introduce yourself to them by sending promotional samples.

Samples are an important sales tool, so put a lot of thought into what you send. Your ultimate success depends largely on the impression they make.

This article is divided into three sections, so whether you're a fine artist, illustrator or designer, check the appropriate heading for guidelines. Read individual listings and section introductions thoroughly for more specific instructions. As you read the listings, you'll see the term SASE, short for self-addressed, stamped envelope. Enclose an SASE with your submissions if you want your material returned. If you send postcards or tearsheets, no return envelope is necessary. Many art directors want only nonreturnable samples, because they are too busy to return materials, even with SASEs. So read listings carefully and save stamps.

ILLUSTRATORS AND CARTOONISTS

You will have several choices when submitting to magazines, book publishers, and other illustration and cartoon markets. Many freelancers send a cover letter and one or two samples in initial mailings. Others prefer a simple postcard showing their illustrations. Here are a few of your options:

- **Postcard.** Choose one (or more) of your illustrations or cartoons that represent your style, then have the image(s) printed on postcards. Have your name, address, phone number, email and website printed on the front of the postcard or in the return address corner. Somewhere on the card should be printed the word "Illustrator" or "Cartoonist." If you use one or two colors, you can keep the cost below $200. Art directors like postcards because

they are easy to file or tack on a bulletin board. If the art director likes what she sees, she can always call you for more samples.

- **Promotional sheet.** If you want to show more of your work, you can opt for an 8½" × 11" (22cm × 28cm) color or black-and-white photocopy of your work. No matter what size sample you send, never fold the page. It is more professional to send flat sheets, in a 9" × 12" (23cm × 30cm) envelope, along with a typed query letter, preferably on your own professional stationery.
- **Tearsheets.** After you complete assignments, acquire copies of any printed pages on which your illustrations appear. Tearsheets impress art directors because they are proof that you are experienced and have met deadlines on previous projects.
- **Photographs.** Some illustrators have been successful sending photographs, but printed or photocopied samples are preferred by most art directors. It is not practical or effective to send slides.
- **Query or cover letter.** A query letter is a nice way to introduce yourself to an art director for the first time. One or two paragraphs stating your desire and availability for freelance work is all you need. Include your phone number and email address.
- **Email submissions.** Email is another great way to introduce your work to potential clients. When sending emails, provide a link to your website or JPEGs of your best work.

DESIGNERS AND DIGITAL ARTISTS

Plan and create your submission package as if it were a paying assignment from a client. Your submission piece should show your skill as a designer. Include one or both of the following:

- **Cover letter.** This is your opportunity to show you can design a beautiful, simple logo or letterhead for your own business card, stationery and envelopes. Have these all-important pieces printed on excellent-quality bond paper. Then write a simple cover letter stating your experience and skills.
- **Sample.** Your sample can be a copy of an assignment you've completed for another client, or a clever self-promotional piece. Design a great piece to show off your capabilities.

Stand out from the crowd

You may have only a few seconds to grab art directors' attention as they make their way

through the "slush pile" (an industry term for unsolicited submissions). Make yourself stand out in simple, effective ways:

- **Tie in your cover letter with your sample.** When sending an initial mailing to a potential client, include a cover letter of introduction with your sample. Type it on a great-looking letterhead of your own design. Make your sample tie in with your cover letter by repeating a design element from your sample onto your letterhead. List some of your past clients within your letter.
- **Send artful invoices.** After you complete assignments, a well-designed invoice (with one of your illustrations or designs strategically placed on it, of course) will make you look professional and help art directors remember you—and hopefully, think of you for another assignment.
- **Follow up with seasonal promotions.** Many illustrators regularly send out holiday-themed promo cards. Holiday promotions build relationships while reminding past and potential clients of your services. It's a good idea to get out your calendar at the beginning of each year and plan some special promos for the year's holidays.

Are portfolios necessary?

You do not need to send a portfolio when you first contact a market. But after buyers see your samples they may want to see more, so have a portfolio ready to show. Many successful illustrators started their careers by making appointments to show their portfolios. But it is often enough for art directors to see your samples.

Some markets have drop-off policies, accepting portfolios one or two days a week. You will not be present for the review and can pick up the work a few days later after they've had a chance to look at it. Since things can get lost, include only duplicates that can be insured at a reasonable cost. Only show originals when you can be present for the review. Label your portfolio with your name, address and phone number.

Portfolio pointers

The overall appearance of your portfolio affects your professional presentation. It need not be made of high-grade leather to leave a good impression. Neatness and careful organization are essential whether you're using a three-ring binder or a leather case. The most popular portfolios are simulated leather with puncture-proof sides that allow the inclusion of loose samples.

Choose a size that can be handled easily. Avoid the large, "student-size" books, which are too big to fit easily on an art director's desk. Most artists choose 11" × 14" (28cm × 31cm) or 18" × 24" (46cm × 61cm). If you're a fine artist and your work is too large for a portfolio, bring slides of your work and a few small samples.

- **Don't include everything you've done in your portfolio.** Select only your best work, and choose pieces relevant to the company you are approaching. If you're showing your book to an ad agency, for example, don't include greeting card illustrations.
- **Show progressives.** In reviewing portfolios, art directors look for consistency of style and skill. They sometimes like to see work in different stages (roughs, comps and finished pieces) to examine the progression of ideas and how you handle certain problems.
- **Your work should speak for itself.** It's best to keep explanations to a minimum and be available for questions if asked. Prepare for the review by taking along notes on each piece. If the buyer asks a question, take the opportunity to talk a little bit about the piece in question. Mention the budget, time frame and any problems you faced and

solved. If you're a fine artist, talk about how the piece fits into the evolution of a concept and how it relates to other pieces you've shown.

- **Leave a business card.** Don't ever walk out of a portfolio review without leaving the buyer a sample to remember you by. A few weeks after your review, follow up by sending a small promo postcard or other sample as a reminder.

FINE ARTISTS

Send a 9" × 12" (23cm × 30cm) envelope containing whatever materials galleries request in their submission guidelines. Usually that means a query letter, slides and résumé, but check each listing for specifics. Some galleries like to see more. Here's an overview of the various components you can include:

- **Digital images or slides.** Send eight to twelve digital images (JPEGs on a disk) or slides of similar work in a plastic slide sleeve (available at art supply stores). To protect slides from being damaged, insert slide sheets between two pieces of cardboard. Ideally, images should be taken by a professional photographer, but if you want to photograph them yourself, refer to *The Quick & Easy Guide to Photographing Your Artwork* by Roger Saddington

(North Light Books). Label each image with your name, the title of the work, the medium and the dimensions of the work. For slides, also include an arrow indicating the top of the slide. Include a list of titles and suggested prices gallery directors can refer to as they review the disk or slides. Make sure the list is in the same order as the images on the disk or the slides. Type your name, address, phone number, email and website at the top of the list. Don't send a variety of unrelated work. Send work that shows one style or direction.

- **Query letter or cover letter.** Type one or two paragraphs expressing your interest in showing at the gallery, and include a date and time when you will follow up.
- **Résumé or bio.** Your résumé should concentrate on your art-related experience. List any shows your work has been included in, with dates. A bio is a paragraph describing where you were born, your education, the work you do and where you have shown in the past.
- **Artist's statement.** Some galleries require a short statement about your work and the themes you're exploring. Your statement should show you have a sense of vision. It should also explain what you hope to convey in your work.
- **Portfolios.** Gallery directors sometimes ask to see your portfolio, but they can usually judge from your JPEGs or slides whether your work would be appropriate for their galleries. Never visit a gallery to show your portfolio without first setting up an appointment.
- **SASE.** If you need material returned to you, don't forget to include an SASE.

* Excerpted from *2012 Artist's & Graphic Designer's Market* © 2011 by F+W Media, Inc. Used with the kind permission of North Light Books, an imprint of F+W Media, Inc. Visit northlightshop.com or call 1.800.289.0963 to obtain a copy.

SECRETS TO SOCIAL MEDIA SUCCESS

by Lori McNee

Lori McNee is an internationally recognized professional artist and art-marketing expert, who writes about art and marketing tips on her blog finearttips.com. Lori is an exhibiting member of Oil Painters of America and ranks as one of the most influential artists and powerful women on Twitter. She was named a Twitter Powerhouse by *The Huffington Post*.

By now, most artists probably use social media in one form or another. On a daily basis I meet creatives with a natural liking for social media and its networking capabilities. However, many of these talented individuals still do not understand how to harness the power of social media to their advantage.

Social media offers large-scale reach for little cost other than your time. The successes you reap from social media will directly depend upon the amount of time you are willing to devote to this free marketing medium. There has never been another era in business when an individual could reach out to hundreds or even thousands of customers in one day. Social marketing eliminates the middleman and provides artists with the unique opportunity to have a direct relationship with their customers.

For me, the main purpose of social media is to drive traffic back to my blogs, lorimcnee.com and finearttips.com. Social media has put my name on the map, has given me international recognition, and been the lifeblood to my blogs and art business. Twitter, Facebook and YouTube are the fastest ways to build brand recognition for you and your art business. I use all three of these social media channels quite differently.

Twitter is possibly the most intimidating social platform because everything happens so quickly. Once you jump in and start engaging, you'll see that Twitter also has the broadest reach. Twitter updates reach like-minded

people quickly and can effectively market a person or a service. Twitter offers an immediate response and is very addictive once you get the hang of it.

Twitter is much like a cocktail party where you can quickly meet and exchange information. But, the social etiquette rules still apply. Would you just walk up to someone and say, "Hey, please buy my art." No, that is just rude. You need to connect and build a relationship first.

Facebook on the other hand, is more like a dinner party, where you build upon conversations and further develop your relationships. Facebook is about connecting with people and prospective customers you have already met. Facebook is a bit easier to market tangible products, such as paintings.

Facebook's platform appeals to the social butterfly and can also be very addictive because it allows people to connect with old and new friends. In fact, Facebook has replaced email, chat and photo sharing for many users.

YouTube is like inviting the person into your home movie theater to learn more about you, your product or service, and what you do. Currently, YouTube is the favorite site when searching for online video.

Remember this: Nearly every single person who uses social media wants to sell you something, whether it is art, real estate, travel, information or a service. This is the trick—how do you learn to market and brand yourself correctly on social media?

Brand identity differentiates you from the rest of the pack. We have all heard the old saying, "Don't judge a book by its cover." But, on social media sites, your cover or profile is judged and very quickly.

Here are some secrets to your social media success:

TWITTER TIPS

Name

Your name is the first thing that people will see on Twitter. Use the name you want to represent your art brand. For example, when I first started tweeting I used @lorimcnee, but quickly changed my Twitter handle to @lorimcneeartist and rapidly gained loyal followers. Why? Because it is easier for people to instantly associate me as an artist this way. Also, when people do a Twitter search for "artist," my name appears.

Avatar

On Twitter it is important to make your profile picture friendly. Recent studies have found that your profile picture or *avatar* is more than just a pretty face. In fact, one's avatar affects how a message is received, and

also how individuals interpret it. The higher the friendliness of the avatar, the more intimate people are willing to be with strangers. It is not a rule, but I suggest using an image of yourself rather than a business logo or a painting as your avatar.

To further your brand identity, it is a good idea to use the same avatar on all your social media sites. You can change your photo, but this will confuse some of your followers. It is best to wait until you have a loyal following before you make any major changes.

Profile/bio

On any social media channel, the profile or bio is your big branding opportunity to make your unique mark. This is your virtual personality. Sound interesting, witty, or clever, but, whatever you do, choose your profile words wisely. These few words will say a lot to the world about who and what you are. Make sure to include the link to your blog or website. If you don't have a website, link to your Facebook page.

Custom landing page

Consider creating a custom Twitter landing page by using a site such as TwitBacks or Free Twitter Designer. A custom page is another branding opportunity. Potential followers and customers will immediately understand who and what you are just by your custom page. I made a collage of my artwork, together with some images of me painting in the field—at once, this states, "artist."

Get followers

Once you have an informative and engaging profile page, you will automatically start attracting new followers. You have already begun to build your brand.

Interestingly, I have found that most creatives use Twitter as a way to connect with other creatives. True, this is a great networking opportunity, but they are missing an important marketing opportunity to reach out to prospective customers.

Be a good follower

Decide if you want to actively engage with your followers, or if you want to follow everyone back. Do what works best for you. It is nice to reach out to your friends and followers. Do not forget the little guy as your following grows. They helped you get to where you are now, and they are loyal. I do my best to thank my followers because I truly appreciate them.

It is good to reach out to some of the bigger Twitter names. These tweeters have a lot of experience and if they retweet (RT) you, it helps with your own Twitter influence.

Tweet!
At first glance, the famous Twitter logo might look like child's play. But don't let this little bird fool you—there is a lot of power in a tweet!

Make the Connection
Twitter is all about making friendly connections in order to build a strong social networking community through your following.

What to tweet

To gain new followers, be sure to pass along good content. Your followers are looking for tweets with value. If they do not find it, they will either delete you or forget you.

Engage with your followers and don't focus on selling. Focus on giving. Learn to speak with your audience, not at them. You are here to build valuable, real relationships. By engaging your market, you are creating a community around your brand. This will lead to trust and eventually sales. About 80 percent of my tweets and retweets share useful information and resources, including links to my blog. The remaining 20 percent of the tweets are reaching out to my following, small talk, inquiries and relationship building.

Share photos of your latest painting using Twitpic or yfrog, ask for feedback from your followers and get instant replies, or share inspiring quotes. Link to your YouTube or Vimeo videos as a great way to engage your following in conversation and strengthen your brand. Learn how to abbreviate your tweets. You can use URL shorteners such as bit.ly or TinyURL. Manage your Twitter following with helpful applications such as TweetDeck or HootSuite. To be effective, plan to tweet at least once a day. Ten to fifteen minutes of tweeting is enough to keep a consistent presence on Twitter.

Share links to your latest blog posts, and recycle your blog's old content. Make sure your Twitter stream is interesting and vary the content and cadence of your tweets. Be consistent with quality. You can tweet a lot or just a few times a day—this is a personal and business choice.

Make sure your last tweet counts. At the end of each Twitter session, leave a valuable tweet. Your potential followers will judge whether or not to follow you by your last Twitter update.

Reach beyond your niche on Twitter

When I first started Twitter back in 2009, my target niche was artists and art collectors. To my surprise, my tweets and blog posts began to capture the attention of a much broader audience.

Why? My Twitter updates have an appeal that reaches beyond my own art niche. How? I am able to reach beyond my art readers by understanding that most people have broad interests. I tweet about art, and share my other interests that include blogging, social media, nature, quotes, photography and outdoors. Not only can I attract my own niche readers, but I can also appeal to multiple profiles while staying true to my target audience.

FACEBOOK TIPS

Facebook is the largest online social networking site. It allows people to interact and to share photos, videos, links and more. Facebook is an invaluable tool for small businesses for its networking and marketing capabilities.

Facebook offers three ways to build your brand, and there are a few major differences between each: profiles are for people, fan pages are for businesses, and groups are for special discussions and events. Each of these entities provide for different networking and marketing opportunities. However, you must have a personal profile before you can add or create a page or a group. Many artists incorrectly use their personal profiles instead of fan pages for their art businesses. For branding, both the profile and the fan page are necessary. As an artist, you need a profile to network and promote your personal brand while using a fan page to promote your art business.

Facebook profile page

Your profile gives you visibility as a real person. Be sure to set up your profile with your real name. It is against the Facebook terms to use a profile for your business. Profiles limit Facebook users to five thousand friends. I like to use my profile to connect with my family and art friends. However, I can still connect with friends on a business level via my profile. Nowadays, people want to connect with the person behind the brand; this is a good way to interact with them.

In order get the best *return on investment* (ROI) out of your Facebook experience, update your Facebook profile status and keep it active. Once a day, or a few times a week at minimum, is enough. Share interesting thoughts, links and videos or informative content.

Facebook fan page

The purpose of a fan page is to link to your website or blog. Fan pages are set up to target your customers with bigger viral marketing potential. Pages are public and can be linked to externally. Fan pages are an important part of your *search engine optimization* (SEO), while profiles are not. Fan pages allow you an unlimited number of "fans." Facebook has been touting the pages as the strongest marketing vehicle.

The pages allow you to customize a welcome page, add your company's newsletter sign-up box, embed widgets and other social media buttons, and add on applications.

Facebook marketing expert Mari Smith's elaborate fan page is a great example of a welcome page that invites more followers and provides a sneak preview of her service.

Facebook also allows you to have multiple fan pages. This is important for people who want to promote more than one business. Using a fan page allows you and your art business to connect with current or prospective customers. Your followers and customers can easily receive any offers, special announcements and promotions. The pages allow for extra applications to be added. Pages are generally better for long-term relationships with your fans, readers and customers. In order to simplify my life, I manage just one fan page. My fan page, Fine Art Tips, is named after my art blog.

Facebook group

The main advantage of a group is that it offers the ability to message all the members via Facebook email, and these messages will show up in their personal email inboxes. A Facebook group is set up around a special group of people rather than your art business or brand. Unlike fan pages, groups allow you to send out bulk invites that easily invite all your friends to join. These people become members and can also send out invites.

Groups are generally better for hosting quick, active discussions that attract attention for a specific purpose. For instance, I set up the PowerArtists Club group. This group consists of the artists who I have interviewed on my blog for their excellence in the arts and social media.

Extra fan page tips

- Choose a page name that reflects your brand. Once you have one hundred connections, you will not be able to edit or change your fan page name.
- To gain more fans and followers, add a Facebook widget on your blog. By adding a fan box or "like" button to your blog, you will encourage visitors to join your page.
- You should always post your blog links to your fan page wall. You can choose to use a blogging network such as NetworkedBlogs or Blogged to automatically integrate a feed of your latest posts.
- A good rule of thumb for the frequency of Facebook updates is at least four times a week, but no more than five times a day with these postings preferably spaced apart. You might start to get complaints if you flood your followers' feed with too many updates.

YOUTUBE TIPS

Artists should discover the value of video marketing. The basic marketing idea behind video is to drive traffic back to your website

or blog. Video marketing will help your website ranking and page results on Google, Yahoo and all the other search engines.

Since 2008, YouTube has been recognized as the number two search engine, after Google. YouTube has continued to dominate as a specialist social network for video content. This means millions of people choose to use YouTube as a general search engine for researching and gathering information. Approximately 65 percent of all people are visual learners. Once your video is uploaded, it is immediately available to the rest of the world. YouTube's compelling statistics cannot be ignored.

YouTube stats

Here are YouTube's impressive statistics at the time of printing:

- YouTube exceeds two billion views per day.
- The average person spends fifteen minutes each day on YouTube.
- More video is uploaded to YouTube in sixty days than the major U.S. networks created in sixty years.
- Twenty-four hours of video is uploaded every minute.
- Seventy percent of YouTube's traffic comes from outside the U.S.

You don't have to be the next James Cameron to create an entertaining video that generates views and increases traffic to your site. Keep reading for tips on making video marketing work for you.

Make videos geared toward your audience

There are many topics you may want to cover in your videos:

- Demonstrations
- How-to's
- Product reviews
- interviews
- Portfolio presentations
- Gallery tours
- Upload relevant and entertaining video

Create a video title that stands out

Use keywords within the title of your video. For SEO purposes, use keywords that are applicable to your product, service or brand.

Video length

The most popular videos on YouTube average about three minutes in length. People's attention span begins to wander after only eight seconds—keep the video short so you do not lose them. The optimum video length is two to four minutes long.

Copyright laws

Intellectual property law protects digital music and other recorded music just like it protects the rights of visual artists. Just because you bought a CD or can download music for free does not mean you can use the music without paying a royalty for it. The use of copyrighted works for nonprofit documentaries or educational purposes may be considered, but ask permission of the artist. Consider purchasing a legal music license from royalty-free music websites such as Premiumbeat.com. You can choose from thousands of sound tracks by paying a one-time affordable fee. YouTube will take down your video if it violates copyright law.

Tag and categorize for video SEO

Use description words or tags that users most likely will be searching for on the Web. Add as many keywords as you can, and try and match to the existing content—this will help your video become "recommended" in the sidebar. Video optimization is becoming more important as a mainstream aspect of SEO.

Get a YouTube Channel

A custom YouTube channel is a great way to brand yourself as a professional in your niche. Create a variety of interesting, entertaining and informative videos to keep your viewers happy.

Sign up for a free trial subscription of Artist's Market Online at artistsmarketonline.com.

Include your URL

When you post a video, make sure to add the URL to your website or blog at the top of the descriptive text. This way, when the "more info" is collapsed, the user will still see your link and can click it.

Create a channel

Creating a YouTube channel is your first step towards becoming a video creator. A channel gives you the opportunity to create a profile for yourself and your content with links back to your website and blog. To be successful on YouTube, you should consider adding video consistently. This will help build your brand and help people find you, and, as a result, it will drive more traffic to your site.

Promote your video

Use your social media networks such as Twitter and Facebook to virally market your video.

See, there really is a method to this social media madness: When used properly, the various platforms work together to give value to your audience, and then social media drives the traffic back to you! This in turn grows your brand and your business, which is the purpose of a successful social media strategy. Be sure to *pull* in your audience through engagement and relationship building, rather than *pushing* and forcing your message upon them.

Any new small business venture takes a while to build before you see your ROI. Measure your ROI and influence with social media measuring tools such as Klout, Tweet-Reach and Twitter Grader. Be patient and do not expect it all at once. Just like with your art or craft, it takes time to develop your skill.

Remember, compensation comes in many forms. Yes, I have sold artwork via Twitter and Facebook, but, more importantly, social media has provided me with unique business opportunities and relationships that would never have happened without this new marketing medium. In fact, I wrote this article because of my social media relationships.

* Excerpted from *2012 Artist's & Graphic Designer's Market* © 2011 by F+W Media, Inc. Used with the kind permission of North Light Books, an imprint of F+W Media, Inc. Visit northlightshop.com or call 1.800.289.0963 to obtain a copy.

ArtistsMarketOnline.com
Where & How to Sell What You Create

FREE TRIAL
for First-Time Subscribers

Get a 7-day risk FREE trial with any annual subscription.

ArtistsMarketOnline.com features include:

- Almost 3,000 updated listings of where to sell your art

- Tools to track your submissions and manage your contacts

- Custom folders that allow you to store favorite market listings

- Market news with regular updates from the creative industry

- Answers to the most common business and creative questions

- Advice and inspiration from experts

Establish a more successful freelance career now!

Let Artist's Market Online help you find the right markets to sell your work. ArtistsMarketOnline.com is the online version of both the *Artist's & Graphic Designer's Market* and *Photographer's Market* books, known since 1975 as the best reference guides for emerging artists, designers and photographers who want to establish a successful career. You'll find listings for magazine and book publishers, greeting card companies, galleries, art fairs, ad and stock agencies and more. You'll find thousands of continually updated market listings that just aren't available anywhere else. Subscribe to ArtistsMarketOnline.com to get instant access to:

- **Updated market listings**
 ArtistsMarketOnline.com provides the most comprehensive database of verified markets with updated contact information available anywhere.

- **Easy-to-use searchable database**
 Looking for a specific magazine or book publisher? Just type in the name or other relevant keywords. Or widen your prospects with the Advanced Search. You can also search for listings that have been recently updated!

- **Personalized tools**
 Store your best-bet markets, and use our popular record-keeping tools to track your submissions. Plus, get new and updated market listings, query reminders and more—every time you log in!

- **Professional tips and advice**
 From pay rate charts to sample query letters, from how-to articles to Q&As, we have the resources creative freelancers need.

INDEX

Photogrpah by Peter Roertson.

Dedication

This book is dedicated to every person who has dreamed of taking on the joys and challenges of making a life as an artist.

About the Author

Margaret Peot is a painter, printmaker and writer who has been making her living as a freelance artist for over twenty years. She is the author of *Make Your Mark: Explore Your Creativity* and *Discover Your Inner Artist*, published by Chronicle Books. *Make Your Mark*, a fully illustrated guidebook, contains no-fail techniques designed to jumpstart ideas and map out new pathways for the reader's personal artistic journey. Her book for kids, *Inkblot: Drip, Splat and Squish Your Way to Creativity*, published by Boyds Mills Press, shows all the fun things to make and do with inkblots.

Margaret has been painting and dyeing costumes since 1989 for Broadway theater (*The Lion King, Wicked, Shrek The Musical, Spamalot*, and hundreds of other projects), dance (San Francisco Ballet's *Nutcracker*, Pilobolus, The Feld Ballet), television (Siegfried and Roy Special), and film (*Bram Stoker's Dracula*, The Coen Brothers *Naked Man*), and circus (Ringling Bros. and Barnum and Bailey, and The Big Apple Circus). She is a member of United Scenic Artists Local 829, USA and has taught costume painting at Tisch School of the Arts at New York University.

In the '80s, as a decorative painter for Tromploy, Inc., Margaret worked on murals for public spaces including the LA Museum of Science and Technology, a Gaudi theme restaurant in Tokyo, and many residencies. Margaret also worked as a dyer for the theater, a textile designer (Cosco, bandanas, apparel), and a theatrical scenic artist. She has painted furniture and onesies for babies, briefly had a business printing etched plates on silk for pillows, has sold textile designs, and worked for a summer as an illustrator for the United States Air Force.

Margaret lives in New York with her husband, Daniel Levy, and their son Sam. Visit her website at margaretpeot.com.

The Successful Artist's Career Guide.
Copyright © 2012 by Margaret Peot. Manufactured in China. All rights reserved. No part of this book may be reproduced in any form or by any electronic or mechanical means including information storage and retrieval systems without permission in writing from the publisher, except by a reviewer who may quote brief passages in a review. Published by North Light Books, an imprint of F+W Media, Inc., 10151 Carver Road, Blue Ash, Ohio, 45242. (800) 289-0963. First Edition.

Other fine North Light products are available from your favorite bookstore, art supply store or online supplier. Visit our website at fwmedia.com.

16 15 14 13 12 5 4 3 2 1

DISTRIBUTED IN CANADA BY FRASER DIRECT
100 Armstrong Avenue
Georgetown, ON, Canada L7G 5S4
Tel: (905) 877-4411

DISTRIBUTED IN THE U.K. AND EUROPE
BY F&W MEDIA INTERNATIONAL, LTD
Brunel House, Forde Close, Newton Abbot,
TQ12 4PU, UK
Tel: (+44) 1626 323200
Fax: (+44) 1626 323319
Email: enquiries@fwmedia.com

DISTRIBUTED IN AUSTRALIA BY
CAPRICORN LINK
P.O. Box 704, S. Windsor NSW, 2756 Australia
Tel: (02) 4577-3555

Edited by Christina Richards
Designed by Clare Finney
Production coordinated by Mark Griffin

Acknowledgements

The Successful Artist's Career Guide began as a conversation with Virginia Clow about what we wished we had been told before we had graduated from college with art degrees. My gratitude, appreciation and admiration go to her and the working artists who kindly contributed their time and attention to the interviews, as well as their wonderful artwork to this book: Marshall Arisman, Michael Bendele, Margaret Janik, Jeanne Gentry Keck, Ardis Macaulay, Catherine Redmond, Jennifer Sattler, Anne Sessler, Parmelee Welles Tolkan, Gia-Bao Tran, April Vollmer. Thanks as well to Barbara Jones and Scott Rodabaugh for their valuable expertise, and to Ann Taulbee at Miami University for letting me try out my worksheets on her Capstone class.

Special thanks to my editor at F+W, Christina Richards, for her unflagging enthusiasm for the project, and Clare Finney for the lovely book design. Thanks to my super agent, Anna Olswanger for shaping the proposal, to Daniel Levy for helping me organize and simplify my ideas, and to Barbara Clark for her always-sound advice. And for assistance and encouragement all along the way, thanks to Gary Finkel, Sally Ann Parsons, Clyde Wachsberger, Barbara Ellman, Kim Ablondi, Mark Cupkovic, Frank Krenz, Dallas Middaugh, Tom Effler, Susan Kristoferson, Michael Griffiths, Tom Gilmore, Geoffrey Fishburn, Alex McKibben, Heather Kogge, Hans and Kathie Peot, and Samuel Archer Levy.

To convert	to	multiply by
Inches	Centimeters	2.54
Centimeters	Inches	0.4
Feet	Centimeters	30.5
Centimeters	Feet	0.03
Yards	Meters	0.9
Meters	Yards	1.1

METRIC CONVERSION CHART

IDEAS. INSTRUCTION. INSPIRATION.

Receive FREE downloadable bonus materials when you sign up for our free newsletter at artistsnetwork. com/Newsletter_Thanks.

Use Color Trails to Lead the Viewer's Eye

the Artist's ma

2-Point Perspective

The Wow Of Wa...

Transpar... Opaque... in Lands... & Figures

Exclusive: 9 Need-to-Know Principles of Design

the Artist's ...zine

5 Plein Air Palettes

Complete Guide to Acrylic Mediums, Gels & Pastes

the Artist's magazine

Make Your Colors POP!

Catch the Glow
Copper as a Surface for Oil

Versatile Acrylic
5 Masters Share Tips

From the Ground Up:
Pick the Right Underlayer for Pastel

Drawing Lesson:
Conifers & Hardwoods

September 2011
www.artistmagazine.com

July/August 2011
www.artistmagazine.com

celebrating artistic vision

SPLASH 12
THE BEST OF WATERCOLOR

edited by
Rachel Rubin Wolf

Find the latest issues of *The Artist's Magazine* on newsstands, or visit artistsnetwork.com.

These and other fine F + W products are available at your favorite art & craft retailer, bookstore or online supplier.

Visit our websites at artistsnetwork.com and artistsnetwork.tv.